LEAP
OF STRENGTH

**A Personal Tour Through the
Months Before and Years Afte
You Start Your Own Business**

Walt Sutton

**Silver Lake Publishing
2025 Hyperion Avenue
Los Angeles, CA 90027**

Leap of Strength
A Personal Tour Through the Months Before...and Years
After...You Start Your own Business

First edition, 2000
Copyright © 2000 Silver Lake Publishing

Silver Lake Publishing
2025 Hyperion Avenue
Los Angeles, California 90027

For a list of other publications or for more information from Silver Lake
Publishing, please call 1.888.663.3091.

Library of Congress Catalog Number: Pending

Sutton, Walter G. III
Leap of Strength
A Personal Tour Through the Months Before...and Years After...You Start
Your own Business

Includes index.
Pages: 278

ISBN: 1-56343-702-3
Printed in the United States of America.

Acknowledgements

Merci! Danke! Gracias! Thank you!

We don't do near enough of it! Who among us doesn't have reason to express thanks at least a dozen times a day? Yet how rarely we say it—thank you.

One of the lessons I've learned during the solitary process of writing this book is how dependent we really are on one another, even those of us who consider ourselves rugged individualists. You just can't ignore the fact that most of our accomplishments are born out of grace provided by others. And so with this in mind, I want to say thank you to the most significant others who have given this journey all of its good parts.

Thank you, Deborah, for sharing the roller coaster ride.

Thank you, Jessika, Marcel and Nik for being who you are; it has helped me to work harder at being who I think I should be.

Stuart Ende, your counsel and guidance have earned you the dubious honor of being my most trusted and credible advisor. Then there is Jack Grapes, who is a great poet and the best teacher I have ever known.

Thank you, Bill Green, for both encouragement and seed capital when we were truly down and out.

To all of the wonderful people who worked in the businesses that made my 23 years of entrepreneuring so rich, thanks for all of it. Larry King, you were the first one to suggest that

there were other ways to live, then you encouraged me to investigate them, then you were a good friend along the way.

TEC-31 was a caring but demanding group of CEOs who shared so many adventures with one another. Isn't it interesting that we were brought together by business, only to learn about life?

Gayla Reid is a gifted writer and editor whose touch and editing skill were just perfect, exactly what this material needed before it could be launched.

Carl, Phil, Dick, Betsy, Bill, Frank, Bonnie and Ralph, mentors all, whose early reading and encouragement kept this project alive. And Betsy again, thank you for helping me through the first round of rejections.

TEC-235. Another group of CEOs, Canadians, who rightfully insisted that they wouldn't follow my advice unless I followed it first...I hate that!

Warren and Ginger were the earliest practitioners and the greatest of friends.

And most importantly, to the thousands of CEOs worldwide who, during the last five years, have challenged and tested my early musings on what life as a CEO or business owner is all about. To the extent there is real meaning in this material, it comes from them.

Thank you all!

WGS III
Seattle, Washington
January 2000

Table of Contents

Part Three: Valuable Tools

An Interior Journey

We know more about the atom, dinosaur blood and the crystal content of moon dust than we know about what it takes to start and grow a business successfully. This book is an attempt to shift the balance of knowledge back the other way.

Why me? Why would I dare to write such a book? Because I'm an entrepreneur, I spent 23 years constructing and reconstructing businesses, while paying neurotic attention to the doing and undoing of myself and others in the process.

I am not taking literary license or falling back on hyperbole when I say *undoing*. I have seen it happen time after time—and it's happened to me. Make no mistake, starting a business is one of the most frightening things you will ever do. It is also the most rewarding. The go-go IPO and venture capital markets, which define our current economy, make starting a business sound like it's all Amazon.com and Yahoo! But it's not.

When I decided to stop being an entrepreneur and become a full-time writer, it seemed the least I could do was to tell aspiring and practicing entrepreneurs about the traps that no one ever bothered to mention to me.

At first I thought that successful entrepreneurs knew all about these traps and were just not sharing their hard-earned knowledge. But you will be happy to know that, as a class, entrepreneurs aren't quite that devious or mean-spirited. Most of us are just too busy surviving to recount the details of each problem we've encountered. Knowing that this secretive be-

havior is unintentional has certainly helped me feel better about the entrepreneurial tribe.

Knowing about these traps does make a difference. I've had the privilege of leading CEO workshops based on some of the material in this book. As of this writing, I have helped over 4,000 CEOs grapple with this material.

In one early morning session, we were around a conference room table on the 43rd floor of a new office tower in a large Midwest city. It was September and already some of the trees were turning. Wet permeated everything; it was hot and uncomfortably humid during the day and getting cold at night. Nine men and two women CEOs struggled with the issue of how much money is enough money.

The issue was phrased as bluntly as that: "How much is enough?" This is an uncomfortable question for everyone, and this group was working hard at the problem, but getting grouchy. Finally, each participant settled on a number—an amount of money that would be enough for a lifetime. There was a shared sense of accomplishment as chairs groaned and squeaked, filled with self-satisfied reclining bodies. Then one of the CEOs, a man in his mid-60s, gently flipped his pencil so that it somersaulted and landed right in the middle of his page of calculations.

"Dag nab it," he said. We all fell silent. "Dag nab it, I don't have to do this anymore. I can let them do what they want with this darn company and go do something I want to do."

He was right. So right, in fact, that his proclamation clearly jolted the other participants, who knew him well. It turns out that he had never considered the possibility of using his earned nest egg as a platform for another life—a life away from the family business he had successfully run (as an unappreciated son-in-law) for over 40 years. It would have been fun to hear

what he had to say to his family at dinner that night. I was sure he was going to make the change.

Simple lessons: You don't have to do this job—any job—for life, and there are limits to the amount of money you can enjoy. He learned both of these that morning, and my day was stamped with a gold star. For most of my career, these two basic lessons were literally beyond comprehension, as were dozens of others. They are what brought me to write this book.

Business writing often focuses on success, the grand spot-lighted moments that rarely occur in the real world. It doesn't take a genius to realize that what makes these moments grand is the problem solving that precedes them. Here we will spend more time on the difficult moments that define the experiences of starting and growing a business or practice. All of the people I write about are successful in one way or another; it's just that their mistakes are often more interesting—and instructive—than their moments in the sun.

Writing *Leap of Strength* has helped me answer a ton of questions I've had for a long time about business, about being an entrepreneur and about life. However, the entrepreneur's path is less one of answering questions than one of making decisions. Even after having started and run a successful business, questions remain.

There were plenty of times during my career when I could have more easily understood the chemistry of moon dust than deciphered the vagaries of lease options, bank covenants or compensation matrices. The upside of this seeming deficiency illustrates one of the many extraordinary benefits of being an entrepreneur: Being your own boss means that you don't have to learn anything unless *you* want to learn it. So, "just-in-time" learning, describes a real entrepreneurial asset. The obverse, not learning on time, however, can be horrific. At best you get

hammered, at worst you die from wounds inflicted with a blunt instrument. The truth is that I did a great deal of both: learning just in time, and getting hammered when I didn't.

Since the day I opened the doors of my first business, I have been collecting material about the entrepreneurial enigma. I've also kept a diary—an abundant document, as you may have already guessed. And I have interviewed dozens of other entrepreneurs who have started and run all types of businesses.

Sören Kierkegaard once said, "Life can only be understood backwards, but it must be lived forwards." The opportunity I am offering you is to have a good look backwards over the experiences of many entrepreneurs so you can make whatever adjustments you deem necessary for your own business and career. Consider this book my gift to you: just-in-time learning without the pain.

For those of you who are uncertain about starting an entrepreneurial career of your own, this book gives you a chance to take a dry run through the issues an entrepreneur faces.

The World Has Already Changed

When I set out to write this book, I estimated the potential audience to be perhaps two or three million people, folks who are entrepreneurs, aspirants or entrepreneurial managers. That was until I had dinner with a good friend who earns a smashing living as a corporate management consultant. He spent most of the evening giving parts of his stump speech, entitled "Why the U.S. Economy Must Globalize Now or Die!" He punctuated the highlights with drafts of a premium Scotch I would later be paying for (it was my turn to buy dinner).

By the time we were rounding the clubhouse turn, with chocolate mousse and some alarmingly expensive brandy, he

had hit his stride. For although he is a volcanic proponent of free trade, his current ranting was something more like: Most people don't even know it yet, but the world has already changed, and to compete at the new game people are going to have to catch up fast.

What piqued my interest was how he described the nature of this change. As I sculpted my overpriced mousse into a miniature landscape, simultaneously calculating how many miles it was going to take to burn off the evening's calories, I realized he was articulating the very thoughts that had been rumbling around in the back of my own head for some time.

The central element of this change is that small entrepreneurial units are the newfound building blocks of growing global enterprise. Even the mega-multinational corporations of today are being run less and less by CEOs and top-down management than by an expanding cosmos of core directors and coordinators who orchestrate thousands of projects carried out by contract workers or subcontracted businesses. What we are now calling "outsourcing" (as if it were some cute passing phase) is a manifestation of a new era of doing business, where much of the work will be done and much of the money will be made by a growing strata of small, independent companies and sole practitioners.

This strata is being created from the ranks of currently employed, but soon to be downsized, rationalized, reorganized and reengineered, employees. It is also being created by a new generation of living-seekers determined to create their own security because they have no reason to believe it will come from anywhere else.

"Millions of today's employees will become tomorrow's entrepreneurs," my friend prophesied, waving a final glass of brandy in the air for dramatic emphasis. "That is, if they want

any money in their lives. The days of lifelong employment are gone."

My friend pulled a cigar the size of my arm from his suit pocket and lit it. His eyes twinkled in the lighter's dancing flame. At that moment, I realized that my prospective pool of readers had just quadrupled, and I understood why my friend gets the big bucks: he eats well and knows just how to make the payer feel good.

I decided then and there that instead of writing a book for a limited subset of rather neurotic risk-takers, I would write a book that would be of value to a much larger pool of neurotic risk-takers.

The message is that many of you are no longer going to be employees—you are going to be entrepreneurs, like it or not.

I can hear the cry, "Oh, the end of the world! Where are the good old days of management and labor, full-time employment and unions?"

Some Background

If you paid better attention to your high school history teacher than I did, you probably know the answer. What is happening to the population economically is more like the good old days than we think.

Once upon a time in America (I'll stick to the short version), our economy was driven primarily by the work of farmers and self-employed artisans. Even factories, where they existed, were small and usually family owned. Families themselves were essentially entrepreneurial units. Industrial expansion in the mid-nineteenth century, fueled by increasing commercial opportunities and coupled with increased immigration and a demographic shift internally from the country to the city, wrought a new era of production.

Factories grew and employed more people. The work force segregated into management and labor. As our nation's population grew, increasing numbers became dependent on big business for jobs and paychecks. The twentieth century business paradigm, perhaps best symbolized by the great American automobile industry, was set. A couple of human cataclysms, World War I and World War II, further stimulated the trend.

Over time, the labor movement steadily led to an improvement in working conditions, compensation, benefits and job security. Those of us raised in the United States and born before 1970 are products of this economic model. To succeed is to get bigger: more sales, more factories, more employees, more middle managers, more branch offices, more phone lines, more office supplies.

More is the operative word. We have known no other model in our lifetime, and because many of us were daydreaming out the window in that history class when we might have learned otherwise, we have presumed it to be the norm, and accepted that retirement at age 65 with company benefits is a right protected somewhere in an early draft of the country's Articles of Federation. But the economic transformation of the last several decades has proved otherwise.

A Window of Opportunity

As the Boeings, Motorolas and General Electrics of the world retool, reorganize, downsize and bloodlet, and as they look outside for software, assembly, transportation, printing, planning, communications, tracking, accounting, payroll, administrative services and a veritable well of other potable resources, a window of entrepreneurial opportunity is opening up for those who have the eyes and interest to see it. (Given that you are reading this book, you probably do.)

How do you prepare for and incorporate all of this change? At least some of the answers are in the pages that follow.

Call It a Midlife Crisis

You may wonder why I left my job as an entrepreneur, and more particularly, why I am not sipping exotic fruit drinks at some exclusive tropical resort while resting on the laurels of my own brilliant career. (It could be that I *am* writing this on my laptop on some sun-painted beach.)

I started and ran four businesses in my working life (so far). I hit age 48 like a rocket slamming into the great pyramids at Giza. While reeling around in the hot desert sand, I discovered that I wanted to write, create art and pay just a smidgen of attention to that other side of my brain—I always forget which is which, right or left?

If this sounds like a midlife crisis, it may well be. However, I like to interpret the collision as a spiritual experience.

Twenty-three years in the saddle was plenty for me—been there, done that and got the T-shirt. So I sold the farm—for cash money, mind you—and started my new career as a writer. Although I no longer run businesses, I thoroughly enjoy thinking and writing about them, just as long as I have enough sunblock. But, enough of history, moon dust, demographics and midlife crises. On to the rivers of cash, vision and the land of survival—the real stuff of entrepreneurship.

I am writing this book with the intention of avoiding war and sports metaphors, or at least keeping them to a minimum.

I recently sat through a three-hour presentation on marketing techniques and left feeling that in one afternoon we had won several wars all by ourselves, using marketing weaponry and good tackling techniques—it was irritating and exhausting.

There is something about the American business model (an act that by definition requires cooperation among participants) that implodes upon home runs, double plays, grand slams, strafing fire, slaughter, flanking movements and nuclear attack. I mention this because I hope that at least half of my readers are women, and that the other half could use a rest from the search-and-destroy mind set that often permeates business writing.

What's Coming Up

I'd like to take a minute to explain the structure of this book. I include lots of personal stories, because I've found that storytelling is often more instructive than lecturing. You will find that each story is tied to a specific entrepreneurial dilemma.

This book's journey has markers that I call "Experience," "Core Tasks" and "Tools."

First, I take you through my experiences as a business founder and owner. This is a way of working from the inside out—from the heart to the skin. I am certain that most decisions an entrepreneur makes are on an emotional as opposed to an intellectual level.

We spend several chapters living through as much of the process as I can meaningfully bring to you.

We travel as close to the center of entrepreneurship as we can get. There are, I believe, a group of core tasks that are absolutely critical for success. These constitute—appropriately—the center of the book.

Finally, there are several chapters that describe the major tools accomplished entrepreneurs use to build successful businesses and, often, happy lives. This is linear material that will be useful only for those who understand the preceding parts. Please don't confuse this section of the book with a "system."

This book is not intended as a scheme for my consulting practice, or anyone else's for that matter. It's not even meant to be a management book in the traditional sense. It's more personal than that; it's a guide to the issues that you're likely to face as an individual striking out on your own.

It's an interior journey as much as a professional or financial one. Success in this regard is a matter of putting the tools into context. However, unless you understand the emotional and artistic nature of the job and the core tasks inherent in it, the tools aren't as much help as they could be. It's like finding a chisel but not knowing anything about sculpture—nice tool, but so what?

This book aims to help you *answer* that question.

Part One:
Experience

1 The Hard Part

The word *entrepreneur* is derived from the Old French verb *entreprendre*, which means "to undertake." However, the word *entrepreneur* has come to be associated in English more with developer, car dealer or slumlord. Actually, loud and boorish slumlord is closer to the mark.

As a British friend of mine agrees, the word is "off-putting."

But even Old French doesn't reach far enough into the past to embrace the genesis of entrepreneurship.

Will Durant, who chronicles the entire span of Western civilization in *The Lessons of History*, tells us there has been some form of commerce for at least five thousand years, and more recent discoveries suggest it dates back ten thousand years or more.

Consider that each exchange of goods (excepting robbery) requires at least one entrepreneur—perhaps two or more. Without getting into cultural anthropology, it does seem reasonable to presume that herding, crafting, farming and hoarding were in part entrepreneurial acts, and from such noble roots our profession springs.

In short, commerce and the entrepreneurial way of life go back to the very dawn of history. Indeed, they are two defining aspects of our species.

Entrepreneurs Never Learned to Share

The irony is that even with all this entrepreneurial history under our collective belt, we know remarkably little about how to become successful entrepreneurs. In fact, most entrepreneurs I've met still survive throughout their careers by reinventing the wheel several times over. Whereas new heights are reached in other disciplines by climbing onto the shoulders of those who went before, entrepreneurs seem to start at ground zero each and every time.

Learning is simply passing common experience from one generation to the next. We have plenty of channels and rituals for conveying entrepreneurship and other related skill sets to interested students. Apprenticeship is the oldest model of learning. A student shares in mature experience by watching, helping and participating. With the rise of civilization, we have added books, technical schools, universities, television and computers to the learning equation. Even without the recent refined uses of media, we have exhibited the capacity to pass technology and skills across generational boundaries.

As of this writing, my oldest son is an engineering student. For me, one of the attractive features of engineering is that engineers write their discoveries down and share this information with other engineers. The same is true of the sciences, both physical and social: lots of discoveries, lots of writing up results, lots of sharing of (and quibbling over) details. In the process a body of information emerges about almost everything important in, for instance, electrical engineering.

What is it about engineering that encourages the accrual—and, just as important, the sharing—of this wonderful and growing body of information? Is it the plastic pocket protectors, the snappy white lab coats, those calculators bristling with brightly colored buttons? Is it the engineering lexicon, the mastery of

which grants admittance to some sort of special club of initiates? What is it that causes these men and women to share information on such a grand and methodical scale while entrepreneurs—those seemingly natural talkers, backslappers, entertainers, inventors and leaders—tend to share next to nothing with their own tribe?

Be Specific

Getting entrepreneurs to loosen up about specifics is like trying to open a childproof aspirin bottle when you have a hangover. I confess, I've hung out with entrepreneurs a lot over the years. I can't help it. One reliable feature about conversing with other entrepreneurs is that the script usually starts with an obligatory "How's business?" and inevitably concludes with either "Great, just great" or "We're struggling just to get by. You know how it is."

Hardly ever is there a middle ground: it's either upbeat or moribund. Almost never do details burst forth spontaneously. At least not about business. Mind you, entrepreneurs will talk all evening long about every other topic under the sun: growing backyard lettuce, stock market trends, scaling the south wall of K2. But getting them to loosen up about the specifics of their business affairs is harder than lifting a manhole cover with a toothpick. And although I can probe and ask questions with the best of them, I still leave the exchange with little more than "great" or "struggling."

Then one day I figured it out.

I found myself in a delightful conversation with the doorman of our building, Armand. We'd been going at it for about 15 minutes. He was telling me about Todd, his four-year-old grandson. It seems Todd has a bit of a behavior problem. He

spits at grown-ups and recently the parish priest. As Todd's grandfather, Armand is the only person who has been able to keep Todd and his saliva together for extended periods of time. This has not only created a warm and abiding bond between Armand and Todd, but also has raised Armand's status with his son.

We were about to plunge back into Armand's youth when it suddenly came to me. I understood the problem.

Entrepreneurs act social, like Armand, but when it comes to business, they are lone wolves, single cave dwellers, secretive and untrusting. Then as an elaborate deception, they act cheerful and engaging. They aren't able to share the joy and pain, or to talk about what they really care about—their businesses!

I don't mean this as a backhanded indictment of entrepreneurs in general. I have answered "great" about a thousand disingenuous times myself. But as Armand and I delved deeper into his favorite subject—his grandson—I was struck by how much easier growing a business would be if we entrepreneurs could discuss entrepreneurship with such openness and enthusiasm.

What if entrepreneurs somehow were able to share secrets about inventory or slow payment? What if, like engineers, they wrote their stories down in some central tome for all other entrepreneurs and aspirants to learn from?

I'm reminded of the Sherlock Holmes story in which the mystery is solved because a dog did not bark: the key is in what's missing as opposed to what's there. In other words, if you just listen to the banter you'll get nothing. You need to intuitively hear what is *not* said.

And then there is the matter of sharing, which is a separate but related issue. In fact, sharing is the central issue of this book.

Dogs That Don't Bark

Interviewing dozens of fellow entrepreneurs as part of my research for this book, I had an interesting experience. Although most of them were supportive of my effort and politely cooperative, many of their interviews were pervaded by an underlying tension. My subjects typically looked distracted and a little crazed. Of course, these are really busy folks, most of whom feel as though they are being chased by the devil himself. Talking about their careers doesn't make their Top-10 list of things to do this decade, let alone in the middle of a busy schedule.

So the answer to "what's the hard part?" is that people who undertake this work are very, very busy. What we are talking about here is not just a full-time job—it is a chosen way of life, one that doesn't leave much time for the sort of discussions Armand has in front of our building.

But there are other, more subtle reasons why the dog doesn't bark. It is more than a full schedule and a haunting fear of death (or worse, failure) that keeps entrepreneurs from sharing more about what they do for a living. Again, consider engineers.

Engineers are often painfully afraid of public expression of any type (my son is an exception to the rule). But get an electronic engineer going on some micro point relating to resonance in an inductive circuit and she'll make Armand look shy and retiring.

Several years ago I talked to a small business owner named Jason who was trying to sell widgets to his state government. (I use this example because it illustrates why it's crucial to pay as much attention to the motivation underlying a person's actions as to the actions themselves. If Jason had followed this advice, he would have saved himself a lot of time and effort.)

Jason courted his target for two years, doing a masterful job of hammering his competition on both quality and price.

His was the best widget you could buy, and he could deliver the required quantities at the lowest price. Yet for all his time and exhaustive efforts, he couldn't make the sale.

His contact in the state office was a fellow named Cecil, but the ultimate decision-maker was Cecil's boss, George. Cecil agreed that they were great widgets, but George just wouldn't buy off on it.

One day, Jason and I were sitting in a swank but noisy restaurant. As he continued his story, he leaned across the table and began to whisper. Wondering if a competitor had just been seated next to us, I nonchalantly shifted my eyes to the left, then the right, but saw nothing suspicious. Jason explained about taking Cecil out for beers one Friday evening. After three or four drinks, Jason finally broke down and popped the question.

"Darn it, Cecil," he said, "what the hell is it with you and George? We have the best widgets, we can deliver on time and we have the best price. We can save you a bundle."

An emboldened Cecil replied: "George doesn't care about price, Jason, or how well your widgets work either. Don't quote me on this but George only cares about George. He will buy your widgets only if he gets brownie points by doing so, and you haven't figured out how to deliver them."

At first Jason feared that Cecil was talking about something illegal, but he wasn't. Cecil was simply telling Jason that regardless of price, Jason had to figure out a way to make George look good by choosing to buy these particular widgets.

Jason literally reddened as he told me this story. "Two years of screwing around trying to get this damn order, and all I had to do was make this guy look good and we would have been in the door a long time ago. I felt like an idiot! Just call me the village idiot," he said.

And there you have it, another important reason why entrepreneurs don't share. Much of the entrepreneurial mystique involves making others feel confident in your business acumen and savvy. Yet, so many of the important entrepreneurial lessons are learned in the same way Jason learned his. Many of the truths—large and small—are stumbled upon, backed into or simply come to light as a result of bone-headed oversights or mistakes. It takes a rare bird to admit to these misadventures in learning, let alone get up and broadcast them at the next entrepreneurs' convention!

Jason's experience illustrates yet another obstacle to sharing. After investing two years of his life chasing an illusive order, it seems unlikely that he would be willing to help his competitors along by telling them, "Say, old chaps, having trouble with Cecil and George? All you need to do is to find a way to get George a couple of civil service brownie points and you've got a good shot at the order."

Jason correctly assessed that his discovery about George is as much a tactical edge as are his quality control or production departments. He is likely to whisper to himself, "Why should I tell them?" as he addresses his industry peers. "Why should I share this hard-earned secret?"

Is It Possible to Learn to Be an Entrepreneur?

Although there are some fine business, service, trade and management organizations, there are few, if any, places where entrepreneurs come together to talk about being entrepreneurs and share what they know. The fact is, learning to be an entrepreneur is basically autodidactic, or self-taught. Many of the lessons are learned painfully and under lonely, unique, difficult and sometimes embarrassing circumstances.

Add to this emotional mélange some high stakes and perhaps an obsessive fear of failure, and you don't exactly end up with a clubby group of folks. You end up with people who only *look* like entertainers and extroverts. And although entrepreneurs do gather, such meetings rarely result in shared secrets, open hearted discussions or candid psychoanalysis of the craft. There are, of course, exceptions.

One organization, The Executive Committee, gathers entrepreneurs into committees that meet regularly to discuss its business problems. TEC, as the group is called, has as a motto: "It's lonely at the top."

Although it is a tremendous learning resource for entrepreneurs (I was a member for six years), TEC has attracted a relatively small percentage of the qualified entrepreneurs in the business community. Nonetheless, I can say that entrepreneurs belonging to a TEC group are having a considerably richer (and probably safer) experience than those who don't. Beyond the few trade groups such as TEC, there are a handful of other sources of information for the interested entrepreneur. These include the print media—books and magazines—and learning institutions, which offer a wide range of classes.

Start with magazines. There are many that profess a special kinship with the entrepreneur. What all commercial magazines and newspapers really do, of course, is sell advertising. And to sell advertising they create vehicles aimed at specific, yet reasonably broad, markets calculated to achieve a broad and profitable circulation. When you are looking at a magazine you need to ask, who are these people trying to reach? The answer is almost never the entrepreneur alone. Some magazines are written for managers (a much bigger and different class); most are written for investors or would-be investors; and others are written for those who hypothesize that the state of the world

follows the state of economies. There are many interesting and entertaining magazines out there, but few, if any, have impressed me as being a staple of an entrepreneur's continuing education.

What about books? One of the reasons I'm writing this is because the entrepreneur's shelf is almost empty. One notable exception is *Growing a Business* by Paul Hawken, which I strongly recommend. I also think there is plenty to learn from Peter Drucker, Tom Peters and Warren Bennis.

I am also convinced that reading extensively from history and biography at large provides a rich source of emotional and intellectual inspiration—something that entrepreneurs often need. But alas, another characteristic of many entrepreneurs is that they don't read. Most don't have the time.

What about attending an institution of higher learning? I've never met anyone who was seriously hurt by having an MBA. My personal hero, Charles Handy, author and business philosopher, thinks that such a degree, augmented by an apprenticeship, should be a basic requirement for anyone entering a management position.

Here's the interesting difference. You will learn most of the important management tools in an MBA program, but this doesn't necessarily translate to learning to be an entrepreneur.

I spend a whole chapter discussing what I call the "Rules of Entrepreneurs and Managers," so I won't elaborate here other than to say there are millions of managers in the world and far fewer entrepreneurs. Furthermore, there are many managers who will never succeed at running their own business, and many successful entrepreneurs who couldn't spell *MBA* if you spotted them the *M* and the *A*. This includes wealthy, prosperous, expansive people who appear uneducated to a college freshman. So while there is real value in a business degree, it mostly

accrues to one who is going to become a manager. Many universities offer an entrepreneurial program as a business specialty. Although some may benefit from this training, I think it is easier to teach about tools in the classroom than it is to teach about skillfully using them.

One excellent outcome of this specialty is that we will see more entrepreneurial managers as time goes on, which should serve both the managers and industry well.

The other main source of formal education comes at the undergraduate, community college or technical college level. Appropriately, most of these programs are a bit like a salad bar: you can take as much or as little as you like from a line of varied offerings.

One can easily see value in such programs, especially for bolstering technical skills. For example, let's consider the staple of the business curriculum: accounting. Although I know several rich and happy entrepreneurs who don't understand the first thing about accounting, I wouldn't suggest you take an entrepreneurial dive unless you understand how the business community adds up the numbers. It's a bit like flying without knowing how to read instruments: you may have a very exciting trip, but it would be considerably safer and more predictable if you could assess your altitude in the fog or the amount of gas left in the tank. School is a great way to learn such skills, and basic accounting is available in almost every community. Accounting is that perfect example of a tool—a management tool—that can make life as an entrepreneur much easier.

Institutions, therefore, can provide useful education, starting with extension courses and continuing right through to the venerated MBA. The techniques and methods of managers are helpful to successful entrepreneurs, but the job itself is much different. Class work can provide the aspirant with valuable

help, but it doesn't train him for real-time entrepreneurship. This leaves the question open as to whether schooling by itself could ever do such a job.

I believe the answer to this question is no. But a combination of classes and apprenticeship can sufficiently replicate the way these skills were learned in the past and better prepare young people for the rigors of business ownership.

A good example of how skills were taught is the family farm, a classic model of entrepreneurship where both technical and business knowledge were passed along within the family from generation to generation. This is a great example of learning and doing. A cooperative effort between businesses and institutions could reproduce this process today. I wouldn't have to finish this book if these methods were widely used today. You could just go out and enroll for three or four years and be as well prepared as you could be. Unfortunately, the typical entrepreneur is faced with institutions that teach only bits and pieces of what is actually needed to be a successful business owner.

All of these elements conspire against the budding entrepreneur. As you work yourself into a career as an entrepreneur, you will likely experience the loneliness described in this book. This sense of being alone is, in the opinion of those I have interviewed, the hardest part about the job. Most don't ever get used to it. However, the best way I know to mitigate this loneliness is to recognize that you alone understand how to make your business run. Take strength in this knowledge and the knowledge that others like you are struggling with similar feelings of fear and loneliness as they fight to start and grow their own businesses. These are the common threads that bind the central entrepreneurial experience. I encourage you to gather and use these threads to create strong, colorful weavings.

Leap of Strength

2 My Leap

I began my entrepreneurial life in 1972 by founding a small consulting firm. Since the dawn of time, tyrannical bosses have compelled sensitive and imaginative souls such as myself to jump ship and strike out on their own rather than suffer oppression for the sake of a biweekly paycheck. Indeed, I had a boss who belittled and berated me to such an extent that when I saw the proverbial open window I jumped lickety-split through it, taking care to bring a couple of promising clients with me in tow. In fact, these clients were even more delighted because, quite frankly, my boss was difficult to work with.

The first company I founded analyzed and helped resolve complex industrial construction disputes. For example, in one case, a public utility built a large dam with an accompanying electrical generating station and high-voltage transmission lines. The contractor experienced all manner of difficulty in constructing the dam and ultimately charged twice the bid price for building the project.

Of course, the utility was not interested in paying a 100 percent premium on a fixed price contract, and we were retained to help sort out the mess. I assembled a team of engineers and other experts to figure out what really happened, and opened discussions to resolve the dispute. It sounds simple, except there are a lot of parts to dams, generators, turbines and high-voltage transmission lines. There are also a lot of things

that can go wrong while constructing them. The work, in fact, was exceedingly complex, and the service we provided to untangle it all proved to be as useful as it was unique. Unfortunately, as services go, ours lived at the bottom of an extremely narrow market niche.

Nevertheless, my new business was a success. Fortunately for us, there were lots of things going wrong in the construction world, and over time we developed a good reputation and a growing book of business.

I would ultimately run the company for eight years. It grew and made more money each year of its operation; my children were fed and we undertook a bigger mortgage. And yet, even though it was a successful company producing a fine living for the Suttons, there was one raspberry seed snugly stuck between my teeth. For if you stacked this business up any way imaginable, it still came down to Walter and his numerous helpers. I acquired the contracts, I directed all of the work, did much of it myself and even emptied the wastebaskets from time to time. If I accidentally overslept one morning, it felt as if we would find ourselves out of money. The lack of economic certainty drove me nuts, and I yearned, quite frankly, for more power.

At the time, we lived in Seattle, Washington. During those years, I remember being struck by radio and newspaper announcements heralding the purchase of Boeing airplanes. Orders for dozens of planes for United, Delta and American Airlines were commonplace. I also seem to recall orders from Lufthansa, Central Africa Air, British Airways, KLM and other countries and companies that I had never heard of.

Boeing announced orders that would carry them through something like 20 years of record production. They employed thousands of people to fill the rising ocean of contracts. My little business, on the other hand, had commitments that might

carry us six months. Each new job was earned only after hours of coaxing and schmoozing and paying for more food and bar tabs than I care to recall. Never once could we completely pay down our line of credit. Add to this the specters of unending mortgage payments and hungry children, and you get a sense of the stress I was feeling in those years.

So after hearing what seemed like the hundredth announcement for an armada of airplanes, I began to fantasize about having my own two-year backlog of work, with maybe a regional reputation and a prominent industry presence thrown in for good measure.

In short, I began to fantasize about being the owner of a "real" business! I was sure that a real business, a sort of micro-Boeing, would inexorably lead to a greater sense of personal security and permanent happiness for the Sutton clan.

Then a catalyst was introduced (by myself, actually) into the explosive vapor of stress and ambition. We were attempting to analyze thousands of dusty, unreadable, chaotic project documents created during the construction of a nuclear power plant. The project was heading for record cost overruns and a construction schedule that would ultimately quadruple in length. While sweating through this mess, I became enamored of the concept of critical mass.

Remember Critical Mass?

Are you old enough to remember the early 1970s? The management sages of that era taught that the key to good business practice was leaving office doors open, managing by walking around the office, writing detailed job descriptions for every conceivable role in the universe, setting goals and, above all, seeking that magic event known as *critical mass*.

In the context of business, this term refers, of course, to the level of sales or market penetration or production that triggers an added dimension of its own to your top line. In other words, your business takes off because you have either hit or reached critical mass. We are talking about the business equivalent of the seven cities of gold, the fountain of youth and a second chance at first love all rolled up into a single beguiling metaphor. It called to me on my entrepreneurial journey just as the sirens called to Ulysses from the rocky shore of Sirenum Scopuli. I couldn't resist. I wanted it!

Pulling out a trusty yellow pad and pencil I began an analysis of my construction consulting business. The question: How could we achieve critical mass? The search for the answer took more than a month, working mostly evenings, playing out scenarios in my head, trying to get to some place where the phone would ring magically and we would be swamped with clients and orders.

I explored tactical as well as strategic alternatives, trying to ease our service into the insurance industry, into the engineering industry, into the accounting industry. Yet with all of the hundreds of loose-leafs I crumbled and tossed, all I managed to create was a form of intellectual landfill. After a month of what-ifs, there was no critical mass on the map. We weren't going to find the Holy Grail. And I decided that we weren't, when you came right down to it, a real business!

We were really nothing more than an assembly of people supporting me. Extending this flawed construct further, I decided that if we could be made over into a real business, critical mass might be in our future, but my little business would never qualify.

Telling this story, even 15 years later, still makes me squirm. I remember sitting at my desk on a rainy Sunday morning and

tossing the last ball of yellow paper into the wastebasket, and with it my hopes for the future. I then spent the rest of my day trying to figure out what I could do about it. This investigation continued through the evening, as I also explored the medicinal effects of red wine as a hedge against a pessimistic outlook. Neither time nor wine helped much.

Let me now add one more element to the story. As a product of business school, I always presumed that I would grow up to be a great and powerful manager. I also expected to become an owner but felt that equity was a simple mantle compared to the challenges faced by my executive heroes. The idea of being an entrepreneur per se never entered my gray matter.

I imagined one could take the skills and experience of Thomas Watson Sr., Mary Kay Ash, Henry Ford, Bill Hewlett, Dave Packard and Bill Boeing, and chuck them all into a magic machine, mix them up and mold them into a great obelisk soaring thousands of feet into the air. It would serve as an appropriate tribute as well as a beacon for all aspiring young business people such as myself. At the foot of this monument my fantasy placed the single word "manager" chiseled in one-foot-high letters, gouged three inches deep into the polished, gray granite base.

So You Want to Be a Great Manager

You see, I wanted to be one of those icons. I wanted to be worthy of the title manager. I wanted to be a really great one, as did the other five or six entrepreneurs I knew at that time. We all wanted to be great managers just like our heroes. And as part and parcel of this goal, we wanted to guide great businesses to critical mass! Thus, my true mission in life became clear. I, Walter G. Sutton III, would use my consulting prac-

tice as a springboard for acquiring an honest-to-goodness grown-up business that I would skillfully manage to the promised land of financial success. I therefore sold the consulting firm, believing that the real adventure was about to begin.

Of course, you know the punch line to this one. There is no such thing as critical mass as I had envisioned it, and we had been a real business. Go ahead, call me foolish or naive—I was. The Executive Committee may say that it's lonely at the top, but what they don't mention is that it can be stupid at the top as well. I forgive them for the omission, however. It is doubtful they would attract many members by elaborating on the naivete or ignorance of prospective candidates.

In any event, I consciously set out along a path—which I later called "the way of the manager"—toward that imaginary beacon of what I imagined to be a real business. Since many things went well, the journey lasted more than 10 years and the path led me to start and grow two more companies.

In the end, I sold one and, shockingly, went into bankruptcy with the second. I will visit the details later, but the short story is that it happened because of a simple but fatal mistake—I signed a personal guarantee for a five-year lease commitment based on lowball assumptions that weren't nearly low enough. When the guarantee was called, I couldn't ante up the $25 million demanded. It seemed that my mission was taking me places I didn't want to go. (By the way, there is a joke in entrepreneurial circles: What is bankruptcy to an entrepreneur? A low-budget vacation.)

We arrive at May of 1989, in the middle of my low-budget vacation. I had lost most of my family's savings and other assets, liquidated anything with a cash value, moved our home from Seattle to Los Angeles, and begun to feel compressed under the weight of a huge cataclysmic failure. For the first time

in my professional life, I had no idea what I was going to do to earn a living. My children had spent their entire lives knowing me as a successful businessman, my wife was as shocked as the kids were by the unraveling of our world, and I entered an emotional tailspin that took months to attenuate. Were it not for the need to provide food and shelter, the suffering probably would have lasted a lot longer.

This time the question of what I was going to do next had nothing to do with such grandiose issues as "critical mass" or "industry presence." It was instead a more humble one: What does a person with my résumé do for money? And so back I went to the trusty yellow pad.

Even in the bowels of depression there is something animating about scribbling notes onto a clean sheet of yellow paper. Just score a bold line down the middle and label the columns "Pro" and "Con" or "For Sure" and "Improbable" or other contrasting headstones. Then off you go, brainstorming, crossing out, tightening up, dreaming on with more sheets and more opposing columns, balanced quadrants and cross-referencing matrices.

The sheer activity—inherently optimistic—can cover a world of pain. I was doing something.

I worked at this problem for weeks—days, evenings and weekends are all the same to someone without a job. I prepared a real résumé, tests for the type of employer who needed my skills, and lists of reliable contacts who would turn my next job into a bonanza for my prospective (gulp) boss and me. I worked at it until I was exhausted and almost out of yellow pads.

Finally, as a last step, I called some of these lucky people—those who might employ me—just to test my theories before I committed to anything drastic. This was actually the shortest

part of the exercise. It only took three calls before I was dead sure: I, Walter G. Sutton III, last in my family's line of Walter Gardners, hope of hopes for my mother, and supplicant at the altar of good management, was virtually unemployable.

The only thing I could really do well was start businesses— and occasionally run them well. So, like tripping over a tricycle in a dark hallway, I began to realize I was pretty much nothing if not an entrepreneur.

The big problem now was who was going to tell my family that I couldn't get a real job? Who was going to tell my wife and children that I—we had to go out there and once again bet a farm we didn't even have? Who was going to tell them my grand idea was to start another business—from scratch?

I had visions of Armageddon. As a result of my career, my family was to be uprooted once again, and jerked all over the map financially and, ultimately, geographically. For the most part, they would be supportive and positive about our fate, whether I deserved their grace or not.

Losing everything was a considerably worse prospect than any of us might have imagined when I began my career. But happen it did, and my family's lives were disrupted as much or more than mine was. Within a few quick months we went from being multimillionaires to owing millions, with no hope of getting out from under the heavy debt. We went from being a respected family in our community to a watched one as repossessors came at night to take our cars and serve us papers. Our retirement fund was wiped out; phone services were disconnected; and our friends disappeared like stars at daybreak.

Yet, to my grateful surprise, when I faced my family with what I believed to be the truth—that I was virtually unemployable and that to earn a decent living, well, I was going to have to start another business—they were wonderful.

The first step was to wake up old customers, then find a friend to loan me some money. That friend earned more than a place in the dedication of this book for his faith and kindness. Bill Green was also an entrepreneur. He earned his nest egg a nickel at a time in the trucking industry.

When I approached him, he was 18 years into building his own company in an impossibly volatile market, yet was willing to risk more than $75,000 of his hard-earned, after-tax winnings at terms that most saints wouldn't have considered reasonable. For this I am forever grateful.

The next unexpected blessing materialized in the gathering of past employees who booked a ticket for the ride, six of them at the start.

Thus, armed with customers, a product, some capital, great employees and my family at my side, we started off again, charging across the rolling field of entrepreneurship, shouting encouragement to each other and deflecting the fear that radiates from the heart of any start-up. Yes, I was excited, but also noticeably changed from the recent train wreck. I didn't feel the same about business as I had before the crash, didn't feel the same about power or money as I had before the crash, and really didn't feel the same about chasing the manager's mantel as I had before the crash.

At the outset we needed a road map and a set of operating principles that would help guide this adventure toward fun and profit. While laying out the rules for my performance as owner of this fourth business, a voice kept telling me that I was an entrepreneur and definitely not a manager. He told me not to muck this one up like I had the last. He told me to find the initial capital and invest in the vision, and keep a shepherd's eye over how it was run, but also to keep my grubby little hands out of the engine room.

The Rules

Rule one of the new business: I would do the entrepreneurial work while others accomplished all of the management work. My management team cheered loudly. In fact, they cheered a little more loudly than I had anticipated. I was, however, fortunate enough to have a wonderfully competent group of people who were more than capable of managing any business I could conjure up.

I was also lucky enough to be able to recognize what I had.

The second rule: after we pulled the business to its feet, the Sutton family would be physically moved from Los Angeles to a small town...away from the business. The management team would run the enterprise and I would continue being the entrepreneur—but from afar.

The third rule: we would run with no debt. Really. Once our guardian angel, Bill Green, was repaid the seed capital, our new enterprise would pay cash for everything. We would have to pull in our metaphoric belt until we had the cash to pay for operating expenses and capital expenditures. In short, we had to earn enough money to become our own bank, which in turn would finance our needs for expanding and upgrading technology and facilities. Since we were a computer services business, this was no small feat.

The fourth rule: I would move from being a full-time owner/entrepreneur working 60 to 70 hours a week to a living, breathing entrepreneur person working about 20 hours a week. I eased into fulfilling this commitment over a four-year period, but announced it at the beginning, drawing the proverbial line in the sand and growling at anyone who appeared to be in opposition.

When I finally sold the company, I was working about 10 hours a week, and worrying another 10.

These operating rules and objectives—especially the first—ended my aborted journey toward becoming a great manager once and for all. I realized that the most crucial thing each of my businesses needed from me was entrepreneurship.

Appreciate Managers, but Don't Become One

Recognize, embrace, delegate to, include and watch managers, but don't become one. I believe the paradox of entrepreneurship and management is that it takes an entrepreneur to start or fundamentally expand a business, but it takes a manager to make a business survive. The entrepreneur creates a vision toward which managers steer the ship. So if you, as an entrepreneur, are working toward becoming a manager, you are, in my opinion, condemning your business to death, because all businesses need that starting and expanding vision or force. As time passes, businesses need even more of the entrepreneurial vision, not less, as the academics often suggest.

One might be dead wrong to suggest that Thomas Watson Sr. or Mary Kay Ash were managers. Although they may have looked like managers from the outside (CEO, chair, head of the executive committee, etc.), they were, in fact, brilliant entrepreneurs whose businesses were run by good (perhaps even great) managers. If you pulled Watson and Ash out of their businesses, then you would have to attempt to fill the entrepreneurial function, but the management function would probably be well covered.

If you attempt to replace the entrepreneurial role with a manager you end up with IBM of the late 1980s, Digital of the same period, General Motors of the 1980s and early 1990s or thousands of other businesses that have faltered, stalled or failed for lack of a guiding entrepreneurial vision.

Every paradox has its opposing force, and the life of a start-up is rarely as rich as it was in my fourth business. Most start-ups begin with the entrepreneur being the visionary, the manager, the worker, the dishwasher and the worrier. Success is measured by how well each of these roles is filled.

It is decidedly easier to do something yourself than to try to hand a crucial task—even something like inventory control—off to an untested employee or team member. But assuming the start-up grows beyond the founder, the paradox is less dramatic and the need for a shift from manager to entrepreneur is clearer.

On the other hand, the temptation to manage is ever present in the mind of the entrepreneur. Remember the adage about absolute power? Kingpins are naturally controling folks. They tend to want to run the show, all the way from creating the idea to authoring the script to directing the actors to deciding on the backstage flower arrangements. Again, my advice is this: recognize managers, embrace managers, delegate to managers, include managers, watch managers, but don't become one.

It is extremely difficult to formulate and hone the vision necessary for business success while doing an inventory of office supplies. And what happened to that long search for a real business? Well, I've owned four of them in the process of looking for just one. All you need is an entrepreneur and some trade, exchange or service. It's pretty simple in hindsight.

For as long as people have been producing and trading, there have been entrepreneurs. These people clearly commanded a crucial role in our society's development. And since every business needs at least one entrepreneur, this is a pretty important role to understand.

In 1989, when I set out to work at the job of entrepreneur, I thought a great deal about what the tradition looked like.

Meet Maalox: Cheese Mountains and Yogurt Seas

Let me introduce you to a mythical shepherd called Maalox, who, for the sake of our narrative, lived in the Danube valley near what is now Baden, south of Vienna in the foothills of the Austrian Alps, in 5,000 B.C.

Maalox was 17 years old, the son of a goat herder, Calcium, who was about to retire from goat herding and become a village elder. Through good luck and extremely hard work, Calcium had succeeded in increasing the standing herd from 8 goats to 12 over his 20-year stewardship.

The village herds pastured in the lowlands each winter, a time when many animals were lost, and moved to the higher pastures during the late spring and summer months. Each milker gave about half a bowl of milk a day, and during the warmer months Maalox could collect as many as seven bowls of milk per day from his herd. He happily settled into the job and completed three years of herding, enjoying good annual milk yields and contributing eight goats for meat while keeping the herd intact at 12.

At the beginning of the fourth spring season, he drove his herd up to their traditional upland pasture only to discover that it was blocked by a landslide. He pondered the problem and decided to go farther east, where he eventually found another valley in which to settle his herd for the season.

Back in the village, word returned that Maalox had driven his goats to strange, unknown pastureland. This upset the elders, and they sent a messenger to instruct Maalox to cut a trail past the landslide and move his goats into the traditional pasture. By the time the messenger appeared in the high alpine valley, a month had passed. Maalox listened to the elders' instructions. But when the messenger finished, Maalox told him that he was not going to move the herd. Instead, he instructed

the messenger to tell the elders that ever since he entered this new high pasture, the herd had produced 50 percent more milk than in past springs. He was staying.

The elders were very upset when they learned of Maalox's rebellion, but none of them was willing to give up a good retirement to go to the hills and take over Maalox's work. The result was, at the end of the high season, Maalox returned 10 animals for meat and ended up with a standing herd of 13.

It was tough being a rebel in a small village, but Maalox had the bit in his teeth. The following spring he headed right to his found pastureland as soon as the snow melted, and he insisted on taking some credit for all of the extra milk his heard was producing. The second year showed a continuation of high meat and milk outputs. The third year was the same. In fact, the herd was growing at such a rate that Maalox spent the warm months building two herder's huts and recruiting and training young orphans to do the day-to-day herding and milking.

The elders were happy to get the extra meat and milk, and to have the orphans off the village dole. Slowly they accepted Maalox's pasture rights, made his father chief elder and, well, you get the gist.

Ten years later, Maalox wouldn't think of touching a goat because he was heavily into yogurt and cheese processing and distribution. Eventually he would become the dairy king of the surrounding villages and ultimately die a rich food manufacturer and trader.

Having read this far, you may wonder if I am talking about some sort of entrepreneurial gene—you've either got it or you don't. It's good to ask these questions early in a book.

I believe most people are capable of becoming entrepreneurs, but many choose not to do so. The personal test might be to put yourself in Maalox's sandals. What would you have

done that first spring when the messenger arrived telling you to get your bloody goats back where they belonged?

Consider the message; consider all that extra milk you are producing, and the fact that your herd is growing faster than any other. Then you decide. If you think, "Well, elders are elders for a reason, better get back to the family pasture," then perhaps entrepreneurship is not for you.

On the other hand, you may be thinking, "Wow, I'm fired up. This could really be interesting. I need to figure a way to finesse it with the elders, sure, but who in his right mind would walk away from this opportunity?" If this is what you are thinking, then keep reading.

My assessment of history is that a large part of our population has been, from time to time, forced into being entrepreneurial—farmers, traders, crafts persons—some for the love of it, many just for survival.

I'm pretty glad to be living in the new millennium, where there exists, at least in the industrial world, more choice. Nonetheless, all of us have roots in an entrepreneurial society, back to Maalox and beyond. It is a much harder job to be an entrepreneur than it is to be a good manager—and being a good manager is hard indeed, so we're not talking about an easy profession here. But many of us can be entrepreneurs. The *how* is what hasn't been clear, at least it wasn't to me.

So as I started out for the fourth time, my quest was centered on lessons from Maalox and any other credible entrepreneurial tradition within my grasp. As the whole thing unfolded, I grew as much from uncovering such lessons and traditions as I did from running an enriching enterprise. When the business began to take hold, it was clear that the lost manager in me wasn't a loss at all, and my understanding of being an entrepreneur was paying big dividends. My real job was dreaming of cheese mountains and yogurt seas.

Leap of Strength

CHAPTER 3

The Practice of Entrepreneurship

In the dead wet of an Iowa summer afternoon I sat with a dozen or so writing students, sweating because the air conditioning didn't work in our classroom and squirming because my pants were sticking to my legs and the seat. I was tilting toward a nervous breakdown. I was an accomplished 50-year-old businessman facing the same anxiety as a young child trying to learn his alphabet. The 34-year-old fellow in the front of the room was directing the whole dreadful moment. He was lecturing me about poor punctuation and spelling as if he were my seventh grade English teacher.

"Let's get this straight. No equivocating, Mister, er, Sutton... yes, Sutton," he needled. "If you can't use the tools properly you will never be a writer, that's all there is to say on the subject." I looked hard at his tiny blue eyes surrounded by the rolling pale flesh of a bookworm and calmly told him that it was my secretary's job to correct punctuation and syntax.

Since this didn't seem to affect his demeanor much, I continued by explaining that she had been unable to travel to Iowa City with me to tidy up my writing assignments. His class wasn't that important. I all but said, "I'd—we'd—get it right when the time came, don't you worry yourself about that!" My voice had risen to a mid-shout when, taking hold, I stopped yelling and we were all treated to an interesting echo. My face was red and I was sweating blood. Our teacher smiled at me, although

he looked more like a gerbil making a silly face through his pretentious beard. Still smiling, he informed me that his last five books had sold over half a million copies each and added that once I had published one tiny real book, we could continue the discussion. Until then, he reserved the right to demand perfect, or at least near perfect, punctuation, syntax, grammar and spelling.

Then a woman behind me raised her hand. She was hot, too, and the sweat rolled off her wrist onto the desk as she signaled her question. She was from Kansas, taught kindergarten and had always wanted to be a writer. I had offended her. That was clear from her red-faced, prune-lipped, head-shaking reaction to my little outburst. She was wearing a Kansas Jayhawk sweatshirt, obviously expecting the air conditioning to work, as it had yesterday. Her hair was wet around the edges, and as she pulled one finger across her forehead like a bus's windshield wiper, ignoring my altercation with the teacher, she asked him, "Would you please describe your writing habits?"

I was in orbit. Decades had passed since anyone other than a customer or my wife had dared to criticize me. Now some teacher from Kansas of all places was fawning over this academic wimp and asking him about his "writing habit." My emotions spun like an empty blender. I was careening to find the perfect barb, a glib missile to hurl into this exchange with the specific purpose of ruining it.

At first I was so mad that I couldn't think of anything nasty enough to say—I decided that telling them that I could buy their children by the pound was a little out of bounds. Then, through the blur of sweat and furry something happened. I noticed that the gerbil, our bestselling author and punctuation czar, was saying something interesting. He was talking about *being* a writer. He was giving away information that I really

wanted. If I didn't shut down the blender and pay attention I was going to miss it. Abruptly I found myself listening, rapt, and scribbling notes, trying to catch up. He was telling us about his writing habit, the dozens of things he did most days as a writer, starting in the morning and working through a full day.

Those who want to run a business face much the same problem as I faced in becoming a writer. You want to know what an entrepreneur does all of the time—how he or she performs the job. What happens when he gets up, what happens when he goes to the office, what does he do all day? These questions seem so basic, but if you haven't done the work before, the whole thing is a mystery.

I, for example, learned early on that writers must write, preferably every day. Well, this isn't exactly earthshaking, is it? Except you try to sit in front of a computer screen every day and create words that might actually be perceived as clever or touching, sad or at least evocative. That is the challenge.

A corollary to "writers must write" is "entrepreneurs must make deals." The entrepreneur is the central, ultimate and final dealmaker in his enterprise, and this role can't be abrogated, delegated or passed off to any significant extent.

The deal-making, which predates sales, cash flow and backlog, is an important aspect of an entrepreneur's habit, along many other jobs or acts that don't otherwise appear on a person's calendar.

Taking the long view, there is a whole career's worth of behavior that adds up to a successful entrepreneurial habit. Yet in the doing, one learns much like my apprenticeship in writing. A big part of learning and getting better, then good, then perhaps successful, is wrapped up in doing it, real time, getting the firsthand experience and understanding as events unfold. You've seen the books about the Zen of entrepreneurship,

juggling entrepreneurship, driving the enterprise. In fact, so much about being an entrepreneur is just doing it. There is an irritating trait among practicing entrepreneurs to brush aside specific questions about habit with "Just do it!" Indeed, *just do it*—but how, when and what if you fail?

Entrepreneurs Learn by Doing

A predisposition to action is at the heart of the entrepreneur's habit. I am fortunate to be one of those people with a predisposition to action. As a young teen, I noticed that the football players at my high school received a disproportionate share of the girls' attention. So I signed up for the team.

The first day of summer practice I got a tangle of stinking pads, a helmet, a pair of shoes with nails through the bottom and a grungy soiled uniform. I appeared at the edge of the field feeling like a pregnant armadillo that had been asked to perform in Swan Lake. My day went downhill from there. Horror speedily replaced the shock of the awkward dress as I collided with oversized, fast-moving, hormonal bodies—bodies that apparently weren't feeling any of the pain I was feeling. Who would have thought that this hitting, spearing, pounding and running could hurt, or wind or injure! It just doesn't look that bad from the stands or on TV.

As I had hoped, I found a girlfriend and learned to play the game—albeit badly. But I had also learned an important lesson that goes along with "Just do it." Years later, a business owner summed up that lesson best: "You're a hell of a lot safer as a moving target than you are as a stationary one." This was absolutely true for football, so I worked hard on my speed. This anecdote also applies to running a company, so I suggest you work on your speed as well. Speed and urgency are two of the

central traits exhibited by most of the entrepreneurs I interviewed. Peter Drucker, one of the most prolific and universal business writers of our time, defines an entrepreneur as "someone who gets things done." And a series of successful "things" makes a business.

You become an entrepreneur by *doing* the work. As I tried to stress in the last chapter, the majority of entrepreneurs seem to acquire their skills while doing—as opposed to going to school. Maalox discovered the effects of a good pasture by observing an increase in the health of his goat herd. He went on to become the cheese and yogurt king of the region.

What about the learning process itself? How does one learn by doing? Academics have come to the rescue with a label for those of us who learn by seemingly random, eclectic self-teaching: We are called *autodidacts*.

After all, there had to be some explanation for people who learned useful things outside of the university. Scholars use this rather difficult word derogatorily, I suspect, because those of us who are autodidacts are not likely to get a diploma for it or even admit to being one. My guess is that the intellectuals sneer when they say it: "Au-to-di-dact." Let them sneer.

When you combine a predisposition for action, a keen sense of being an autodidact, and a little luck, you are well on your way to acquiring an entrepreneur's habit. Looking for autodidact heroes? Think of Leonardo Da Vinci, Gertrude Stein, Joseph Campbell, Queen Elizabeth I, Bill Moyers, Mary Kay Ash, Henry Ford, Buckminster Fuller and almost any successful entrepreneur you can name.

I left the writing class in Iowa with a good idea about my teacher's writing habit and I'm still working on developing one of my own, one that will produce the sorts of positive results that my life as an entrepreneur has. I also learned how to play

football, go to college, be a husband, raise children and many other tasks, all thanks in part to a predisposition to action and the curiosity of an autodidact.

Learning and the ability to use what you have learned come by placing yourself in the middle of an enterprise and struggling to progress toward successful outcomes. It works like a moving piece of art in which you struggle, embrace the role of an autodidact, learn, stumble, regain your balance and learn some more.

You don't have to start a business to acquire the basics. Observation and participation in other businesses can give you a good footing. But finally the day arrives when you must stand at the edge of a field feeling lumpy, awkward, encumbered and sublimely ignorant. Then, if you are lucky, you will hear a voice say, "Let the games begin," and if you don't hear that voice, go ahead and run out on the field anyway; phantasmagoria isn't a prerequisite for successful entrepreneurship. But the commitment to action is.

During that hot Iowa afternoon I spent in writing class, I took a couple of important steps toward becoming a writer. My teacher, whom I intended to humiliate, took hold of us in a heartbeat and began spilling out his secrets. I was—and am—eternally grateful for his care and authenticity in answering Mrs. Jayhawk's question. I am also glad that something inside prevented me from missing the whole thing because of my own anger, humiliation and ego. If autodidacts are going to learn and succeed, they must also listen.

4 Growing Your Business

Looking back, I am amazed by the extent to which growing a company resembles raising a child. This provokes volumes of derision from employees, and even my children; but it's still true. I have found no better example of this relationship than when I was forced to confront "the age thing" for the first time.

My daughter, Jessika, was saddled with a difficult but crucial role in our family history: she's the oldest child. Next comes Marcel, followed by Nick. Jessika and Nick are both adopted, so this cluster of Sutton siblings is separated by a total of only eighteen months. The spread is just wide enough so that two of the children are the same age at the same time on any given day of the year.

Jessika was not only the leader of the pack, but she was born with good manners and special "do good" skills that her brothers seemed to lack. When she was four years old she could pick up her toys, paint without messing the entire neighborhood and eat food with silverware. This remarkable conduct and her acts of coordinated and thoughtful behavior completely eluded her two brothers.

Enjoying her position of sibling dominance, our self-appointed messenger from heaven lulled me into the belief that our lives were bathed in the glow of her goodness and we needed only to wait for further signs of her developing saintliness.

I am a bit of a cook. One school night I was preparing our evening meal. All of you who are parents will know what that means. There's a sort of busy desperation that permeates a house full of children on a "regular school night." A parent must somehow allow for a certain amount of television, help with homework, prepare dinner—which, in our family was a free-for-all, thanks to the boys—oversee bath time, get every child to bed and eventually to sleep.

I had grown used to cooking and keeping the boys from killing each other or driving Jessy nuts, listening to the boys tell me what they would do with my food once it reached the table and listening to the TV bounce from inane channel to inane channel.

So when dinner finally hit the table, I turned off the TV and rounded up the boys to eat. As always, I breezily beck-oned our saint by calling out: "Jessika, your dinner's ready, honey," and began serving the meal. My attention then was focused on guiding the boys through eating, bite by bite.

We were 10 minutes into this when I noticed that Jessika, age four, hadn't appeared. I went to her room and found the door closed. Knocking, I said, "Hey, Jessika, dinner's ready." Upon entering her room I was greeted by the usual neatness. My daughter was sitting in a chair facing the corner, reading to her dolls. "Hey, Jess, why don't you let the dolls have a rest while you come eat."

"No!"

"It's dinner time, what do you mean, no?"

"No!"

"Jessy, hey, come on."

I went to take her by the shoulder, to give her a hug to see if she felt feverish, sick or sad. She squirmed out of my half-embrace and screamed, "No, I won't come, I won't come," and

then went to the floor, shouting and crying in a rage. I stood stunned—all I could do was watch.

The following day when she was to go to a friend's birthday party we revisited her tantrum. This time it was triggered by her insistence that the car ride to her friend's house took five minutes, as opposed to the 10 minutes I had suggested. She wasn't ready to leave, she said, and although fully dressed and properly decked out, she hurled herself at the floor like a deranged stunt girl and came unglued. Less than a day later, she treated us to a third performance and we decided that she had used up all of her good will. I created a "time-out" corner.

Jessy spent a lot of time in that corner, and the family was thrown on its ear by her fall from grace. Our beloved little saint roamed the house like a bottle of nitroglycerin looking for a jolt. We made a permanent time-out corner arrangement: a chair facing into the far windowless corner of the den. It was her frequent fate to spend time in this corner, as she had suddenly become a bratty, crying and misbehaving little girl. We cut her beloved television, cut treats, threatened play times and generally worked every obvious angle of parental extortion.

This was a war of nerves. I remember wondering how children live long enough to grow up. Jessy, having fallen from such a height, was especially puzzling. Even the boys stayed clear of her. They, on the other hand, began to behave at mealtimes, dressed virtuously for school in the mornings and stood in awe of our new family monster.

This was like the dark ages for the Suttons, and accordingly we attempted to apply the thumbscrews to Jessy's outrageous behavior. We also tried psychology, then force, but she raged on, exploding almost daily.

At times like these, you seriously question your life choices. Why would anyone choose to have children if this is what it

entails? Which of your dark, oozing flaws is her behavior mirroring? Which federal prison is she headed for? Will she blame you as she heads off to some distant city on the back of a motorcycle?

Then quite suddenly, the era of Jessika's tantrums stopped.

When something stops happening you aren't really sure of the date or time, but some six months into this family crisis Jessika threw her last tantrum and we all began living more peacefully. We felt that the time-out corner was probably our most effective parental countermeasure, and we adults prided ourselves on guiding our child back to the straight and narrow.

It was summer in Seattle, and, once convinced that the demon in Jessika was exorcised, we risked a family picnic at Gas Works Park. This is a sweeping green place in the heart of the city on Lake Union that caters to kite-flyers and children.

While we dolled out potato chips and orange pop, Marcel, our second oldest child, threw his first tantrum.

This time we consulted a higher authority: Dr. Spock. We were told that many children have a tantrum-throwing phase at or around the age of four years. Full of newfound understanding, we changed the name on the time-out corner from Jessika to Marcel, knowing full well that our youngest, Nick, would likely succumb to the same sickness about six to eight months down the road.

Starting my fourth business was a lot like raising Nick, our youngest son. We had a good idea of what to expect from age-related behavior. So when we were miserably short of cash for the first year and a half, we didn't panic, because that's what the first year and a half of a growing service business is like. When we found it difficult to hire the people we needed to keep up with booming demand, we understood: Doubling your payroll every four months causes you to go through a lot of

employees. You tend to become a bit sloppy in the haste of it all and have very few resources with which to leverage your hiring.

All of the life-and-death events of the first year or two are just part of the start-up drill. Because you are thinly capitalized, growing, learning on the fly, understaffed and have no history to fall back on, there is this melange of urgency, anxiety and excitement that permeates your whole enterprise. Start-ups are a rush; they are also exhausting and frightening.

If, however, your business is 10 years old and you are still experiencing the same sort of fear and excitement and worry that's *not* normal. In other words, your 30-year-old child should not be throwing tantrums!

Those who study business can articulate many more developmental distinctions, but what the practicing entrepreneur needs is obvious divisions. My experience and research points to three clear phases in the development of an enterprise. Understanding these phases constitutes the final core task of the entrepreneur.

Starting Up

The first stage in the development of a business is the start-up. Even IBM, General Motors, Westinghouse and Standard Oil started from scratch; we just don't remember their beginnings very clearly.

Staying with the metaphor of having and raising children, nothing gets the blood running faster than remembering the birth of a business. The stories I have heard are often harrowing and risk-riddled adventures. Yet we all embrace our most vulnerable experiences, and many successful entrepreneurs ultimately express a fondness for their start-up days. True, this

is a fondness for the emotional content, not the financial restrictions, of their business beginnings.

Common entrepreneurial sentiments include: "I never felt more alive than when we landed our first big contract; there is just nothing like it. Hell, I had no idea how we were going to get it done, let alone get it done on schedule! It was one hell of a time—dicey, but one hell of a time."

If there were such a thing as an entrepreneurial gene, it would work overtime during the start-up, pumping wave after wave of expansive optimism through the system. Part of this intensity has to do with the realities of extreme risk, inadequate resources and the tangible nature of the small newborn enterprise. Part of it has to do with the do-or-die nature of the process, given that three out of four businesses don't make it through four years of operation.

Despite and even because of all this danger, the sense of being alive and focused is palpable. Many who experience it remember those feelings more fondly than they will any other experience during the rest of the cycle.

The clear mission in this live-or-die phase is to achieve a position of relative safety as quickly as possible. Like a baby hermit crab, you not only have to scuttle around naked on a predator-infested beach, you also have to find a shell, and live long enough to grow big enough to carry that shell around in order to get a shot at the rest of life.

From the outset you must get to a point of profitability as quickly as you can. I often tell people starting a business that they have to make money (at least on paper) from the first day, or soon thereafter. Any business that requires you to lose money for some time in order to make money is suspect in my book. There are notable exceptions, of course: Yahoo, Amazon.com, America On Line. Each of these examples were,

however, funded by seasoned and well-heeled investors—a condition we might all wish for but are unlikely to encounter.

My experience shows that most successful businesses do make money starting from day one. Bill Gates didn't have the money to go into debt while he hoped for revenues from a BASIC compiler. Bill Hewlett and Dave Packard made money on their first products. John D. Rockefeller's first business was a Cleveland produce trading firm that made money immediately and grew into a huge enterprise. Anita Roddick's Body Shop store in Brighton took off from its first day of operation.

You have so little capital that you can't afford to be squandering it on losses. Since it can take months to reach cash positive (which, of course, is different from but related to being profitable), you need to be throwing profits into the pipeline quickly in order to win the race to both positive cash flow and retained earnings. This state of alert may exist for six months or as long as three to five years. Its depends on your company's margins, growth plans and competition.

The founder (or purchaser) of a business who pushes it through the start-up phase and the dangerous early years rarely, if ever, does so on slim or paper-thin margins. If you are looking at a business start-up that requires you to squeeze through a 3 or even 5 percent window for survival—think again!

The key to getting to business midlife is to become financially stable. This means you have to earn and collect enough profit to pay for your rapid expansion, the development of ideas, unseen potholes and your living while building enough reserves so that you can settle in and compete over the long haul. It is almost impossible to do this with a thin ribbon of profits or severe cost volatility.

At the beginning, more than any other time, you need room to operate (i.e., make mistakes). The notion of taking on

a business that won't afford that sort of latitude is fatally flawed. I've always felt that you need to look at having at least a 20 percent corridor—or more—in early returns to push into a business. Otherwise, why take all that risk?

In addition to having plenty of operating room, you must also have a strong belief in your probable success. Indeed, most entrepreneurs report having a "positive gut feeling" about the outcome of their fledgling enterprise. The sense I get from successful entrepreneurs is that the decision to go ahead with a start-up isn't a close call. Most say they felt they had a very strong probability of succeeding and if their feeling had been more ambivalent, they would have passed on the opportunity.

Successful start-ups are mostly those with an entrepreneur who said something like: "I knew for sure we could make it with just a little luck," or some similar sentiment that you might quantify at a 70 to 80 percent probability of succeeding.

Growing Up

Growing up—that's how I would characterize the second phase, typically three or more years. You have some experience and some resources, and you have made it past the first big cut, where most other businesses fail. You also have a skeletal management team and the resources to move much more forcibly and competently than in the start-up phase. Many of the entrepreneurs who have made it this far express a sense of relief and surprise. It feels better to see the dragon in your rearview mirror than to be looking down its throat all the time.

By this stage you have amassed some people with useful skills and enough focus to develop the business. You personally should be well out of the administrative and management end of the operation. You should also be on your way to col-

lateralizing your company's debt with company assets as opposed to your house or other personal assets. The really smart entrepreneurs are beginning to slowly take some chips off the table at this stage. This means adding prudently to personal wealth instead of leaving it all in the business.

Your management team should know how to hire and expand the business. You should have fully formed your vision, according to which you can direct the enterprise to more successful services or products. You should have enough cash and credit to support your expansion ambitions. You should have the assets to follow aggressive demand cycles and a growing base of project teams to do your work.

As an entrepreneur, you will have the opportunity to view the industry from a broader perspective—especially as you begin to give up some of the day-to-day duties. You will be able to mingle with and learn from other industry practitioners, and consequently, achieve a good handle on the business universe and your place among the stars.

Assuming you have capital and products with which to meet changing demand, you should be able to survive in this stage of business almost indefinitely. You do this by reinventing yourself periodically within this stage and beginning the growing up stage all over again with the new successful products or services that spring from the company vision and core competencies. This is typically a time when businesses expand, add product lines or other services, and do it again and again. I would argue that successful companies like HP, Nordstrom, Disney and 3M have never left this phase.

"I want this company to go on forever," bellowed a client during a meeting about life and business strategies. "Fine," I said, "it's a laudable and provocative choice in a world where the average life of a public company in the United States is

only 40 years." This began a discussion about energy, successor planning and successor development as a core skill.

This fellow was intending to grow, reinvent and grow again, right through his own death and beyond. He had begun to grapple with the idea of a 100-year plan and would eventually author one. If he succeeds at attaining a measure of his goal, he'll be an unusual person and parent an unusual company—one that invents and reinvents itself beyond his lifetime.

For every company that becomes "grown up" there are good things happening. Given some attention and care, this state is the most realistically optimistic a company can become. Having grown up, the company not only dreams but marshals resources to make those dreams come true. This is how Disney went from being an animated film company to an entertainment empire, or how J. D. Rockefeller Sr. went from trading salt, meat and produce to Standard Oil. These are exceptional examples but many other businesses are exceptional, too.

Growing Old

This is the third phase for an entrepreneurial business. Some smooth the edges by calling this the "mature" stage, but I think that's gilding the lily. The onset of growing old is keyed to how long it takes a business to grow up. Certainly businesses five years or older should be watching for tell-tale signs.

Growing old is usually the final stage of a business life span. Very few businesses go from being old to being grown up again. Most go from growing old to being bought or dying. And the condition of growing old is usually directly related to the energy and attention of the man or woman in the catbird seat. A good example of a company growing old is *The Reader's Digest*. No longer under the entrepreneurial hand of its founders—the

Wallaces—the company has struggled to reinvent itself and find a new vision—many would say, unsuccessfully.

To most beginning entrepreneurs, this is an excessively morose topic—their business will grow up, then grow old and die. Very few businesses outlive the founder's active business career. And for some of us there is a limit to the years we are willing to pour into an enterprise.

As long as the business is running, however, you, as the entrepreneur, must be in the wheelhouse. But to live a rich and full life you must have some diversity. For some of us that means the growing old stage is a nice place to be. Managed properly, it should lead to a reasonable pay off.

The older company should have an experienced and competent management team, well-defined market, good cash flow and a robust balance sheet. Plus its owners should have taken some wealth from the business.

Properly managed, the older business has two successful outcomes. It can be sold to another entrepreneur, one who will replace your vision, culture and leadership with her own. Or you can terminate operations in some orderly fashion so as to cushion the impact on your employees, protect your earnings and disengage from the market.

In the workshop I give on entrepreneurship (across the U.S., Canada and abroad), about a quarter of the listeners are looking crazed by this point. The idea of intentionally shutting down an old business for any reason is a complete anathema to many business owners. My response to them—once they settle down a little—is that it makes a hell of a lot more sense to close a business in an orderly and profitable way than it does to lose all of your earnings trying to pay for life support! And it is more common for businesses to end with a single owner than to be sold—for money, that is.

This is why I always suggest that an owner consider himself the most likely buyer of the business and suggest taking dividends to begin an independent investment portfolio as the business grows up. And if someone comes along who is willing to pay real money for your business, all the better. This isn't a likely outcome, even though it is an exciting and oft talked about one.

At one workshop I was talking to a group of entrepreneurs about risk and its relative influence at various stages in the business cycle. My premise was that risk (in this case, the risk of a business failure) is at its highest the day you open the doors. It falls to lower levels as you grow up, and then begins to increase again as you grow old. One of the attendees said, "I think your idea of risk is completely off!" He felt that risk was the lowest the day he opened his doors and grew every day from then on because the longer he was in business, the more he had to lose.

I don't believe in criticizing personal experience; in his world he was right. In my world, however, he was only half right. It is when your business grows old that the risk of losing your investment grows greater.

To understand this we have to step back to the growing up stage for just a moment. At some point in this stage you should experience a choice, one that presents an opportunity to move to (or add) another river of cash. To achieve this move (a simple diversification, reinventing, or even product or service extension), you will need to reinvest a considerable proportion of your retained earnings and/or personal capital. If you are successful in this expansion or diversification, your company will carry on in the growing up phase. But these shifts take a lot more than money; they take energy, and businesses that are old often don't have the energy or purpose to make such life-

extending shifts. In other words, the financial resources may be available, but the ability isn't. As such, baring an extraordinary effort, it's simply too late.

Too late but not over, however, because there are an astounding number of "old" entrepreneurial companies that just seem to limp along until the patriarch or matriarch lets go, and even then some companies limp into another generation. It is hard to kill off a good company, even an old one. Buggy whipmakers held on longer than people want to remember. The small family farm was and is a tenacious entity. For the particularly energetic entrepreneur there are great opportunities among old businesses. But most of them run out of juice and quietly disappear. One woman's dream doesn't look the same through another's eyes. The founder loses drive (quite naturally) or the founder's children or successors never have it in the first place.

This is the business phase that most exemplifies the "Rules of Entrepreneurs and Managers" (see Chapter 12). The old leader is losing interest and the successors are rising. But are they capable of reinventing or significantly expanding the enterprise into another run of "growing up?" Both General Motors under Roger Smith and IBM under John Acres were immensely fortunate. They found CEOs who could lift their enterprises again. Each of these huge companies could have been broken up into smaller unrecognizable units sold into subsidiary hoods, and essentially dissolved. It happens to companies of all sizes: Kelvinator, Hudson, Control Data Corp., U.S. Steel, Woolworth and Studebaker, to name a few.

I have spent a lot of time trying to figure out how and why people start businesses. It seems appropriate to revisit this again while considering a company's death. Certainly a company such as Bolla, the successful wine maker that has spanned more than four generations, is the exception. As is Gallo, another wine

maker. These are two companies (as is true to all exceptions here) that have had the good fortune of finding strong successors, family members or family-approved candidates who can fill the entrepreneur's role. The successor can continue to build the business through another generation. The morbidity statistics attest to the fact that this is a very hard thing to do.

Most businesses die, and I am always sad to reflect on it. When I sold my last company it was a gut-wrenching decision, because I was uncertain as to whether it would survive me. I felt I owed survival to my employees, many of whom were also my friends. The company didn't survive, and in some way, I am still sad about its end. Not so sad that I want to go back and start up another, not nearly that sad, but sad nonetheless.

We start businesses for the adventure of doing so. We all love to solve problems and see some tangible result from making an idea work. At first, it's more like a fearful puzzle than anything else. As we succeed and move past the hazardous start-up, something else begins to happen. We slowly accumulate a collection of people who share the journey with us. It is because of these people—employees, clients, suppliers, partners and associates—that the puzzle becomes something greater. I think we create a society that does the work of enterprising. It is not always a good society or an idyllic one (Dilbert's popularity emphasizes this point), but a society nonetheless. It's the loss of that society and its connections that make the ending so sad. We know that there is something more to it than a job or money. We are engaged in a human experience with positive potential. So, appropriately, we are sad when it ends.

CHAPTER

5

You Really Are
on Your Own

Dover is an English port town buried in a valley cut by the Dour River. High chalk cliffs separate the land from the sea. On the eastern heights of the cliffs is Dover Castle, whose center section was built by William the Conqueror in the eleventh century. Within the same structure are the ruins of a Roman lighthouse dating from the time of Christ. Because Dover sits at the closest point between England and France (approximately 21 miles across the English Channel), it has been a center of international commerce for thousands of years. From the castle walls you can easily walk to the edge of the famous white cliffs. You can stand there, unprotected, where the deep green grass breaks off to the white chalk and falls away—straight down, two hundred feet to the thin rock-strewn beach below—and look out to the blue of the English Channel and up to the sky.

The closest I can come to explaining the sensation of starting your own business is to compare the experience with the notion of stepping out from the cliff. Will the wind hold you up? Can you fly at all in any wind? What the hell are you doing here in the first place?

You're on a One-Way Street

One quality that emanates from successful entrepreneurs is an extraordinary threshold for emotional pain. Although

every successful entrepreneur has had to jump from the same cliff, few remember the experience. And while there are many reasons for starting a business, the memory of making that initial commitment is a hazy one at best. Those who have not felt the terror of those first flying moments might be inclined to interpret this memory lapse as a sign that these first steps are easy. They aren't. Consider feeling the wind buffeting your skin, the gulls crying around you, the waves thumping the shore below you; and then consider whether *you* would step out into thin air and fly.

We all must go through such a moment to achieve any significant goal, but in the calling to run a business we feel particularly alone. What's more, unless we have a special partner or guide, we are destined to be alone not only at the point when we make the first leap, but also far beyond.

I've asked dozens of entrepreneurs the critical question: What is the hardest part of being an entrepreneur versus being a manager in someone else's company? Although the answers varied widely, a common thread ran through most—the sense of loneliness. It seems to be an inevitable element of the job description. I'm not trying to convince you to give up your entrepreneurial aspirations. I'm simply articulating a fear that most successful entrepreneurs have and don't like to mention.

Let me use another analogy. As I mentioned earlier, I have three children, two of whom are adopted. My oldest child, Jessika, was found almost dead when she was two years old on the streets of Seoul, Korea. When she entered our family, there were already two children near her age. Jessy was very sick and didn't speak. We had no idea how she would fare living in an American family in Seattle, Washington. She arrived Thanksgiving weekend aboard a 747 from Seoul. She had a tiny, undernourished body and sores still showing from malnutrition

and her ordeal on the streets. Her head looked twice as large as it should have because her body was so small. Weak little stick arms reached out for help. A scrape from a fall marked her nose. When we got her home she began to cry. Jessy didn't stop crying for almost 12 hours, much of which she spent in our arms. I didn't know if we could make her life work.

To say I was afraid falls short of what I was going through internally. Honestly, terror filled me. But we had stepped from the cliff; she was ours and as a family we were all off on the adventure. Today Jessy is in her late 20s. She's a wonderful daughter and we are all incalculably richer because of the experience. But that Thanksgiving I was a turmoil of gut-wrenching emotion—love, hope, promise and fear.

How does this relate to running a business? Simply put, the most jaundiced entrepreneur—the hardest, most cunning, overbearing business owner I have ever met—will describe his first plunge into business using terms similar to those I use in describing our experience with Jessy. That first step is dramatic and often traumatic. It's hard. It changes people. But it's also typical. Don't let the jovial air of a successful entrepreneur fool you into imagining otherwise.

Never fear, however; there is plenty of planning you can do before you make the jump. There are lots of books about starting up; the mechanics for franchising; beginning your own consulting practice; becoming a sole proprietor, a partnership and so on. Fewer sources exist out there that get to the heart of what it means to be an entrepreneur. That's what this book is about. Here we deal with the guts of what it takes to start and run a business and to keep money in the bank so that the checks you write are good.

Which brings us back to the issue of being alone. A manager in a large corporation can often deflect blame for a failed

enterprise in any number of directions. "There's a problem on the production line." "The shipping department screwed up." "It was a bonehead marketing-team gimmick in the first place." He may even experience the luxury of feeling righteously indignant about the whole botched affair.

But when it comes to running your own business, ultimate responsibility is much less ambiguous: you must rely on yourself. Sink or swim. Not only that, but in the process you must learn on your feet at a rate faster than you find comfortable. There is never enough time. You are often forced to work at a frantic pace while fighting off the paralyzing effects of shortages, ineptitude and insolvency. To make another analogy: Parenting used to be accomplished in pairs, but this isn't necessarily the case anymore as divorce rates increase. Single parenting is, in fact, a good comparison if you are trying to get a handle on what it's like to start and run a business. The big difference here is that we can generally accept the failure of a business, whereas more is at stake in the failure of a family. Single parents are alone; single parents tend to feel solely responsible for the outcome; single parents are in for the duration. All of these parallel the entrepreneur's experience.

Virtually all of the successful entrepreneurs I've interviewed talk in one way or another about this feeling of being alone. It's a difficult topic for most of them, including those who lead spiritual lives and actively practice a religion. Of course, most of the world's religions have an answer for loneliness, but nonetheless it is not an easy state of being. Coping with feeling alone is a task in itself.

Since business isn't considered a formal profession, at least not in the same sense as a doctor or lawyer who learns the craft through formal education, I have always held a special envy for professionals who are also entrepreneurs. One such per-

son, a good friend, is an architect. He has owned his own firm for 13 years, designed and built several houses, office buildings, apartments and factories. He has been in business long enough to have established an excellent client list. Many years of challenging projects lie ahead of him. When I interviewed him for this book, I thought, Here is a business that should last and give its owner a genuine sense of security.

About an hour into our talk he suddenly said, "I love the business; I wouldn't have it any other way, except for the fact that at any moment I may be blown away by a rogue lawsuit. Someone may slip and fall on stairs I designed 10 years ago, and I may lose it all."

"What do you mean, lose it?" I asked. "Surely you're insured."

"No, and that's the heart of my strategy. If I were insured, I'm certain I'd be sued, but since I'm not they don't bother."

"But what happens if someone doesn't take the hint, and convinces a jury that you are party to some damaged bone or whatever?"

He looked at me unflinchingly and said, "Then I'm out of business, it's over."

"You have that hanging over your head all the time. Does it affect you?"

"Well, of course it does, but I love this work. I understand the risk and know I can never get out from under it."

I looked hard at him to see if this was some sort of a joke, but no. He wasn't kidding. He loved the work so much that he was willing to endure this huge risk, day in and day out...alone.

And Then There Were Nine

I am an outliner. It comes from having been educated by

the Daughters of Mary and Joseph during the early 1950s. They believed that a key discipline to succeeding at Loyola High School—our center for Jesuit education in the Catholic Diocese of West Los Angeles—was outlining. Ingrained in our academic minds was the notion of outline or perish—that is, if our hormones didn't snatch us first.

So in the eighth grade we became supplicants at the altar of outlining. Our teacher, Reverend Mother Bonaventure wore two habits: she took the role of our principal *and* full-time in-class teacher. She was a fierce perfectionist. How else do you think she became Reverend Mother?

Outlining was taught by rote; we were not encouraged to play fast and loose with eclectic symbols or numbering schemes. We were given the one true scheme and expected to conform. The first heading in an outline was denoted by a capital roman numeral; the first subsection, a capital letter of the alphabet; the next subsection, a cardinal number and so on. Add the complexities of lowercase, brackets and other modifying symbols, and you could easily indent to 25 layers below the main topic, plenty for a good Catholic boy.

Reverend Mother was Irish (surprise) and had spent her late teens in London during World War II. She had lost her hand in the bombings and a hook had taken its place, which she used with flair and creativity in controling her pubescent charges.

I will never forget working on an outline when we were allocated 15 minutes to summarize a one-page article about a Catholic mission in Rhodesia. I forgot the order of indentation; I remembered the Roman numeral and the capital letter, but I wasn't sure what came next. So for the following levels in my outline I indented and used a simple dash as the symbol for each heading. I was merrily plowing through the material when

suddenly—*wham*—Reverend Mother's hook slammed to the center of my page. I almost passed out, and can still hear her reciting—no, chanting at me—"Roman numerals followed by capital letters followed by cardinal numbers." As you can tell, I haven't entirely recovered from this experience. At my age, recovery is out of the question, so I have simply become an outliner. Which, if truth be known, has served me well.

The next section of this book talks about the nine responsibilities and tasks that are fixed to the entrepreneur for the life of an enterprise. And they cannot be delegated. Since these tasks and responsibilities share important relationships, the end of this chapter serves as an introduction to them as well as a cue to the reader about the logic and structure that lies ahead.

Having confessed to my outlining fetish, let me also confess that numbered lists make my hair bristle. You know what I'm referring to—101 Ways to Make a Fortune or Eight Ways to Skin a Platypus. I don't begrudge list sellers their success, but I do want to disassociate myself from them. This book is not a closed system subtitled "The Nine Answers to Entrepreneurship." Reading this material will not leave you with the urge to start each day in prayer, followed by a recitation of Walt Sutton's litany of responsibilities.

Learning entrepreneurship is typically an autodidactic experience. So this book is about the *doing*, the implementation, and not theory. What follows are the nine essential elements practiced by successful entrepreneurs. These nine responsibilities must define and embody the prosperous entrepreneur.

Twenty-three years is a long time to do anything, especially if you have led as unbalanced a life as I have; 23 years of running an enterprise—morning, noon and night. My friends were entrepreneurs, my dreams were about business, and vacations were a time when I could think of business without the phone

ringing. However one judges this type of life, there was a lot of data accumulated—tons and tons of it.

At the Core

Faced with this Everest of potential landfill, I decided to expose myself, use my experience and accept the daunting task of outlining the unwritten words, thus clarifying the misunderstood attributes of the job. (After the media, the greatest source of misinformation about entrepreneurs is entrepreneurs themselves.)

I put the whole bloody mountain into a sieve and the following list, the entrepreneur's core responsibilities and tasks, is the result of that effort:

1. Survive
2. Make the Deals
3. Navigate the Rivers of Cash
4. Borrow Carefully
5. Discover the Secret and Use It
6. Apply the Rule of Entrepreneurs and Managers
7. Build a Society and Define the Seasons
8. Find Your Vision and Build a Culture from It
9. Get Outside and Live a Life

These are the most important items that emerged from my analysis. And yes, if you do these things well, you will have a greater chance at being a successful entrepreneur. In addition to being able to execute these nine rules reasonably well, you will also need a quality product, efficient delivery, financial skills, fanatic energy, an ounce of luck and a full load of chutzpah.

Part Two:
Critical Tasks

6 The First Task Is...Survive!

The entrepreneur's primary responsibility is to survive! I'm certain we can all agree that the alternative to survival is, well, unacceptable. Perhaps you remember the book *Alive*, the true story about an airplane crash in the Andes where the survivors resorted to eating some of their less fortunate (and dead) fellow passengers. I know it's a ghoulish image, and in our modern society, prime-time television, blockbuster movies and New York *Times* bestsellers love to portray such behavior. However, literature, folk tales and histories are full of these survival tales. And why such tales? Because we are all fascinated—enamored, even—with the act of survival. It's a serious business, whether told from the pages of *The Three Little Pigs* or a Stephen King novel.

Historically speaking, the threat of death has been a close companion for everyone at any age. Diseases such as influenza, cholera, smallpox, measles and appendicitis routinely killed millions of people for centuries. This trend, however, shifted in the early part of the 21st century with the advancement of public-health technology. In fact, only in the past 50 years have we been able to insulate ourselves from a pervasive loss of young and middle-aged people. Our desire to stay alive taps a deep autonomic chord that reflexively kicks in whenever we are threatened. Yet, regardless of how much we have successfully lengthened the average human life span, our bodies

have not forgotten how to respond when faced with bodily harm. Without specific training, we understand how to survive, deeply and fiercely.

I have respiratory allergies that react to dust or anything that's alive and airborne. The consequences aren't huge; I get a runny nose, sinus swelling and tears spilling from my baby blues. And when things get really bad—in spring and fall—I serial sneeze, one *achoo* after another, sometimes as many as 40 in a row. Other than these less than dignified symptoms, the allergies haven't affected my life much—except once, when I was hit by an asthma attack.

It was mid-spring and the business was expanding at about 150 percent a year. I had spent almost three months on the road opening branch offices, gaining pounds and fastidiously avoiding every form of exercise.

This crazy lifestyle set the stage for a physical breakdown. And one afternoon, following a day of meetings with our bankers (they didn't want to let our line of credit grow as fast as our business), I found I was coming up a little short on oxygen.

To compensate, I breathed harder, which didn't do the job. As I began to add the worry about breathing to the bankers' reluctance, my sneezing, my fatigue, my fat, my travel—my everything—my chest started to seize up. Imagine wearing scuba-diving gear 100 feet under water and having someone slowly but inexorably close the air valve.

The harder I expanded my lungs, the more I pulled down on my diaphragm, the worse it got. I knew I wasn't getting enough oxygen.

By the time I reached my allergist's office I was sweating, weak, gasping and seriously frightened. He came into the room, slapped a freezing stethoscope against my soaking chest and started chuckling.

"You know, Walt, you've been my patient for, what, 15 years

now? I was wondering when this was going to happen. Getting a little fleshy there, too. What sort of diet have you been on?"

"I"... *gasp* ... "need help" ... *wheeze* ... "now ... goddamnit!"

I went on to tell him, between gasps, that I would kill him if he didn't get with the program and save the finer points for later. This didn't stop him from chuckling again and telling me that 40 percent of people with my type of respiratory problem have this sort of attack from time to time, and he had begun to think I was abnormal.

As I raised my hands up to his throat, intent on giving him an object lesson in how I was feeling, he relented and gave me the shot, the breathing device with oxygen and some pills. Within about an hour it was over, my first and last asthma attack. The experience taught me a lot about survival.

Don't Waste Time Apologizing

Many years later, our company advisory board convened its quarterly meeting. I had promised to do a market study and was scheduled to report the results to them that night. The meeting opened with my telling the board members that we were under attack by a competitor because I had spent most of the quarter boosting the company's sales skills and product quality—but not watching our competitors. The board surprised me with its criticisms; the members said that my inattention had invited the attack in the first place. They wanted to know why I'd fallen asleep at the wheel. I began to grovel; it was embarrassing.

An advisory board sits by the grace of its good will; I could have simply asked them all to leave. But I was conflicted. I knew that I'd failed to keep an eye on our competitors; but it upset me that I let the board's criticisms sting so much.

When I started a second chorus of apologies, Don Mehlig, a longtime board member, said from his seat at the far end of the table: "Don't waste our time apologizing. We understand, the entrepreneur's first job is to survive. What's next on the agenda?" It was just that simple: let's get on with it.

Survival lies at the heart of many good entrepreneurial campfire stories. The time the IRS put a lien on the whole business; the time the bank called all of its notes at once; the time the bottom fell out of the widget market.

I have a friend who sold cedar shingles to the southern California market right through a firestorm. I have another whose revenues fell by almost 70 percent because two national competitors decided to "buy" market share. And I have a third friend whose defense subcontracting business was cut by more than half after the Berlin wall came down. He said he knew what was going to happen as he shared the world's joy with his wife and family watching the whole thing on CNN—communism was defeated, the world was safe...and his business was going to tank.

In short order, these accomplished business people went from comfortable to afflicted. Don Mehlig would have told them: "Your first job is to survive." Being entrepreneurs, they knew this instinctively. And survive they did.

Take the shingle distributor. He was fortunate to have enough cash and good will with his bank to diversify into other types of roofing materials. He also used the fire to tout a new line of specially treated fireproof cedar shingles, which preserved his aesthetics-driven market niche while eliminating the obvious risk. The change took two years. It was painful and risky. He lost a number of old-line employees who were not as flexible about products and methods as he was, but in the end he created a new, more stable business. He survived. Today he talks about the firestorm experience as if it provided more good luck

than bad. I knew him throughout his ordeal. Sales were plummeting, the bank had started calling its loans, and he wasn't acting nearly so sanguine. Yet I understand how he felt. The memory of having the oxygen turned off struck the same chord in me.

Such a primal jolt sounds a lot like a male-bonding weekend or childbirth. I think that to a degree these associations are accurate. When one is gasping for oxygen, nothing else matters. Fear amplifies purpose, focus and perception to such an extent that, for example, I can recall images surrounding my asthma attack from 10 years ago as sharply as if I were reliving them. My allergist is a very thin man who wears his pants belted tight and pulled up just under his armpits, so his beeper looks like it's in a shoulder holster. I thought he looked ridiculous and would have laughed if I'd had the breath to spare. Standing before this icon from Nerdland, I was overwhelmed by the responsibility of getting enough oxygen, a responsibility that was mine alone, the Hippocratic oath notwithstanding. His oath mandated care, but I was responsible for keeping my body alive. My survival could not be subcontracted, divided up or shared. The same is true when the sky falls in on your business. Remember "It's Lonely at the Top"? Another case in point.

Three out of four businesses fail in the first four years of operation. Imagine, all those entrepreneurs crashing and not even getting past the first task on our list—survival. Worse still, you've got to figure that some entrepreneurs fail a number of times before they get it right. These are, by the way, some of my favorite people. You can almost bet that a person who has lived through the entire spectrum of a business adventure more than once has plenty of good stories to tell and is a great fireside companion.

Hence, the first responsibility of an entrepreneur is to survive. Although many business people and writers cast all sorts

of situations in the orange-red light of life and death, there are, thankfully, few instances in the life of a viable enterprise when its very existence is threatened. However, when and if that time comes, you will know it—I promise you that (and I speak from experience).

When a catastrophe threatens, you won't doubt its seriousness. And after the explosion you will dig deep down into your energy reserves and you will try to pull your baby out of the fire. Whether you succeed or not is up to you...you and the gods of business.

The Time and Place of Greatest Risk

Given the high morbidity rate for start-ups, it's not hard to pinpoint the time and place of greatest risk.

Most businesses begin with too little cash, time or experience. Margins for error are paper thin. Fortunately, this changes as a business grows, because as debt is reduced, relationships are built and experience translates to competence. How fast it changes, of course, varies from company to company, but if you are succeeding, you should begin to see the dragon in your rearview mirror, as opposed to feeling its breath through the windshield.

My businesses were essentially service companies, and we needed to hang on for about a year and a half before we checked out of intensive care. Surviving the initial phase was a function of billing and collecting enough to pay all current operating expenses and debt service and absorb about a year's worth of earnings. This took, on average, 15 months of profitable operations. So we stood at extreme risk in our first year and a quarter. Two years into the cycle we began to acquire experience outside of the pressure cooker and life became much happier. I don't mean

to make this sound like an extended form of hell week or boot camp, because while the pressure of such events is about the same, starting your business is a lot more fun.

One of the common ways entrepreneurs describe their businesses is to metaphorically characterize them as children or lovers. In both cases the parent or reciprocal lover has a visceral responsibility to nurture, preserve and protect. If a rescue mission fails, a deep feeling of guilt follows, and then, in a healthy process, mourning. When the mission is successful you hear reports such as, "I never felt more alive in my life—but man, was it frightening." Some critics of the business life point to such comments as proof that entrepreneurs need to get a life. I disagree. Watch your baby fall into the fire and see how you react. We rightfully become very attached to anything that demands as much care and feeding as a business. It may be true that those of us who run businesses live, on the whole, unbalanced lives. It may also be true that creating a broader palette would enhance our lives. But surviving a near-death experience in business is a real and personal event, and the responsibility for the outcome rests solely on the owner's shoulders. My advice for an entrepreneur facing business survival goes like this: Save your business if you want, then consider creating a more balanced life. In a crisis, survival is a full-time job.

What If Each Hiccup Is a Life-Threatening Crisis?

If survival is the number-one core responsibility of the entrepreneur, what about those people for whom each hiccup is a life-threatening crisis? One of the richest people I have ever known attacked each and every problem he encountered with the equivalent of a nuclear warhead. A hostile takeover threatened a public company in which he had invested. He brought in four or five of

the country's best lawyers, filed suit against the interloper, hired a public-relations firm to uncover and disseminate dirt about his opponent, and initiated unpleasant (and probably untrue) rumors about his opponent's senior managers.

Okay, you say, all is fair in love and war. One day during this fracas he arrived at his office building and discovered that his reserved parking space was blocked so that the lines in that section could be repainted. He called in his mad-dog litigator. He threatened to break his lease for four floors of the building and to withdraw from the board of the bank that financed the office tower. He told the building's management company that he was prepared to take out a full-page ad in the local newspaper complaining about building maintenance, security and construction quality.

This chap lives in survival mode every minute of the day. In fact, he defines himself as a quintessential survivor. It would be easy to write him off as a blowhard—he looks and sounds like one. Yet, as far as I have seen, he never threatens something he can't or won't do. This reputation creates an aura of submissive respect and discomfort all around him—which may have something to do with his behavior in the first place.

I know a representative population of entrepreneurs who act similarly to my very rich friend. Their stories tend to go as follows: They start up a business and live through hell getting it up and running.

The enterprise advances into mid-cycle, becomes more stable, grows and prospers while its owner acts more deranged than Jack Nicholson in the last act of *The Shining*. A psychologist friend suggests there is such a blast of adrenaline accompanying survival scenes that some people treat each problem with a ferocity that produces another adrenaline rush, or hit. Such an explanation always evokes the image of a lab rat pounding the lever for food pellets, and I want to dismiss it.

Yet it is true: Survival issues generate a lot of adrenaline and a small part of the entrepreneurial tribe seems to thrive on it, pounding and pounding and pounding throughout the business life. I have known entrepreneurs who have become bored with good times—read: no adrenaline—and sabotaged their business in order to get some action going. Having pounded the lever enough myself, I know it might be true. Don't let me mislead or confuse you, though. Neither my psychologist friend nor I think this is a happy state of affairs for the entrepreneur, no matter how rich. Surviving a catastrophe rests on your shoulders alone; banging away at the adrenaline lever is something else again; and as we will see, no amount of money will compensate you for a life that is truly out of whack.

Tools of the Trade

Here are some tools that will help you survive and ultimately succeed:

1. Keep daily statistics

Each company has numbers that should be assessed daily. These include cash, accounts receivable, daily billings, receipts, line of credit balance, production numbers, head count, inventory and quality numbers. The daily statistics that will help run your business should report all of the critical vital signs. Do not ask your accountant or accounting department to design this list. Include their input, certainly, but be sure to talk to production, human resources and your support staff as well. These numbers should tell you immediately if an important function or resource is under strain or about to burst.

2. Do disaster planning

Funny, isn't it? That the disasters we plan for never happen? But in business there's a great trick. You can cripple the business on paper and then calculate what it would take to

save its life. One of the things I try to do in strategic planning sessions is to create a scenario where we take last year's numbers, assume that sales were catastrophically cut by 66 percent, then see if the management team can save the company. Most entrepreneurial businesses live in the shadow of severe revenue cuts. I have been gratified by the number of times this sort of generic disaster planning has helped a business survive.

3. Develop a flat, flexible organization

This is simple. Your business has been hit by a tidal wave, you are facing its demise, and now you have to deal with a Byzantine bureaucracy of your own creation. The flatter your organization, the more flexible its structure, and the greater the degree of participation, the easier your recovery will be. By the way, these qualities are highly desirable in a thriving business, too, but we'll talk about that later.

4. Conduct a yearly personal assessment

If you don't know why you are founding and/or running this business, why would you be willing to put your life on hold to bail it out? You must figure out how the business fits into your greater universe. To do this you must ask broad questions about your life and specific questions about your business. (How to go about doing this and specific examples of such questions are discussed in Chapter 14.)

If you do this routinely, the probability of surviving the inevitable tsunami is fairly high. Because life's most predictable attribute is change, you should visit these issues each year.

7 Making Deals Is Critical

"You could sell rain to the mayor of Seattle, you son of a bitch." That's what he said. I took it as a compliment, but that wasn't how he meant it.

Jack and I were seated across from each other in a fishbowl conference room that law firms and other professional corporations use as client bait. The room shouts, "Look at how trendy and professional we are. Look at our tufted black leather chairs, so soft and plush like they are covered in chamois. Look at our long oval table: carved, inlaid, shining and perfectly sedate—almost Zen-like in its relationship with the earth and its necklace of chairs. Sit in this room and you will not only be at one with the earth but ruler of it."

My earth, on the other hand, was shifting nauseatingly because my client, Jack, was about to renege on our contract. Renege after having ordered and consumed about a million dollars in services. He'd decided that he wasn't going to pay the bill, or so he said.

I know this raises all kinds of questions in your mind, most starting with the phrase, "How could you be so stupid?" I'm not re-creating this scene from my own personal hell to review the merits or demerits of my company's performance for Attorney Jack's firm. The ultimate outcome of this meeting was that Attorney Jack got sued, and Attorney Jack's firm paid the

entire bill. But the end is not what's important here; it's the journey that matters.

As I left that glass-enclosed altar to professional fees and endangered contracts, I swore I would never sell another job as long as I lived.

Attorney Jack was, I thought, trying to take advantage of the fact that I had personally sold him the services and I, therefore, was responsible for his (imagined) problems relating to our services. Selling these contracts—not marketing but selling—was at the heart of my business. After about 12 years of this selling, and a mere 45 minutes with Attorney Jack, I was beset by ennui, a growing feeling of weariness and irritation for what I thought was a job *others* should be performing. From someplace deep in my past came the idea that being the salesman or dealmaker and being a business-owner weren't particularly compatible. You know, owners do loftier things and sales people sell. So I set out on a mission to change my relationship with selling.

Which Comes First: Marketing or Sales?

This decision was a huge mistake because the second most important core task of the entrepreneur is to make the deals, and major sales contracts were part of that task in our company. Now it all seems so simple: no deals, no business. But back then nothing seemed simple.

Among business types there is an old enterprise conundrum: what is marketing and what is sales? I first heard the question while in business school at the University of Washington, and hardly a month goes by even today that I don't see or hear the question asked several ways. It's not that people can't differentiate between marketing and sales; they can look up

the terms and be quite precise about their meaning. It's that most companies overlap between the two and it's just one of those purely personal issues like, Do you prefer black licorice or red licorice? The heat turns up as people take sides. Which is more important to your organization, marketing or sales? Which to consider first, marketing or sales? Marketing, sales...sales, marketing. These questions pass right through a hundred scenes in my career like grass through a goose!

I don't want to come off here like a person who belittles others in their search for truth, but when it comes to running a business, what matters first and foremost (after survival) is the deal. And a deal resembles sales more than marketing. In the beginning of a business you make a deal. You do the work associated with the deal. You collect some money for the deal and with some care and perhaps good fortune the money you collect is greater than the money you spent performing the deal. There, I've revealed the whole secret of capitalism. It all starts, and if neglected, ends with deals. And you as entrepreneur are responsible for making them, period! I'm not kidding! You alone are the dealmaker.

There Is No Business Without the Deals

This is why "Make the Deals" is the entrepreneur's number two core task, right after survival.

Many businesses start with a deal in hand. With one fell swoop the entrepreneur has been able to create the potential for a revenue flow before committing too much money. Many entrepreneurs cut their teeth by making that first deal, and by doing so bring a business to life. There are a lot of fond memories in start-up stories of this early deal-making. But as with anything, deal-making can wear thin over the years. I remember

hearing a woman who owned a distributorship complain that she felt like the mother robin returning to a nest filled with 15 screaming, open-mouthed chicks. The 15 chicks were her employees, who depended on her to bring home the worms in order to preserve their jobs. She told this story because her three outside sales people were performing well below expectations and budget. As usual (her judgement, not mine), she threw herself into the breach in order to reverse the situation.

As this story was told I remember tut-tutting about underperforming subordinates, missed targets, accountability and other delegation virtues. She looked at me and said, "Who the hell is going to make up the shortfall while I whip my sales force into shape? Who is going to fire half of the screaming chicks when we can't cover their salaries?" I withdrew my tut-tuts in an inhalation of embarrassment.

This scene occurred soon after my love-in with Attorney Jack, and I was suffering from what can best be described as an attitude. I hated being the dealmaker. At the base of this hate lay the misconception that an entrepreneur can and should be able to delegate the task of deal-making. I spent the next six years trying to force that attitude into what I saw as my dream.

The dream looked like this: I, Walter Sutton, am the president and owner of this business. That means that as I grow this business (by making some deals) I can hire and train others to make sales—and ultimately deals. After a time I will be sitting on my own version of Mount Olympus, looking down on a happy kingdom, watching the fertile vista of deal-making and profit-collecting from on high. The more experienced entrepreneur might be wondering at this point if I am describing a dream or a hallucination. I lost staff, suffered financial setbacks and paid three different consultants in an attempt to make this dream come true. The harder I worked at achieving my ideal,

the more my ethereal throne looked like a deck chair on the *Titanic*.

There followed a period of reading, thinking and looking at other businesses. If Windows NT doesn't pass muster, who is responsible? If the Ford Excursion doesn't sell, who has to compensate? If Sony loses $3 billion in moviemaking, who is responsible? The person filling the roll of the entrepreneur, that's who. Oh, sure, lots of marketing, design and sales folks will be on the street first, but ultimately who is responsible for making the deals profitable? You are.

This answer came hard. It was a kind of shock therapy really. Fortunately it happened before I had to clean out the nest entirely. As I look back at the definition of an entrepreneur—one who organizes, operates and assumes the risk for a business venture—it again seems clear that the deal-making responsibility can reside in only one place. Eight years and many hundreds of thousands of dollars later, I discovered the same truth. I hope you don't need to make anywhere near that investment to arrive at the same conclusion.

I've lamented here and in other places about the unwillingness of entrepreneurs generally to share, express inner feelings and especially admit to pain. Yet one theme I've heard over and over again is reminiscent of my Mt. Olympus faux pas. It is tough being responsible for the deals. The professional management crowd insists that almost everything can be delegated. Entrepreneur after entrepreneur has complained to me, "Boy, as soon as I get bigger I'm going to stop selling," or "After we pass a million in sales I'm turning all of that front-end stuff over to some bright MBA."

Buck Rogers tells the story of Thomas Watson Sr. calling on each of IBM's 20 biggest customers each year. I have to remind myself that he didn't do this because he liked hanging out

with them; he did it because he knew how important relationships are to making deals, and IBM thrived on those deals. If you need further evidence of this, read the parts in *Iacocca: An Autobiography* where Iacocca is turning the company around—the deal with Congress for guarantees, the deals with the public about quality and safety, the deals with dealers about high-quality, high-demand vehicles.

Yes, indeed, Watson and Iacocca were great entrepreneurs. And each was his company's primary dealmaker!

You might also look to any biographical material about Donald Trump and his love of the deal, or to books about Microsoft to see how Bill Gates does it. If you have any question as to who makes the deals at and for Berkshire Hathaway, read Buffett's book, *Warren Buffett Speaks*. (Hint: the answer is in the title.)

At the other end of the spectrum, think of who oils and repairs your car, sells you cookies, serves you your favorite meals—there's an owner/dealmaker asking you to dance, and you are accepting.

There is some good news about being the dealmaker. It is the best way to know how well your company is performing, because customers will call you in a heartbeat when the deal isn't going well. You also meet interesting people.

Attorney Jack was intriguing. He almost worked my people to death preparing for a huge trial. At the time, he was about five foot eight and weighed almost 250 pounds. He had played football in college and was busy converting a muscular body to a fat one. A black rounded beard hid his face well, and his deep voice rumbled when he spoke.

"How can you do this to me?" I asked him. "We have known each other, worked with each other, for six years now. How can you do this?"

He rolled and shifted in his seat, the chair squeaked. Dollar signs decorated his green suspenders, which hung limply over his starched blue shirt. His jacket lay across the back of the chair next to him. He pulled at his beard and cocked his head sideways. "I'm going to do it by not paying you, that's how. We've decided to refuse to accept your latest invoices; we reject them. We owe you nothing."

"You've got to be kidding," I bellowed back.

"No, I'm neither kidding nor joking. Our deal is finished and we are paid in full. This meeting is over. I have other things to attend to this morning, good-bye." Attorney Jack pushed himself up out of his chair, tugged his beltless suit pants up over most of his belly, pulled on his suit coat and walked out of the fishbowl saying, "Would you show Mister Sutton to the elevator, please."

Did I say we collected our money? Of course we did, and it only took a (gasp) year. And I am certain that if I hadn't closed the deal personally, we would have never seen a penny of it.

A Dealmaker

There was an Italian restaurant in Santa Monica called Maria's. You wanted a table, Maria got you one; you wanted to know what was good to eat, Maria told you; you wanted entertainment, Maria sang an aria; you hated the food, Maria exchanged it; you wanted your check, Maria ran it through the credit card machine. Maria didn't wait on tables. She didn't cook. She may not have even known the recipes. But if you were going to have dinner at Maria's, you put yourself in her hands. Driving in that section of Los Angeles a couple of weeks ago, I noticed that the restaurant was gone, transformed into a PIP instant printers. I found myself wondering what had happened

to Maria. Was she wealthy, retired and transplanted to Las Vegas to be closer to the action? Perhaps she had gone back to Umbria. Perhaps she was sunning herself on the beach right there in Southern California. The last time I ate at Maria's, she must have been in her 70s: the night was like many, exchanging $12 for a bathtub-size bowl of cioppino over bruschetta, a glass of red, a strained but exuberant aria and a little frantic attention. It was one hell of a deal. Maria, more than most, understood she was the one responsible for making the deals and closing them.

Tools of the Trade

Here are a few time-tested tools to deal-making that I guarantee will help you construct a successful deal.

1. Master the art of public speaking

Find a regular course or a proven teacher and acquire the skill. One of my best teachers, Ron Arden, tells the funny story about a nervous Christian preparing to enter the coliseum to face the lions. In this scene, below the coliseum floor, the Christian is lamenting his fate to a lion in the adjacent pen. After listening to the Christian's recital for some time, the lion interrupts and says, "You think you're nervous? I have to give an after-dinner speech when this thing is over. Now that's pressure!"

The ability to stand up and speak in front of four or four hundred people is the single most important deal-making skill. Chapter 18 explains in detail what the payoff is for entrepreneurs who master the art of public speaking. Although you may be nervous, there are specific tasks you can perform to create a reliably good outcome, and throwing up doesn't need to be one of them.

2. Know, and get to know better, your Top-20 clients

Visit them, listen to them, survey them—send them candy if you have to. Do whatever it takes to be as close to them as you can. Tom Peters says a lot of instructive things about visiting and listening to clients in *Thriving on Chaos*, as does Harvey Mackay in *How to Swim With the Sharks and Not Get Eaten Alive.*

3. Delegate

Delegate all the support, fill-in, market research, sales preparation, scheduling, chart-making, proposal-writing and telephone work.

Review your workload often and reassign anything that can be done by others. Build a sales and marketing team, meet regularly and keep the pot stirred.

4. Consider a board of advisors

A carefully assembled group of three to six advisors meeting at least quarterly can often make your job of deal-making easier. Chapter 18 contains details about convening such a board They will understand your responsibilities better than anyone inside your organization and will be more likely to support you on important issues.

Leap of Strength

8 Navigate the Rivers of Cash

The third core task of the entrepreneur is to find and navigate the rivers of cash.

As an adolescent I was thrilled and stimulated by the stories of Alan Moorehead. He's not currently well known, but at the time he was a bestselling author—an Australian and a historian to boot. *The White Nile* and *The Blue Nile,* his history books detailing the European discovery of that mysterious river, instantly hooked me. Moorehead's narrative style presented the past in an exciting and dramatic way—a technique of teaching and telling to which I'm still very partial. The adventures created by the discovery of the Nile are thrilling, even though most of the stories end miserably. European explorers invading the African continent highlight themes that can make us uncomfortable: man the conqueror, the ruthless trader, the spoiler of indigenous peoples' lives, the slave-owner. These stories end badly too, because this exploration did not take place in a Winnebago.

I'm certain Moorehead's stories are at the center of this metaphor—my image of a river of cash. In this context we are not talking about a place of death. We are, however, talking about uncertainty and fluidity as things that press in on an adventurer. And the stakes of doing well feel almost as high. Just as Moorehead's narrative describes the exploration of the Nile, this metaphor describes the adventure undertaken by all en-

trepreneurs. Here, the rivers of cash are the businesses' products and services. The entrepreneur must find them and navigate them under conditions almost exactly analogous to an explorer. She is likely to experience turbulence, water falls and competition from other boats, with no real way of knowing what lies ahead. And throughout, the product or service must make real money; hence, "river of cash."

What's in a History?

The historical depiction of a business might read something like this: She started building widgets in a garage, and worked for a couple of years until she had 15 employees. Then the widgets appeared in the corner of a *Time* magazine cover, almost by mistake, and the widget revolution began. You can substitute Bill Gates, Warren Buffett, Bill Boeing or Martha Stewart in this framework and that's how the story goes.

Those of you who actually run companies know it isn't that simple. Writers of such history don't understand business, or if they do they are reluctant to dwell on what may appear as boring detail. For example, some business journalists focus on celebrity. They think the reader would not be interested in such mundane details as *why* Bill Gates, Paul Allen and their buddies wrote BASIC for the Altair Computer and what it meant to that band of counterculture programmers in 1971. These writers want to know how much money they made and how quickly they bought their Ferraris. But such logic is flawed: the journey, not the end result, provides the lesson.

The story (the one that is only concerned with the end result) goes that seven or eight young programmers were holed up in Albuquerque, New Mexico, where they wrote BASIC and began their journey down the road to success. This is true,

in part, but it doesn't tell the whole, or even the most important—part. For entrepreneurs, though, the important thing is that BASIC was Microsoft's first river of cash! This was the first deal, the first cash stream, which would be used to pay the electricity bills, the payroll and rent until another deal could be made, thus starting the cycle again. In the story of Microsoft, there was a lot of history between that BASIC compiler and DOS, Windows and Windows 95. There were also many rivers of cash for the company.

Hewlett Packard started out with one audio oscillator as its first river of cash. Some 10 years later they were producing a whole range of electronic test equipment, which represented another stage in their trip. Today they have more products than I could research, including laser printers, calculators and computers.

Maneuvering on the River: Collecting Cash

An accounting firm's river of cash is typically the sum of confirmed and potential contracts for accounting services. A hamburger stand's river of cash is the total amount of money its owners are going to receive in meal sales. A gas station's rivers of cash are the sum of gas, car service, parts service and now, mini-store sales. So, a fully outfitted gas station, as in this example, has four main rivers of cash—each with its own characteristics.

Described thus far, the river of cash sounds more like sales on an income statement than cash. When you are sailing along, selling hamburgers and french fries for a living, your river of cash is the amount of cash collected for food, and the expectation of continuing to sell your hamburgers and fries and collecting more cash. If there is a mad cow disease scare in your town, your river of cash may become a stream, or dry up entirely. Alternatively, if

the American Heart Association issues a report that ties your hamburgers to increased longevity, your trip may take you from a relatively small tributary and into the mighty Missouri—lots of hamburgers, more hamburger stands, perhaps more towns as well. So the metaphor derives its meaning from both an amount of cash you get, the amount of cash you can expect to get, and from the specific task or service that generates that cash.

Thus, the founding team at Microsoft made a deal for a BASIC compiler, sold a contract for it, wrote it and started collecting. This was an early river of cash, and it would go only as far as the Altair computer would go—which wasn't very far. Then the team wrote another BASIC compiler for the TRS-80, and that created another river of cash, which the company rode until the next project. Soon they were adding products and services in an attempt to build a bigger company using several rivers of cash. Later in their development came compilers, word processors, spread sheets, databases and operating systems. Each of these represents a significant river of cash for Microsoft. Managing the business on each of these rivers is part of the entrepreneur's fundamental responsibility.

Back to the hamburger stand. You, the owner of that stand, must make decisions, such as how much hamburgers and buns to buy, how many people are needed to run the stand, and all the other cost considerations to make sure the enterprise makes some money. The first and rock-bottom assessment you have to make is: How many hamburgers are you going to sell? And assuming that you collect cash for all that you sell: What size enterprise does this look like?

Let's say you have already established your stand, so you know roughly what can happen in a given day. You are on a predictable stretch of river. You know how wide the river stretches and how fast it moves. Plus, you can handle the boat.

You can also predict pretty accurately as far as you can see, although all enterprises run on uncharted rivers (no matter what the academic types tell you). Around the bend may be a much wider section with a rougher current, in which case you might need a bigger boat to navigate safely. You see this coming, add another hamburger stand on the other side of town, doubling your operation—bigger boat, bigger margins for error. Somewhere farther along the river you are faced with Victoria Falls (the American Heart Association says that hamburgers are quite unhealthy, indeed). You look down at the cascade of water falling 300 feet to the new stretch of river below. Somehow, you have to dismantle your boats and transport them to this part of the river. Knowing the vagaries of river exploration, you have saved some money and are able to convert to a healthy chicken-sandwich stand. You reassemble one boat, then another, on this new river of cash. How much money can you collect selling chicken sandwiches? You are off again.

You're the Captain of This Trip

The entrepreneur is the outfitter, financier, navigator, tactician and the captain of this trip. She is responsible for all of these functions, and often must perform most or all of them personally. The job is sometimes aided by marketing, demographic analysis and other numerical, economic or empirical materials; consider these as charts and weather reports. To the extent that charts and weather reports are accurate, they are very helpful. Unfortunately, the charts we are talking about resemble fourteenth- and fifteenth-century maps more than today's surveyed, sounded and satellite-corrected materials. And weather reports are about as accurate as ever. Sure, it may be

partly cloudy, but does that explain the torrent of hail pounding down on the tin roof of your riverboat, or the glorious day of hot sunshine that follows the hail?

In 1980 we were cruising along a fabulous river of cash, selling computerized services to law firms. Reading the weather reports might have scared us off this river and forever changed our fortunes.

This was during the Carter presidency. We were expanding at over 100 percent a year, so we needed to borrow money. The oil embargo and other demonic forces were taking aim at our economy, causing legitimate interest rates to soar. I was paying a bank 22 percent for the privilege of using its money. This wasn't Bob the Bone Breaker's Bank; we were dealing with a subsidiary of Bank of America. The *Journal of Commerce* was screaming about how small business was being crushed. Loans to small companies were being reviewed and called in as the entire financial community clamped down to protect itself against this inflationary and hostile business environment. If there was one message out there, it was, "Pull in your horns, you small business owners, you'll be lucky if you get through this!"

It was not a weather report; it was a hurricane warning shouted over the howling sounds of building winds.

Despite the inhospitable economic climate, my business was doing well. I kept making these deals, and client after client kept asking for our services. We were able to make good margins even with the outrageous cost of money. We pressed on through the economic storm, only it wasn't a storm for us, it was just a brisk wind, and we had a great ride.

The Carter years were tough on our economy, but they were great for Walt Sutton and his business. Our river of cash was a specialized sort of computer service, and there were more

clients than available vendors. The weather had almost no effect on us because we had the right boat, crewed properly for this incredible stretch of river. For all of the 23 years at the helm, for all of the charts and aids I used, none was more important than the sum of my gut, my eyes, my experience, the feel of the wheel, the sound of the engines, the health of the crew and the sturdiness of the vessel.

The world was telling me to pull in my horns, become conservative, stockpile cash and reduce leverage. But my gut was telling me that we were the only company in the world providing this service, and that we weren't in the storm but just ahead of it, and, if anything, we needed to pour on the coals, crank up the engine and go for it—which we did.

Steering Your Vessel

You must drive your vessel using your senses and immediate indicators. I knew a chap who sold wool—that's all, just raw wool—and he summed up his work by saying, "There is no substitute for the feel." I believe this is true for the successful running of any business. And feel comes from experience, not imagination. Imagination can be helpful, but experience provides proven reactions to big waves. It gives greater skill in discerning the harmless dark cloud from the one filled with brick-size hail; it gives rise to the voice that guides your boat with greater certainty of a successful trip. "Go left," "Not that way," "Into the surf," "Watch out," "Get up into the wind," the voice says. And in time, you learn to listen.

We live in the cyberage, a time when a plethora of information is available. Computer models can replicate a complete manufacturing line, test it, then guide you in ordering the robots and placing them for the best result. No doubt such techno-

logical advances can help a small company compete, but don't let such aides get in the way of your seasoned hunch or gut feeling. Having your hands on the tiller and feeling the currents tug you from side to side and finally steering your ship to safety—these are the experiences that make for a competent captain.

Try not to become frustrated. It takes time to gain experience. The more evenly you can balance your level of experience with the aggressiveness of your business plans, the better your journey is likely to be. This is not an easy balance, because many of the forces, once engaged, are out of your control. You are riding a vessel along an uncharted river, not playing an arcade game.

The first and most important way that most entrepreneurs exert control is in making the choice to be on the river in the first place. Having decided to take the plunge, there are decisions to be made about the type of vessel, the sort and quantity of crew members, provisioning, equipment and the time or circumstances of departure. However, once on the river you are committed to the trip.

Deciding on a Business

Part of becoming an entrepreneur—or surviving the process of becoming one—is identifying which river of cash you want to navigate.

Take the case of my friend Bill. Bill learned how to cut men's and women's hair. He began by working in someone else's salon. Later he earned enough money to open his own small salon in San Francisco. He was popular with a socially active crowd that used his services frequently. He expanded until he had 40 chairs, which were full almost 24 hours a day. Bill was making so much money he had to put it someplace else. Because he couldn't merely continue to expand the hair salon, he

bought a beauty school. The government was giving tax incentives and loans for training people at all kinds of schools; beauty colleges were a favorite. After no time at all, Bill was navigating along two lucrative rivers at the same time.

Soon Bill was looking around for a place to put all of the money he was making in the beauty school. But then his wife filed for divorce and both river trips ended abruptly.

His wife took her share of their assets and Bill took his, disappearing from San Francisco entirely. He went to a very small town in Arizona and lived frugally. He remarried about 10 years later and fathered a baby. He opened a small two-chair shop in the town, hired some help and made all the money he and his new wife would need. He was even able to save. By the time the baby was two years old, her college education money was in the bank, right through medical school if she so chose.

So in his early days, Bill had two rivers of cash. First, the beauty salon and next the beauty college. He was riding both very comfortably until the divorce arrived. Later, when he moved on to his new life (with his share of the proceeds from the divorce), he only needed a trickle of cash—a stream, if you will. A two-chair operation in this case was plenty.

You need to spend time considering what *your* rivers of cash are. Start by looking at your business and asking, What are my main rivers of cash? This is the same as making a list of your main products and services. Once you have listed them, calculate how long you have been riding each of them. Next, make an estimate of how long you think each of the rivers will last. And finally, try to identify prospective new rivers of cash, products and services you see in your company's future. It would also be wise to consider how far along the river you think you have traveled. Consider whether you have set out in the proper vessel to get the most out of your trip.

My second business was a rudimentary computer service. I started it in 1978, when computer services were almost nonexistent, so I had very little upon which to model my decision-making. We took documents from clients and made computer records that could be retrieved quickly and reliably. We were paid by the hour, plus a premium for the computer we provided.

I founded the company, made up the service, sold contracts and collected payment for the work over a four-year period. I never had the slightest idea what river we were on or how we stayed afloat.

Crazy, you say? You'd be surprised how many successful entrepreneurs sail along happily in the same blissful state of ignorance. Of course, this is not the ideal way to approach any new business venture.

Tools of the Trade

Here are some tools that will help you choose a pathway:
1. Answer a few questions
- What is my river of cash?
- Where am I on this river?
- Do I have another river to move to when this one peters out, becomes too rough, too crowded or turns into Victoria Falls?

2. Write a strategic plan
This is the best navigational device I know. Developing a strategic plan is the process of thinking through a business, its direction, the threats and opportunities that might affect it, and its long-term goals and objectives. Work at the plan, then write another next year.

3. Consider using a consultant

Many consultants offer strategic planning processes. If you choose to use one, keep the following in mind:

- You and your management team, not the consultant, should be the writers of the plan. This is not work that can be delegated.

- Your consultant should act as a knowledgeable facilitator more than as a group leader. The planning process must be participatory. Typically the work is done away from the office, over a number of days. A good facilitator will also conduct individual preparatory meetings with the planning group.

- Once the plan is written, there should be a scheduled feedback loop to insure that work promised at the planning session gets done.

- Your group should feel comfortable with the planning consultant. This may sound obvious, but it needs saying. The work is best accomplished in a free flowing and trusting environment. If you are led by a person whose personality doesn't lend itself to this sort of atmosphere, you have lost a lot of the potential benefit.

- You should call and interview references. Ask them a variety of blunt questions and listen carefully to the answers you receive.

4. Write a marketing plan

The marketing plan is the method by which you explore the river ahead. This shouldn't be attempted until after you have done your strategic plan. In fact, a good marketing plan slides right

into the tactical section of the strategic plan—under a heading such as "Marketing."

Consider that a river of cash sustains you, and this river is described in part by the opportunity to make deals. The more you know about those opportunities, the better off you are.

Here, too, a consultant can help a great deal—especially with the first effort. My suggestion is that you use the consultant for designing the process, but wherever practicable, you do the work. For example, if a consultant suggests that you survey your Top-100 clients, you and the consultant collaborate to design the survey, but you do the actual work of surveying your customers. This will give you (or your people) a first-hand experience with the data and an opportunity to have an interesting conversation with clients.

5. Read biography (business or otherwise), history, travel and even fiction

Since becoming a writer, I've come to understand the need for writers to read more. Even before I considered writing I found biography to be a special form of mental engagement.

When you read the trials of trailblazers like Abraham Lincoln, Amelia Earhart, Sir Edmund Hillary and Martin Luther King Jr., for example, it is possible to sense what drives them. And what drives them is also what isolates them. These are some of the people who taught me about leadership, about being alone and about making tough decisions. Whatever I have been able to learn about courage, I learned from them.

I still look over the biography and history shelves first, then move to the fiction section of the bookstore.

We've lost so much in the new media age. We seem to be willing to forego real experience for electronic stimulation—be it TV or the Internet. It's a mistake. There is no substitute for feeling the wind at your back, blades of sea grass brushing against

your legs, and the grittiness of sand sliding around and encasing your feet. Electronics can't give you that, but ironically, reading can. When you are struggling with issues of integrity, read about Lincoln's signing the Emancipation Proclamation. When you are wondering where courage comes from, read the diaries of people who came west along the Oregon Trail, or *The Diary of Anne Frank.*

I strongly recommend such sources as superior teaching tools for entrepreneurship and, more importantly, life.

Leap of Strength

9 Borrow Carefully

It has taken me most of a busy adult life to come to the firm and informed conclusion that borrowing money from banks is a bad thing. A very bad thing. In fact, I admit that my conclusion is probably more extreme than most; in the course of this chapter, I will explain how I came to this place. It should be worth some attention from people starting out.

This chapter also has a bit of fun with society's least stable but most often exercised institution, marriage, because of the nature of *that* relationship and its metaphoric connections with debt, business and basic notions of partnership.

Before we get into the details of this chapter, let me say one thing up front. Most small businesses, like most people, need to borrow money at some point. But borrowing is at best a necessary evil that causes more harm than most people—even most business people—understand.

I have heard many small business owners say half-jokingly that they measure their net worth by how much a bank is willing to loan them. Anyone who says this—even in jest—hasn't dealt with a bank in bad times. The restrictions and limitations that borrowing imposes on a company are severe—and never more so than when a company is having hard times. This is when you learn how heavy the ball-and-chain of bank borrowing really is.

I saw Tab Blackman for the first time long after his bank and I had gotten engaged. This is too bad, because the minute I laid

eyes on Tab, I knew he was a priggish jerk. Our meeting was intense and, although I've never bothered to press for details, I'm pretty certain he looked at me from the beginning as a smarmy, steal-the-children-and-pets entrepreneur. Ain't love grand?

Tab was the vice president in charge of corporate banking at First Universal Bank of the Western United States, which has since been swallowed up in several mergers and goes by some impossible acronym—UniWesFirsCorp or some such. He wasn't the salesman who'd brought in my business; he was the manager assigned to deal with me on a daily basis once the loans had been arranged.

Banks, law firms and other business service providers are notorious for doing this. They send out their brightest, smoothest, most attractive people to bring in business. Then they hand that hard-won business over to people like Tab.

We met at what I like to call the wedding. His bank and my company had decided to mingle affairs to such an extent that marriage is the appropriate image to invoke. The package—a good one by financial standards for a company our size—included payroll administration, checking accounts, corporate credit cards, a revolving line of credit, capital acquisition loans, take-out loans for our existing encumbered assets...everything short of a gold money clip stuffed with C-notes for me (though I'm sure that could have been arranged).

Millions and millions of dollars flowed around in a banking relationship that took Tab's people and our people four months to negotiate.

These were heady times. We felt particularly powerful; sales and profits had swelled at a nearly obscene pace. In this self-impressed state, we even made it all a contest, pitting one bank against another for our regal hand. It was the Banking Olympics; the gold medal was the honor of loaning us money.

My vice president of finance acted as matchmaker, minister and family doctor. He was, after all, vice president of finance; and this was why I had hired him—to attract lots and lots of financing. And he did his job. "I'm telling you, Walt, this is a great deal. I know these people are a little stiff, but I can handle them, really. And after all is said and done, remember: this is what you hired me for. It's going to be a great marriage—trust me."

He brought us all together in the executive dining room in the UniWesFirsCorp tower in downtown Seattle. There, I saw Tab and hated him right away. I had thought of my business like a blushing bride; my red face had more to do with dread.

We were ushered into the executive dining room, framed by a floor-to-ceiling window extending the entire length of the room, overlooking Seattle's downtown and the Puget Sound beyond. It was one of those days when the city must have been full of tourists: in this window full of blue water, the sun sparkled in the wake of crisscrossing ferries; dark green islands lay beyond; and above a single puffy cloud hung against a light blue sky.

In contrast to and in the middle of this exquisite view stood Tab: about my height (medium short), thin, wearing a brown suit, a starched white shirt, gold Cross pen in his pocket, brown twin-tassel loafers, brown tie, brown hair combed dully to the side and the handshake of a freshly slain halibut. When he smiled, two white shingles appeared in unison beneath a dark brown mustache. The exposed teeth made a dutiful appearance, acknowledging the social act of smiling without pretending a micro-calorie of warmth, greeting or pleasure.

"So once we get the signing done—these papers here, Mister Sutton—we can have a little toast to the future and enjoy our specially prepared lunch. We've located these Day-Glow tabs in the places where you must sign; there are six of them. Here,

let me turn the pages for you so you don't get confused. I understand from your people that you don't like paperwork. You may not know it, but chef Jacque le Mangier is our corporate chef and I understand he's made something very special for us today."

Tab whipped out the gold Cross pen, twisted the point out of its nose, and handed it, still warm, to me. Then he took a white, hairy finger and pointed at the first Day-Glow tab. The arrow pointed at a line with my name typed out in full beneath it. Through his large teeth he hissed, "Here."

This was not my first foray into the world of big debt by a long shot. But it was my last...and easily my most memorable.

Tab Blackman—who I'm sure is a perfectly fine fellow in banking circles—and the unraveling of our corporate marriage four years after the wedding day in the boardroom overlooking Seattle lie at the heart of my hard views about debt.

We sat at what Tab called the Esteemed Corporate Client Dining Table, which looked remarkably like any other boardroom setup to me. We were treated to four courses of wonderful food which, as I ate, began to back up in my stomach.

I had just signed agreements to borrow millions. On one hand, I couldn't wait to get to the gym to tell my buddies in the aerobics class that we had finally pulled it off. On the other hand, something wasn't right, and I knew it. There we were, six of us, eating the bank's food, Tab flashing his teeth at me from time to time...and my stomach clenching up a psychosomatic warning.

My nerves were warning me to get up, tear the contracts to smithereens, leave a couple of hundred for the lunch and bolt for the elevator. If I haven't mentioned it before, I want to say it now: Your gut—even (or especially) when it is being seduced by French food—is vastly underrated as a business tool.

But I didn't listen. Instead, I chitchatted along, ignored my stomach, let the alarm bells ring in my ears and, as per the nuptial agreement, accepted the money.

I have had a lot of time to think back over the wedding. I know I didn't have a good attitude about Tab and his banker buddies. I understood something that should have made a difference—but didn't. Each person is equipped to receive a broad spectrum of signals other than those picked up by scientific instruments. We may not be able to consciously articulate these signals, such as intuition, but we do receive them and should listen.

It took me almost 10 years to figure this out.

That evening after I went to the gym to work out the tension of the day, I sat in the steam room with my other entrepreneur buddies, soaking in the warmth and wetness, and I said, "Well, now I know I'm worth $10 million because that's what they loaned me."

We smacked sweaty high five's all around. That's what I said to the world.

The reality of what I had done, however, was much grimmer. And therein lies the cause of my dyspeptic reaction to Tab and his crew. They had just signed me up to a deal by which they would get everything if the business so much as burped at the wrong moment. They now carried a license to take it—all of it. They would take my stuff with a glow of self-righteousness that would make the sun look like a cheap 60-watt bulb. What was mine was going to be theirs, and the *going* wasn't expected to be pretty.

That's what I was feeling, because it was true.

Convinced I was worth it, I took their money, signed their deal and swallowed hard. For it came to pass that I—the corporate and personal *I*—did indeed have more than enough assets

to cover the money we borrowed. But it would be close...and painful in the process.

I'm getting ahead of myself.

Partner? What Partner?

By entering any type of formal debt relationship, you are taking on a partner—usually a banker—because close coordination is either an explicit or implicit condition of the loan agreement. By taking the money, you are taking on the lender as a partner. In my case, it was Tab Blackman and his bank.

What's less understood is that this is an unusual and rather dangerous relationship. It is a textbook example of what psychotherapists mean when they say "dysfunctional."

Most banking contracts have conditions that take effect only when something bad happens, or when it looks as if something bad will happen. But none of the parties usually discuss these terms during the document drafting process. The bank doesn't want to draw attention to the often outrageous rights it is requesting; the borrower doesn't want to seem like someone who is anticipating trouble.

So if your debt-equity ratio gets out of whack, if your receivables aren't collected in a certain cycle, if your sales drop, or profits fall, or...whatever, the bank can demand all of its money back immediately.

And if you can't give the money back immediately, the bank can send in its people to take your stuff—and they are well equipped to do so, with surgical precision and an incredible disregard for the long-term health of the company. That's the deal. But the *doing* is considerably worse than the *telling*.

When something bad happens to your company you usually run out of cash first. (Of course, this *something bad* can sometimes

be a harbinger of something good; like demand for a product that outstrips current production capacity or sales growth in an industry with slow pay cycles. But I'll stop talking like a cockeyed optimist.)

In fact, even the most optimistic business person has to admit that a lack of cash is often the terminal result of something bad happening.

It's a little like breaking your leg in a skiing accident. You may have been increasing your skills dramatically all day before the fall, but your leg doesn't care. It hurts like hell. Of course, the leg can be set and healed—if you don't die from shock first. And your nervous system doesn't care why it's going into shock; the reactions that cause shock can't differentiate between a broken leg on the sunlit slopes of Whistler Mountain and a bullet through the leg on Crenshaw Boulevard in South Central Los Angeles. The system goes into shock—*Bang*. There's one outcome and that one outcome can kill you, no matter what your story is.

The same is true for most borrowing agreements. If your company is in trouble, the bank has a perfect right to take all of your cash and start removing your stuff until the debt is completely paid off. It is also entitled to collect huge "service" fees to compensate for the cost of taking your stuff.

In most cases, these terms are part of the deal you have signed and, given the risk-prone nature of most entrepreneurs, the "stuff" at stake includes your house.

So this money comes with a pretty high risk. Most formal borrowing agreements increase the risk in an entrepreneurial adventure by multiples, not by increments.

Here's the reason: while you are attending to the problem of your broken company, the lenders are sucking out all your cash and preparing to take the assets you need to make a recovery.

They put you in deep shock even if, with a little care, the leg might have been set and the patient healed.

Scared? Good. And you haven't even heard the part about my bankruptcy yet.

When you borrow money from banks or other institutions, and when you sign certain types of contracts with certain types of people (like leases with landlords), these institutions and people become your partners until the respective contracts are fully satisfied.

As a hard-charging, independent decision-maker, you may shrug this off as better than giving up equity. While that may be true, technically, the difference isn't really so great. In the real world, long-term financial agreements are often as difficult—and as binding—as partnerships.

This practical partnership gives lenders and landlords rights that are blithely glossed over by the financial community, other entrepreneurs and academics as "normal" or "business as usual."

I don't think such arrangements are even close to being *normal*. Your care in choosing and discharging these sorts of debt relationships is the focus of this chapter.

Loan agreements should make you as nervous as being near the summit and discovering the disclaimer label on your coil of orange mountaineering rope. It doesn't mean you don't finish the climb—what else are you going to do?—but it does mean you should be very careful and appreciate the continuing level of heightened risk. And when you get off of the mountain, weave your own rope so that your next trip will be a whole lot safer.

This is a good place to mention that most new entrepreneurs are inoculated from these worries because no one will loan them a dime. When I mentioned this to a burgeoning gallery owner, her reply was, "Well, there's always the Discover

Card." She was right. Even in this economy, which is heavily dependent on start-up businesses, it's easier to borrow money on credit cards and against the equity in your house than it is to borrow money as a business.

(By the way, have you ever read your credit card or equity line agreements? If you are considering using them as a source of funding I suggest you do read them—carefully. Some people are good at—and even enjoy—rolling credit card balances from one account to the next. But it's hard to do this and grow a small business.)

For years I lived through the vagaries of slow pay on the cushion provided by our MasterCard. But even these seemingly innocent forms of credit can extract a very high price. I know of plenty of people who have lost their houses because they were unable to clear up one of those personal credit lines. Many lines are collateralized against your house or some other specific asset. This risk is in addition to interest rates that run as high as two to two and a half times the prime.

But I know well that you have to move somewhere. Every business needs to borrow money at one time or another. I know this to be the truth, and I understand that you must do it. Just be careful.

Here's how.

When you're starting a business, you will borrow money against your house (home equity lines are usually the cheapest and easiest means of raising money), you will use your credit cards, you will take a loan from a brother, sister or college friend, or withdraw funds from your savings account. You may end up doing all of these. The seed capital has to come from someplace.

You might even be the one-in-a-million wunderkind who has such a good idea that you get institutional money from the start. But somehow, someplace, you are going to have to come

up with the money to get going. And for that money you are going to have to make a deal—a deal that involves giving up control in one form or another.

Later, as the business grows, there will be times when you again need outside capital. The main issue here is not that one *incurs* debt. The issue is what the entrepreneur *does* about his or her relationship to the debt.

At the beginning of Chapter 5, I described the moment of launching yourself off the white cliffs of Dover—into your business, hoping and believing you can fly. Such a leap is an act of faith; there's no doubt about it.

The greatest single inhibitor to entrepreneurs actually making that leap is the issue of debt. The exceptions are so few that they don't count for the purposes of this book. You, the founder or chief or owner of your company, will forever and always be *personally responsible* for every nickel your company borrows or pledges to pay, *period.* If you doubt what I am saying read about the roller-coaster sagas of Donald Trump, Bruce McNall (the West Coast coin dealer), Jim Rogers (the runner and entrepreneur) or Kareem Abdul Jabar.

One way or another you will have to pay it all back. No kidding. This realization is buried some place deep in our genes (I think) and the difference between the entrepreneur—the practicing entrepreneur—and the rest of the commercial world is that entrepreneurs are willing to embrace this risky prospect.

It is a line that not many people cross; it's a most dangerous path taken by only a few. This is the difference between you and all of those people around you who bitch about working for others but who don't engineer a change. Most people don't want to take the risk, no matter what they say.

Even though this risk is assumed only by the few, the requirements of a free and expanding economy are forcing huge structural changes. These changes are forcing more and more people

over the line. Lifelong jobs are growing scarcer; more of us are being forced to fend for ourselves. Although this may not mean starting a company with employees, it may mean becoming an independent contractor and learning the ways of a business owner. Most of the same rules apply.

In other words, sometimes the leap from the white cliffs of Dover isn't entirely voluntary. We all have to earn a living. And in the case of a solo practitioner or an entrepreneur who wants to sell hamburgers or start a high-tech widget plant, this leap means bearing debt and, one hopes, allocating profits. These two fundamental responsibilities are borne solely on your shoulders. It's the price of entering the entrepreneurial life and it isn't fully paid until you leave.

One last point before we get to the good (proactive) part. For every economic undertaking there are good times and there are bad times. No enterprise, no matter how big or small, dynamic or mundane, is immune from the good and the bad. For dramatic lessons in this predictable variability, just consider the histories of IBM and General Motors over the last 50 years.

Remember: good times and bad times, always. This is an immutable rule of the universe and acknowledging it helps a lot. By the way, I don't think that the "good times, bad times" rule means that the universe is a hostile place, just that it is a challenging one. My grandmother, who lived to be 99, used to say all you could count on in life was that there would be problems, and the wonder of creation was in solving those problems. Good times, bad times, in an unpredictable procession.

Given that all businesses borrow money, is one course better than another? I think so.

Becoming Your Own Banker

Given that the entrepreneur is irrevocably responsible for

paying back every borrowed or committed dime, wouldn't it be a reasonable alternative to make a concerted effort to some-how eliminate debt over time? That is, become the bank your-self, then borrow money from yourself when expansion be-comes necessary. My strong bias says yes!

There is nothing new about borrowing. I'm certain that the first coin ever minted was also loaned early on in its life. The entire merchant class of the fifteenth century was centered around the guy willing to loan money. But borrowing has al-ways been dictated by local rules—very local ones. The village lender, the local marquis or Bob the welder sets the rules. Further-more, you get the feeling from reading history that the price of borrowing was more clear-cut—albeit harsher—in the past than it is now. Being sold into slavery, having a hand cut off, losing one's children to a creditor and/or being sent to the workhouse were some of the consequences of nonperformance.

I was edging into the adult world when credit cards started their explosion onto the American scene. I remember when a vacation to Europe meant that your Visa charges would be kited out over three or four months time while the slips made their way to your home bank. Those were the days! I also remember when having the cash was the threshold requirement for buying something. I give you money; you give me the blue suede shoes. Simple.

More than anything, I think the institutionalization of mortgages and, much later, credit cards has changed our view of credit. We have gone from societies where credit was con-sidered a high-risk, dangerous and seldom used option to societies that spend most of next year's income before it's earned. Is that social magic or what? Whatever you call it, we are certainly more acclimatized to borrowing than we have ever been in the past.

The Power of Cash

Recently our family decided to purchase a new car. After devouring all of the consumer magazines and reviewing what we believe to be repair records for vehicles in our target zone, the decision was made to get an XYZ Urban Wagon. Those trips to the supermarket are getting more dangerous every day and you can't have enough truck between you and the road. The interesting ripple in the deal is that we wanted to pay cash. This anomaly caused the advertised price on XYZ Urban Wagons to go up once we made our intentions clear to the Car Sales Professional who greeted our assertion with: "You want to do what?"

"Um, sorry, but we want to pay cash."

"Oh, you really want to borrow the cash from our Finance Department, then buy the truck, right?" He glowered. I hate it when someone looks up at me—seated at his desk as I stand— and still, makes me feel like a little kid

"Um, no, we just want to give you the money for the truck, that one in the paper." I pointed to the ad pasted to the glass wall that ensured that the entire showroom could watch my red face. This scene played out under a sign that read "Your Satisfaction Is Our Number One Priority."

He chomped his cheroot—car dealerships are the last place in America where smoking is encouraged—and said: "That one in the paper is a lease option, extended payment, low down, super convertible residual truck, buddy, not some silly cash truck. Do you get my meaning here?"

"Yes, sir," I mumbled.

"You don't borrow all of the money for that truck, you don't get that truck, at least not at that price. This isn't some sort of a joke is it, cause if it is I'm gonna call my credit manager and he'll

straighten you out big time. Now, how about a 10-year lease? We got a hell of a deal on a 10-year lease."

The last time I was browsing through a history book, Henry Ford wanted your $500 before he gave you that Model A, and even though "easy credit terms" were available to a select few, no one wanted them. It just seemed right to earn the money and pay for the car. We were finally able to find someone who understood cash and would accept our payment in exchange for an Urban Wagon.

It's nice knowing I won't have to give up my oldest son to servitude if the economy turns bad on us.

Acclimatized to Debt, Anesthetized to Cost

Since we have become acclimatized to debt, we have, in turn, become anesthetized to its cost. I have already mentioned the cost of associating with a powerful partner. There are also interest and service fees that can be proportionately huge. I love watching someone in the grocery store buy coupon items, then make payment with a Visa credit card, triggering the additional cost of double-digit interest. Save 5 percent at the store and pay as much as 20 percent in interest—go figure.

Out of this mélange of contradiction we have devised the theory of leverage. This is the self-same term that convinces us that we should be glad to be in debt, that debt is a more efficient use of our money and a better state of financial being. So, for example, I buy my $28,000 truck for cash and as you can see it costs me exactly $28,000.

Leverage as a concept has convinced many of us that paying $4,000 down and monthly payments totaling $37,576.34, for a final cost of $41,576.34 for the same truck is somehow better. Who can blame someone for pulling in an additional 48

percent for the same truck? Of course, if you don't have the money, and you need a truck now, this might be a reasonable proposition. But if you have the money and need a truck, why would you even think once about it? I am certain that as a consumer it would be better for me to have the $13,576 to spend on other things.

And there is the gist of my recommendation to all entrepreneurs. As the person who must bear debt and allocate profits, I suggest that you allocate profits to taking out debt, and eventually run a debt-free company. In time you will accumulate cash and securities on your balance sheet and you will take on the appearance of a bank. In times of expansion or trouble, you borrow from that bank and pay a reasonable interest rate to yourself.

What better partner to have than yourself? No funny business, fewer surprises, and if you break a leg on the slopes, you take a smooth ride down the mountain side, set the leg and let it mend.

My theory of debt extends to estate planning too. Certainly there are a million reasons for running your own business, but at least one of them is to earn a living and perhaps provide something for the future when you aren't working. Even great businesses hit speed bumps, sometimes terminal speed bumps. If you act as your own bank, the worst thing that can happen is that you sell your assets and add the proceeds to the money you have in the bank. Not bad. Sure beats giving all of your assets to another bank, along with parts of your personal assets that have been collateralized against your loans. The dark side of leverage is that it works both ways.

In talking to entrepreneurs, I have found that the doomsday scenario—the one where the bank takes everything—most definitely haunts them. A judicious use of profits can greatly alle-

viate the risk pressure that most of them feel. I can say from personal experience that the difference in running a business with no-debt versus running a business with average leverage is like night and day. And even if a no-debt scenario is unrealistic, the closer you can get to it, the more comfortable life becomes.

A Useful Exercise

During the last five years I've asked hundreds of entrepreneurs to estimate their business and personal debt. Most can't get within 20 percent of the correct answer. Modern accounting does a wonderful job of surfacing comparable numbers from company to company. But it doesn't do a very good job of telling the owner how much he is really worth or how much she really owes. This may seem a little simplistic, but those are the only two numbers I really care about—at least in the first and last analysis.

In August of 1987 I signed a lease for a ton of office space in a high-rent section of Beverly Hills—a glitzy section of Los Angeles. By a *ton* I mean whole floors of a landmark edifice. My company promised to lease this space for five years. Attached to the lease was a single sheet of legal-sized paper stipulating that if the company wasn't able to make lease payments, I must make them. The document is called a personal guarantee. At the time, my business was still married to Tab, and we were incredibly fruitful. The initial loans had been kicked up to more than double their original size in order to fund our explosive expansion—an expansion that was then in its seventh year.

Then the impossible happened. Through a series of freak events, none of which were caused by our actions or inaction, revenues fell by more than 60 percent. We were a project-based company, and suddenly unrelated instances haulted our two big-

gest projects. We were ordered to stop work immediately. And no one saw it coming—not even our clients. We started by laying off 200 of our 350 employees. In the *best* of worlds it would have taken at least three or four years to cut, recover and build again. But we owed Tab all of this money, and he and the bank moved in.

The irony of all this is that the bank didn't precipitate the final crash; we fell to the personal guarantee. Although Tab took most of our cash and assets, we laid off most of the staff right away and were able to downsize in every quarter except for the leases. Had the lease agreements not been guaranteed, we would have walked away and negotiated some sort of a settlement. But no, I was on the hook personally. It took two miserable years of trying to make the thing work, save the business and strike a deal with the foreign investment company that owned the fancy tower in Beverly Hills.

We sued each other, talked, didn't talk, paid lawyers hundreds of thousands of dollars—until finally they pushed me to liquidate everything and go into bankruptcy.

Was it the worst thing that has ever happened to me? Nope. Was it awful in the extreme? Yup. How did I feel after 19 years of growing success only to find that I had nothing left? Pissed. Did our friends stand by us? Only a very special few. How did my family feel? Shell-shocked. What happened to my self-esteem? It was shattered.

The bankruptcy court in Los Angeles is a large dark room with the judge sitting behind a long, ponderous table. I stood in line as one person after another was shuttled in front of the short, distracted-looking man in black robes.

On one side of the table lay stacks of thick, overstuffed case files. The woman who tended to these files would take one, check something inside the front cover, then lean over and whis-

per something to the judge as the next debtor stepped forward. Sometimes the judge shouted questions; sometimes he mumbled a legal benediction. I couldn't figure out the pattern. And it made me really nervous.

There is an irony here: to be forgiven of a big debt you have to pay lawyers more than a small debt. Thus, I was not only interested in ending the nightmare of a $25 million guarantee, but also the hemorrhaging expense of my lawyers. Finally the chap in front of me peeled away and I faced the judge, who, after listening to his assistant's cue, said, "Mister Sutton, I find your materials in order and grant your petition for bankruptcy. Better luck next time. Next, please." And it was over. I walked into the glaring June sunshine and, squinting, thought how grateful I was not to have cancer.

I don't want to end this chapter with you bummed out—at least not on my behalf. I started another company (it's all I really know how to do, remember) with a $75,000 loan from my good friend Bill Green. Other than paying Bill back, we ran a debt-free business and four years later I sold the company and acquired the wherewithal to sit here and pound out these stories. (By the way, it is a lot easier to sell a debt-free company. No nasty partnerships lurking in the weeds, remember?)

Ah, yes! Selling the business! A tantalizing possibility that stimulates a whole collection of emotions and fantasies. For example, say the finance types tell you that your company is worth five times earnings. You can figure this out! It isn't hard to silently multiply the numbers and revel at your abundance! It is an extremely hard task to build a business, one that banks and lending institutions view as being viable. When it happens, when you have real payroll, real corporate status, real borrowing capability, the glee is infectious. I am all for celebrating this achievement extravagantly.

Just don't spend the money before you get it, because the finance types and their suggestions of value are rarely, if ever, realized—at least not net.

We've already seen what happened to one fellow who thought he was worth what the bank loaned him. It is the same deal for those who get carried away with what they think they are worth based on a business valuation.

Valuing Your Business

In the interest of manageably sized egos, I would like to introduce Walt Sutton's sure fire method for valuing a business. The idea came from a longtime friend named Barry Rogers, who ran businesses very well. Here it is, on paper now. Close the doors:

- Pay all the bills, taxes and debt the company owes— don't forget long-term commitments like leases and term loans.

- Collect all of the receivables you can collect, terminate all of your employees (remember severance, benefits, taxes, promises).

- Sell your fixed assets at auction and multiply the receipts by 75 percent, because none of us can resist overestimating the value of land and assets.

- Subtract the payments you've figured from the cash you have created.

And this is the worth of your business.

I promise that by using this method of valuation—at least in the privacy of your office—you will never leave disappointed with the outcome of a sale. Oh yes, if you are selling, go for the big multiple! Who knows what will happen?

Lastly, there is a middle debt ground that you might consider. Suppose you run one of those businesses that needs a banking relationship, or you decide Walter's full of hot air and you want to borrow the money for expansion as opposed to saving for it.

One middle ground is to insulate your personal finances from those of your company. This doesn't happen quickly, but as your business establishes credit and as you build up some retained earnings, you will achieve a profile where the lending institutions like you because, after all, they make their money loaning money to people who pay it back.

In the early part of your relationship, the lenders will demand personal guarantees. But as you prosper, after you pay them back a couple of times and when you are smart enough to shop your banking business around a little bit, there should come a time when you can get a finance package using only a corporate guarantee. Do it!

After crossing over into a place where you are no longer signing guarantees, never go back. This insulation should allow you to build your personal holdings knowing that they aren't subject to the vagaries of business volatility or the whiplash effects of leverage. No matter what anyone says, you aren't rich until you really have paid all your taxes and have real money in your personal bank or brokerage account.

Tools of the Trade

Here are some of my favorite tools for bearing debt and allocating profits:

1. Know thy debt

This simply means that a couple of times a year, you get out a piece of paper and calculate all of the money your com-

pany owes. Do the same for yourself: don't forget the mortgages on real estate or lease obligations—including estimated residual on your cars.

2. Consider achieving a debt-free company

It may be easier than you think. First, you must understand that your cohorts and society will interpret this behavior as radical and antisocial. Some may even argue that you will only be enriching the government by paying more taxes. Just show them the door; they clearly don't get it.

It may take three years or more to channel profits into debt payoff. Then it will take some time longer to become your own bank. My last business was able to reach this level in year four, but it varies wildly with business and personal needs.

Since the other place where profits usually go is into your pocket, you will be taking less out of the business while you make this investment. In my opinion, it is a very good use of your money. Lifestyle spending doesn't have near the pay off, and you can eventually have the high lifestyle if that's your inclination. All you have to do is wait a couple of years.

And what about that interest deduction that used to reduce your taxes? Just pay your taxes and keep all of the rest. It's a wonderful and rare feeling to own everything outright or at least have all of the money in the bank to pay off all of your obligations. If you want to get back at the government, put your money in the stock market—blue chips—and leave it in there for 10 years.

This is one of those rare suggestions where even doing the task halfway pays proportionate dividends. If you are able to do it all the way, you just get this giant balloon payment of being completely free.

3. Find and hire a personal financial advisor

I have handled millions and millions of dollars in my life, and when I heard Hyrum Smith, the founder of Franklin Quest—the time management people—say that this was one of his personal

action steps to financial independence, I didn't believe him. Here was a chap who was even richer than I could become in seven lifetimes, and he purports to be looking for a financial advisor. After a while it came to me. Running a business and managing your investments—your financial life—are not one in the same thing, even though they may be closely related.

Without a doubt, the story I have heard the most about entrepreneurs is the one where she goes out, starts a business, makes $5 million, and then loses $6 million in real estate. There are a thousand permutations of this tale, but the message is the same. We may be able to run our companies but we are often idiots with our own money.

One of the insights that occurred to me after my bankruptcy was how bloody hard it was to really earn a million dollars. I have to say it is one of the hardest things in the world. Note that I am not saying that it's hard to be worth a million; I am saying it's hard to *earn* a million. Well, the idea that one wouldn't hire a professional to help with managing that hard-earned money is ludicrous. Yes, there are plenty of charlatans out there. But you know enough people who can lead you to a good person. There are also plenty of books that will help you in this quest. One last thought: the money managers themselves say it can take up to two years to find a good personal financial manager. Test and be patient.

4. Calculate how much is enough

I was talking to a fellow who runs a paint store. He'd owned and run it for 10 years. It was a good store, in a good location, with good brands, and he had made a lot of money. We were talking about how happy he was with all that money. After a while I asked him, "Well, how much is enough? I mean, when have you earned enough money to where you can't realistically spend all of it before you die?" He was quiet, as if I had said something profound.

"I don't know," he said. "I have never thought of it that way—how much is enough. I've always just thought of making more."

His perception of being lost in the works of running a business is very common. But if you consider moving out of the operation's chair and into the owner's chair of your business, you'll be closer to the right perspective. You are working and slaving and hopefully accumulating money or value. How much money do you need for the rest of your life? When you have calculated this amount, ask yourself what you think you want to do when you have acquired that much money. These are extremely important questions because sweating to earn more money than you need is not a satisfying undertaking, unless you just love, love, love the game. I know very few entrepreneurs who fit that description. Perhaps one in 20. All of us act like we love the game to death—few genuinely do.

Once you have accumulated a significant percentage of your life's target, you have what I like to call F*** You Money (see Chapter 17 for more about F*** You Money). This is the most powerful economic position I know. Someone comes along with a complicated proposal or contract and you don't really want to do the work or take on the commitment. You can say, "F*** you, I have enough money." It's a wonderful feeling to be able to say that and mean it.

Leap of Strength

Discover the Secret and Use It

The secret. That phrase evokes in me childhood images of Long John Silver's hands unrolling the parchment map in *Treasure Island* and growling something like "X marks the spot." There's a kind of tension to it—and that's appropriate. The secret is the least thought of but most useful thing I know about being an entrepreneur. It's even better than buried treasure, because, once found, it will produce and produce and produce...into at least one, and perhaps many more, rivers of cash.

We started our third business in April of 1982. It was a highly specialized computer services firm. We served two of the four or five existing clients in the northwestern United States.

In 1973, relatively early in the life of computers in commerce, I uncovered something important. I developed a way to use a computer and some home-brew software as an accurate and speedy data retrieval device. The software was of a type that only a few understood, and even fewer knew how to write.

Using that knowledge, I was able to save a small but commercially active class of people lots and lots of money. I wrote a klutzy but workable series of programs that added up to what would today be called a database manager or data warehouse. (Said simply, a database manager creates computer files that cross-reference information.)

We focused our database manager in the construction industry, aimed primarily at tracking documents and data. It worked miracles.

This was the first—and perhaps the only—original idea I've actually produced by myself in business. And it was a beauty. We were able to sell our service at good rates, keep a large and steady amount of work and collect our bills with relative ease. The company was a cash machine. We clipped along at 100 percent growth for the first three years with nothing but opportunity in the windshield. It was a wonderful time!

Then I met Sheldon. He made his living by taking privately owned businesses public. We were gym acquaintances and often found ourselves perched, with others, on the terraced benches in the cloudy upper reaches of the men's steam room at the Seattle Club.

The steam room was an after-exercise ritual for about 10 people. So there was a regular Greek chorus of chattering chaps lost in the mist and free-associating in what we thought were healthful vapors. These sessions were a bit like a mixture of tag-team psychoanalysis, encounter therapy and Comedy Central on dirty-joke night.

So here we were, six or seven of the steam room regulars. I'm talking immodestly about 100 percent growth, bigger facilities, branch offices and who knows, maybe a corporate jet in the offing. This was not a particularly reverent group but there was general acceptance going on. Then Sheldon suddenly asks the critical question. "Walt, what is it *exactly* that you do?" I stammered a little, said, "Hmm," and finally offered up this wet noodle: "We use computers in interesting ways to help people keep track of important information."

"Like what, exactly—phone numbers?"

"No, we really help people, you know, solve problems. Problems that are related to lots of paper. You know, computers and paper."

I won't bore you with any more of this exchange because it only got worse. Moving right in for the kill, Sheldon asked

me if any of my children could understand what I did for a living. I had to tell him no.

A long silence followed and then he gave me this advice: "Walt, if you don't know what you do, or how you do it, answer me this: How the hell do you convince someone else they need your service? No, don't interrupt. And, more to the point, how the hell could you ever borrow real money or sell shares in your company? Because if you're not BSing your buddies here in the sacrosanct steam room, you can't keep up this type of growth without some sort of outside financing. No one is going to give a nickel to a person who can't explain his business. Get my drift?"

This is the point at which you think "X marks the spot." I would like to describe a miraculous conversion from dullard to enlightened entrepreneur but—since you've already read the previous chapters—you know it isn't very likely. I mumbled something like, "We earn lots of money and I'll figure it out later and mind your own damn business." But he had stung me.

Every Business Has a Secret

The secret is the guts, the special inner workings, the gears that no one can see, the connections and relationships that make the whole thing work. It is the engine beneath the shell that allows you to navigate the river of cash.

It's understandable that people on the banks of the river don't know much about the inner workings of a boat they're watching from a distance. What's shocking is that most of the business owners and entrepreneurs standing at the helm of the boat can't articulate this most important attribute of their venture.

Let me make it clear: these successful business people usually know something about their secret and often, instinctively,

operate based on this knowledge. But there are few more powerful states of being than that of really knowing, consciously, the secret of your business and cruising confidently on a wide, smooth stretch of a river of cash.

My steam-room epiphany happened 10 years after I'd first leapt from the white cliffs of Dover. Hell, I was on my third jump. And it had never occurred to me that there was some important central scheme that drove and gave continuity to an enterprise.

If you won't ask it, I will. What was I thinking all of those years? This may sound silly, but one of the reasons I didn't work to articulate the secret was because I felt that, if I analyzed it, I might screw the whole thing up—as if the secret were some sort of a butterfly that had to live in the dark.

I found later that the secret was more like a special machine that needed lots of light, oil, tweaking and air to flourish. By the time I had figured this out, about three years after the steam-room encounter, I'd missed several boats in the computer services industry.

Yes, I'd also made a lot of money. But any one of the missed opportunities might have created something *really* unusual and successful. You see, the secret of the business was that I could build and install systems that could reliably retrieve everything important about any one document among millions of other documents. I could not only retrieve the important information, I could get you to the document in a heartbeat.

But we only performed this service in a few situations, often related to litigation, for a few industry niches. These were cases whose evidence comprised millions of pieces of specialized paper. There was a huge world of opportunity beyond the borders of what we were doing.

I missed the idea that my system might be a wonderful thing for an insurance company or a newspaper or a government

contractor. (To be more precise, I saw these applications...but not until much later, when others were doing the same thing—big players who outweighed us by tons.)

One other part of our secret was that we performed this work while making the computer almost transparent to the users, so they didn't have to struggle with computerese to get their information. As most business people know, there are scores of problems solved daily with database managers; companies like EDS—the Ross Perot-founded computer giant—are models of where we might have headed, had I thought about the secret sooner.

The last part of the secret was that we did this work on computers—then called minicomputers—which were far less expensive than the leviathans used in industry at that time. We discovered the power of the early Digital and Wang machines, which, when cleverly programmed and operated, could run rings around mainframes at a fraction of the cost.

It was a really wonderful secret and it is still paying off, by underwriting the cost of bringing you these words.

The relationship between information, computers and documents was also at the heart of my fourth company, so I've had a pretty good run at it. Not near as good as Ross Perot, however.

What could have helped me grow? A better understanding that the secret is as important for the people around a business as for the entrepreneurial founder himself or herself. In fact, it's probably *more* important for them than it is for you.

You know in your gut what you do and why you're good at doing it. You need to articulate your secret for the crew helping you navigate. If the young, bright salesperson you just hired who's going out on her first call, knows what you do and why you do it, she may be able to see opportunities you're too busy to notice. You need it for the people watching from the shore—the investment banker who can raise millions...but

wants a quick, trenchant explanation of your business. He may act like a jerk, but his demands will force you to be succinct.

And, finally, you need it so that your *family* knows what you do.

Secrets of Success

A couple more broadly accessible examples might help here. Consider Microsoft. Its secret has something to do with knowing how to buy code and/or write code (software) that is indispensable to using computers and selling that code reliably and in huge volume. I say "something to do with" because I only know the company from the outside.

Or consider Boeing. The company clearly knows its airplanes, but I'm pretty sure its secret is more complicated than that. Certainly, Boeing knows how to make the types of airplanes its customers want but, furthermore, it manufactures these airplanes in a decentralized way—by spreading the manufacturing among many subcontractors located all over the world.

3M has many secrets—one for each of its hundreds of product groups. But if you shift your focus to the corporate level, you'll find a secret that talks about getting the process and products discovered, tested, financed and to market in great number. Also, 3M knows how to really flog the successes that emerge—consider Post-Its. I believe 3M is the quintessential entrepreneurial company, with hundreds of successful entrepreneurial units working around a central organizational structure.

Berkshire Hathaway, the investment wonder, certainly has as part of its secret that chairman Warren Buffett knows how to value companies and how to choose investments that will, on average, grow reliably and remarkably. (Though some observers say his real secret has become leveraging his reputation to make deals others can't.)

Steven Spielberg has a secret about being able to touch and entertain millions with images. It's my guess that this sense of popular sentiment is more important to Spielberg than his technical filmmaking skills.

Charles Schwab has a secret about giving everyone access to the securities markets less expensively than the full-service brokerage houses, but with a good level of quality. And he knows how to do this nationally, on a huge scale. This is why, though Schwab's company was not the first discount brokerage to concentrate on online trading, it has been among the most successful.

Hewlett-Packard has a secret about finding great technology, bringing it to market and deftly running the product cycle. Like 3M, HP understands winners and giant winners—and knows how to ride price and demand eddies. Hewlett Packard also has the added twist of investing giant sums of money and time into its people. In the late 1990s, after a period of successful but somewhat unfocused growth, HP spun off several units and refocused its efforts on developing practical tools from cutting-edge computer technology. This is its secret.

Nordstrom? If you wonder what their secret is, just go to any one of their stores and buy a gift for yourself, a mate, or a friend. Nordstrom has built a culture that creates a pleasant, cared-for environment in one of the toughest retail markets, and they can do it on a national scale, reliably.

Now if you were the CEO/owner of Nordstrom or Boeing or if you were Bill Gates or Warren Buffett, you would of course have a deeper, more articulate and visceral understanding of your secret than *I've* presented here. Furthermore, if someone asked you to share it, you probably wouldn't. Why should you tell the world how you do it?

Well, of course, I've made the case for why you should. But not all entrepreneurs do.

Finding Your Own Secret

I assume you are living—or at least considering—an entrepreneurial adventure. The sooner you discover your secret, the sooner you'll begin to master your own economic future. This issue is critical.

Before we get to the *how* of discovering the secret, one more image may further clarify the mission.

Think of grandfather clocks: great, wonderful, shining wooden boats on end, huge round dials, complicated moon and astrological charts that move at a pace so slow you never seem to catch them. Think of the bonging chimes and the satisfying clicking as the weights are pulled up, tucked into the top of the belly cavity for another week's work. Imagine yourself admiring such a clock from about 10 feet away. This is roughly the same view most people have of businesses—too often, owners included. And, even though the overall picture *includes* the secret, it can't be clearly seen or understood from this perspective.

The secret is in the workings, the gears, springs, distances, meshing relationships, weights, applied lubricants and attachment devices. In short, all of the guts that make this lovely thing a clock, all of the things that are mostly hidden in the case and behind the delicately painted or gilded face—these comprise the business. The arrangement and relationship of parts is the secret.

When you are looking for the secret of your business, you are looking for oily parts, taught springs, dusty weights, sharp gears, embedded screws, hidden dowels and thin tough wire. You are looking for the ways all of these are hooked together in the dark, how they move and create the entire kaleidoscope of external events. You are not just looking for their presence or aesthetics; you are looking for their measurements, their relationships, the tension between them and the chemistry of their mass.

You must, when all is said and done, be able to take the whole thing apart and put it back together, understand what each piece does, why it does it, and what it's made of. And when you are done, the clock must tick and chime correctly.

When you understand the secret of your business, you sit in the most powerful position that a properly capitalized entrepreneur can attain, you really know how the whole thing works, how it can be manipulated and how you can succeed with it.

When I figured out my computer business's secret—as I've described above—it was a huge breakthrough, even though we had missed some great opportunities. It brought me back to the essence of the business. After about four years of growth, large machines filled our computer department, run by professional computer people and supported by a whole stable of programmers. But I'd drifted away from details. Smart kids were writing computer codes and they were using newer, more modern computer languages. I felt like I'd been a surgeon and someone had taken some of my fingers away.

I'd become disconnected from something that was important to me. No longer could I look over an operator's shoulder and say, "Oh, I see, just change this subroutine to that and you'll fix the problem." Getting back to a place from where I could do this—at least occasionally—was difficult but critical for me.

Growth was an important dynamic of that company and because of rapid changes, I lost part of the secret in the rush and had to rediscover it. Another truth about the secret: over time the secret needs to be refined, just as a clock's inner workings do.

Discovering Your Secret Is a Creative Exercise

Before we get obsessed with change, consider this: How do you build an understanding of the clock in the first place?

First, plan to do this work in a place where you won't be interrupted, at a time when you are alert and can apply yourself for a couple hours at a time—in two-hour increments at least. This is a great job to tackle on a winter Saturday or holiday morning. Most of your work can be done away from the office. I actually made the breakthrough in finding my secret during a transcontinental flight—can't beat being in a prison cell at 30,000 feet for isolation and concentration.

Once you've found a good place, start your thinking process by asking the sorts of questions a six-year-old asks. W. Edwards Deming's "five whys" model is a good, practical version of the many queries I've faced at the hands of my own young children.

Ask yourself, "Why does this business work?" After writing an answer, ask "Why?" again. Keep doing this through the five "whys" and you will have a beginning pile of raw information.

Another way to do this is to ask a six-year-old to sit in and let her bug you to produce answers about your business. Here are the sorts of questions:

- Why does this business work?

- What do we do for our clients?

- What does time or timing have to do with what we do?

- How do we do what we do?

- Why do we make money?

- Why don't we make more money?

- What do the relationships among people, plant, space, location, government and society have to do with it?

- Is there one act at the center of the business? If so, what is it and how is it done? Are there several acts?

What are they, how do they work and how are they related?

- Is there gear or technology at the center of the business? Are there several pieces? How are they related?

- Is there an important place at the center of the business?

- Why isn't every Tom, Dick and Mary doing the same thing and kicking our butts in the market?

- What is our market?

- Who else does what we do? What is it that they do differently?

I am not going to insult your intelligence by filling the rest of the pages in this book with more questions, as if this were an endless word game. I leave it to you to sit down, a few times, when it is quiet, and begin to work the problem.

After going through all of my questions and adding and answering a bunch of your own, you should have a lot of raw data in the form of partial answers or phrases.

Next, pick through this data and compile a list of your business's important attributes. Begin making short phrases that contain all of the attributes you've uncovered. Try not to use adjectives or adverbs as qualities unless they translate into important parts of your process. "Reliable" is a central attribute to Federal Express; it is a platitude when used to describe a window-washing service.

This process is a distilling of all the material you have uncovered during the questioning phase. You should have perhaps a page of important bullet's about your business, consisting of mostly nouns and verbs. After being certain that you have wrung all of the good material from your question-and-answer work, put the project aside for a few days.

Much of the writing about creativity suggests that you first scrounge up lots and lots of data, stuff, skills, whatever goes toward making the end product. We generally do this scrounging without knowing exactly where it is going to lead. Vincent van Gogh certainly didn't know he was preparing to paint *Starry Night* when he first learned to mix the color yellow. He was just gathering information and skill at mixing paints. But his learning about yellows paid big dividends later, as he painted his way through Provence and into the great museums and collections of the world, and he did this on the shoulders of many a wonderful yellow.

There is another part to this creative work: a gestation period for this raw mix of stuff and skills. It seems that one needs to take time and move one's attention away from the raw mix and let it slosh about. This is why I suggest a separation between the data and skill gathering phase and the creation phase. Working at discovering the secret is a creative exercise.

When you revisit your work some days later, review the list again, add anything that might have surfaced in the intervening week and begin squeezing the information down one more time, concentrating the description of your business; the heart and soul of it.

You will probably end up with eight or ten statements that are important, central and special about your company. When you get this far, pat yourself on the back—or let your six-year-old do it. You've gone farther than 90 percent of the entrepreneurs I have known.

Now hold this close for a couple of months and see how it stacks up to life at the shop. Of course it won't exactly do the job, so just add and modify as you see contradictions or omissions from your real operation.

Then sit down and refine it again. At some point, if you are persistent and reasonably thoughtful, you will get pretty close to the secret of your business.

The Best Part

Take the secret and, in a model that takes no more than a single page on a spreadsheet, create a financial engine—probably some sort of pro forma income statement that you can use to calculate the financial effects of manipulating your secret. This is the place where you are forced to translate the secret into a model that scores the cost and income given a certain range of assumptions. It's a second crucial step in developing your set of internal assumptions.

Let's apply this process to the ubiquitous neighborhood lemonade stand. You, as a young entrepreneur, have decided to sell lemonade from a single stand to passing cars in your neighborhood. Since you are keen about quality and taste, you hand-squeeze the lemons and add nine drops of almond extract to each pitcher, which makes the juice taste a little exotic. You save the cored lemon halves and stack them in the shape of a pyramid at the side of your lemonade counter. The sign you've drawn reads "Fresh Squeezed Lemonade Today—Only Two Pitchers Will Be Sold. Two Dollars a Glass."

At the start of this analysis you might have said, "I can sell some lemonade and there is money left over."

After looking at the situation more carefully you have a secret that is described more like this:

- I take a basic fresh lemonade recipe.

- I add almond extract to make it exotic.

- People always remember the taste.

- I can make batch after batch.

- I have a colorful hand-crafted stand.

- I have a sign that says exactly enough.

- I show the fresh ingredients.

- Customers can smell the lemons.

- I limit my production to a level I can handle in a short period of time.

- My corner is good in terms of both foot traffic and car traffic.

- I sell at a price that is competitive with soda pop from a machine.

- I use plastic glasses with lids so people can walk or ride with my lemonade.

In the world of selling lemonade to people in your neighborhood, all this adds up to a very good secret.

Now let's build your spreadsheet and consider some scenarios.

- You scrounged up the wood for your stand and sign (*depreciation* is a word you have yet to learn).

- The paint was purchased from your allowance.

- Lemons are $0.46 per pound, sugar is $0.45 per pound, and almond extract is $3.25 per bottle. Ice is $0.75 per bag. Glasses with tops are $3.10 for a pack of 36.

- Each pitcher holds 64 ounces of lemonade and you can sell 5 glasses with a little left over.

- It takes one hour to prepare one to four batches of your brew.

- You can sell from one batch in an afternoon (two hours) to four batches in a long summer afternoon (three hours).

- You have decided to charge yourself $0.50 an hour for your preparation and selling labor.

Those of you who may have run the numbers in an under-

graduate or MBA program may be getting irritated at this example—way too simple, you are thinking. But let's press ahead and work a couple more options, say two- and three- pitcher comparisons.

Already we are getting an interesting picture. We have almost tripled our return by making two pitchers and selling them. I would want to know this if I were a 10-year-old running this enterprise. I remember as a child being overly worried about the amount of work I had to do in life. Chores were measured in minutes of slavery, as I recall.

Clearly this is a very simple example. Nonetheless, you could examine any of the prices, quantities or assumptions in your secret using such a model. It's easy to be more sophisticated, yet simplicity is one of the characteristics that can make this a very powerful tool. Remember: What we are trying to develop is a strong intuitive relationship between your understanding of the business and the sorts of changes that challenge your decision-making skills almost daily. What would you do if the price of lemons doubled, or how would it affect you if sugar were flooding the market and driving the price down? Should you open a second stand?

Simplistic perhaps, but I maintain that for purposes of bringing your secret to life, a single-page model that accurately depicts the major variables can be worth millions. Furthermore, you could do this for the Post-It division of 3M just as you can for the lemonade stand. In fact, I'm pretty sure that it's been done in one form or another at the Post-It division many, many times. They may have a 50-page spreadsheet, but I am suggesting that you boil it down to one page. Because when all is said and done, you must not only have a visceral sense of what variables are important to your business, but how much each of these major variables tends to affect outcomes. One sheet with all the main variables (no matter how much generalizing this takes) and you have everything

you need for the first full-blown iteration of the secret. Then it is time to test.

First, run the model at differing production or sales volumes. Then test it against actual results. See how accurately you can predict outcomes. In two to three years you should be able to predict changes with uncanny accuracy. Most people I know who have done this sort of work can, in fact, do it in their heads by then. Bingo!

So, let's presume I figured out the secret and worked my spreadsheet prior to 1987 when I went bankrupt. Let's also presume that I was paying attention to the fact that my company's expansion was causing me to confront a $25 million personal guarantee for all that office space we needed at the time. I would have withdrawn my pen and insisted that we find another alternative. You see, a simple analysis of our secret numbers would have shown that the new rent would be way out of the ball park if sales dropped by, say, 40 percent. This may sound catastrophic to you, but our business was one that earned high margins on a few specialized contracts. Dropping 40 percent in revenue was a highly probable outcome. Because our contracts were driven by disputes, they tended to end abruptly and uncontrollably. So such a drop should have been expected. Had I done this work I wouldn't have signed the guarantee. It's just that simple.

It's easy to talk about me, but what have my interviews shown? The magic that others ascribe to successful entrepreneurs seems to be related to the secret. The physical evidence of an innate understanding of a business leaves a track, like streaks in a cloud chamber at the end of a particle accelerator. No one has ever seen a subatomic particle, but many of us have seen the tracks recorded on film plates. This is the same sort of relationship the outside world has to an entrepreneur's understanding of her business. People see the marks of perfor-

mance, of manipulations, of actions that arise from unseen stimuli.

Most entrepreneurs I've interviewed talk about having a "feeling" as to how all of it works—the company, its people, the products and so on. But most of them haven't worked it out in words, and fewer have a single spreadsheet that explains the company's workings.

This extends to the accountants as much as it does to the financially illiterate; in fact, the financially illiterate, like blind people, have heightened their other business senses to compensate for the fact that they don't "see" numbers. There are also many entrepreneurs who would say that accountants are themselves financially illiterate, but that's another story.

Two Peculiar Things About the Secret

There are two peculiar things about the secret. The first: it is often geographically specific. This means that although you may be able to sell lemonade on one particular street corner, you face different problems selling it from another street corner. Second locations, branch offices and split facilities are among the more severe speed bumps in an enterprise's existence. Of course, many companies work and sell from many locations, but changing or adding locations requires significant alteration to the secret itself. Changing geography is a fundamental change in the business and should be treated as such.

Robert Townsend, in his book *Up the Organization*, hinted at this by asserting you could take the distance between your present location and the new location in miles, square that number and arrive at an approximation of the number of problems created by the move. Yes, the Internet and telecommunications mitigate some, but only some.

The second anomaly of the secret has to do with the effects of success. The wildly successful business eventually generates a lot of cash. There is a serious business theory that suggests this cash be invested in some analog of the successful business in order to create an entity with greater diversity, and therefore, greater stability. That's one interpretation. Another is that you have just won a jackpot at blackjack, and you can now have greater stability by continuing to play blackjack with half your pot and opening up a position at the craps table with the other half.

Las Vegas and its casinos have grown at staggering rates over the last 40 years; dramatic testimony to the effects of a simple risk-diversification strategy. But most real business isn't a table game. Its rules are less clear.

I've seen the diversity trap triggered in three recurring ways. The first and most common is real estate. The entrepreneur makes a great pot, then decides to invest in real estate or become a developer, and either the market goes south or the project becomes too expensive—there are many ways this can happen. The second permutation has the entrepreneur enter a new industry believing that capital is the only resource necessary for another great business. The last area is to invest in securities—usually risky ones—believing that having money begets having more money.

All three of these traps turn on the same fatal flaw. The entrepreneur has used a hard-earned secret to earn money and then overcomes the need for having a secret in the new area of endeavor. It seems absurd to suggest that successful people would fall into such a trap, especially after working so hard to earn the bag of gold in the first place, but it happens, and more often that you might imagine.

Having a secret doesn't give one any extra edge in other commercial endeavors. Marketing consultant Mitch Gouzee says to successful entrepreneurs that they can go into any business in

the world. The only caveat is that the cost of succeeding in the new enterprise is exponential to the distance between the new undertaking and the entrepreneur's strategic center; "so you can do whatever you want, just don't run out of money," he says.

Thus, once discovered, molded and nurtured, the secret becomes as much a part of your business intelligence as being able to sign a payroll check or make a deal. Wayne Huizenga, a man who *Fortune* magazine says has done more than 1,000 acquisitions in his business career, recently began a third empire—after Waste Management and Blockbuster Video—by purchasing a relatively small Florida-based garbage company. At this writing, he is adding all sorts of disparate types of business units...including a chain of giant car dealerships and a home-security-system empire.

Huizenga explains his starting with a garbage company by saying, "This is a business we know and understand." Indeed, he does know the secret of that business—front and back. My guess is there is a great cash cow in there somewhere, one that Huizenga understands how to get at better than most. What could be more useful than a reliable cash cow for financing the discovery of the secret for this new enterprise?

From the outside of an entrepreneurial venture, one can't easily see the secret. In fact, what can be seen from the outside is often misleading. But from time to time there is convincing or suggestive evidence of some important underlying presence suggesting the secret. Huizenga's acquisition is one such example.

Here's another: I know of a fellow named John who is the son of a jeweler and the father of a burgeoning jeweler. John also has several uncles, brothers and sisters who enhance the family's retail jewelry credentials in their region of the country. Separately and

together, family members have owned a small chain of jewelry stores and they have prospered. If you have time and are interested in an eclectic and surprising type of business endeavor, talk to someone who has been in diamonds for three generations.

While talking to John and learning about the glitz and grime of the New York diamond markets, I couldn't help notice a very large diamond set in yellow gold flashing back at me from his wedding finger. I commented on the diamond and received the following response: "Oh, that's an imitation. I don't wear real diamonds, I sell the real ones to 'them' so that I can buy waterfront property." There's a secret in there, one that is working for the third generation of John's family, many of whose homes are built on waterfront property.

Knowing the secret is a wonderful thing, yet people rarely understand it, including your employees. At the heart of your stump speech about the business lies the secret. Behind all of your exhortations for better, faster, cheaper is the secret. Yet it doesn't translate easily. I have little advice to offer about this other than to say keep working at it, keep exhorting, keep sharing and trying to transplant snippets of it to others in the organization.

The challenge is to discover and use the secret; but for long-term success, *using* it means more like *sharing and spreading the word*. Alas, even in many successful businesses, much of the secret remains, well, secret.

At the head of our list of core tasks for a successful and happy entrepreneur is survival. The secret is the place you go when the survival of your business is threatened. By focusing on the secret and using it boldly, you have the greatest probability of overcoming life-threatening adversity.

One last point. Over time the secret changes. When we first discovered how to retrieve documents reliably with hand-

written indexes, we had one type of secret. When we learned how to use a mainframe computer to help retrieve documents, we had another type of secret, and when technology put PCs on every person's desk, we had a different secret yet again. Part of having the secret is reviewing it and updating it as life and your enterprise change.

To indulge in just one military metaphor: the secret is a killer tool, the mother of all entrepreneurial tools.

Tools of the Trade

Here is another way to keep the secret fresh and working for you.

Do a yearly personal inventory and assessment.

Later in this book, we will discuss the particulars of doing this. Some of my more successful friends submit to this type of self-analysis every six months. This work is a retreat activity (as opposed to updating your To Do list).

An important part of the retreat and personal assessment is to review your understanding of the secret. Test it against known results, play the devil's advocate, bounce out of the box and take a look at your assumptions.

Based on this work, you should make whatever changes you see as being necessary to nourish the secret.

This work certainly should be done before you prepare your company's yearly strategic plan. As an entrepreneur you should have a good grip on the secret before you begin to plan another year's business activity. It is, after all, your secret.

Leap of Strength

Entrepreneurs and Managers

Of all the interview material I compiled while writing *Leap of Strength*, none surprised me more than the resistance among the interviewees to being labeled entrepreneurs.

"Oh, I don't think I would call myself an entrepreneur really. I'm just a guy trying to run a business," one of my more stubborn subjects equivocated.

"A business you founded, though, right?" I prodded.

"Well, yes, founded and own; but I'm just riding the thing. I'm pretty sure I'm not an entrepreneur or anything like that."

"So you created the company from scratch; this is the second you've founded, as I recall, and you run it, it's yours—and with all that, what would you call yourself?"

"A business guy, I guess. You know, I just don't think I'm an entrepreneur."

It might surprise you to learn that this particular interviewee has a personal net worth in excess of four million dollars, is not afflicted with terminal modesty, runs his operation in the mode of a benevolent despot and has a college education buried somewhere underneath all of this confusion about labels.

It's easy for me to have the last word and just assure you he's an entrepreneur, because he is. If I were to ask him whether he is a man or not he would respond quickly and clearly that he is, you can count on that. If I were to ask his mother's maiden name, he'd reply accurately and crisply. So what is it with denying

what he truly is? And why did I get the same uncomfortable response from many of the other entrepreneurs?

It seems merely a matter of confusion. As I explained earlier, there is very little shared information about the job of being an entrepreneur. So little that even the people who are unqualified successes don't know how to catalog themselves. This disconnect by itself is hardly worth a whole chapter. Who cares what this multimillionaire calls himself? He doesn't seem to be troubled by semantics. He can call himself anything he wants. Beneath the label, what does matter is that he can execute a role. And the central purpose of this book is to tell others about how successful entrepreneurs did what they did, got where they got and made what they made, not to insist on the label.

Whatever he calls himself, I want to dissect the process and lay it out for those who are learning the trade. "Aw, shucks, it's nothin'" doesn't cut it.

Sutton's Rules of Entrepreneurs and Managers

I'm only now getting to a discussion of entrepreneurs and managers because it doesn't seem to be much of an issue when you are starting out. It becomes an issue after you have cleared a few of the early hurdles, made some deals, located a river of cash and settled in to run a company in earnest.

The distinction between entrepreneurs and managers doesn't matter to the sole proprietor who has no employees. But once you take on an employee or two and begin to realize the benefits of distributing the workload, the distinction between entrepreneur as a class and manager as a class (and workers for that matter) becomes very important.

Entrepreneurs are the people who start, significantly expand or transform an enterprise.

This is Sutton's first rule of entrepreneurs and managers. It should not be earth-shattering news. Henry Ford, Anita Roddick, Ross Perot and Mary Kay Ash, for example, delivered the initial spark and vision for growing their businesses. No manager could do this for them. And that brings us to the second rule— a corollary of rule number one, with a twist:

Every business needs management, but managers don't found, significantly expand or transform businesses. Managers do, however, run most parts of most businesses.

In our Maalox story in Chapter 2, our hero builds up the herd and hires herders to manage the larger flock. By doing so, Maalox is handing over a management role to people who will oversee parts of his growing enterprise. This is a healthy pattern; in fact, I suggest it is the key element in the rule of entrepreneurs and managers.

Entrepreneurs do the work of entrepreneurs, while managers manage (and workers work); the entrepreneur has the responsibility of maintaining the proper balance among these functions. And in practice it is a surprisingly difficult balancing act to accomplish.

At the heart of the rule of entrepreneurs and managers lies the difference between the two classes. This brings us to the third rule:

Good managers often exhibit some strong entrepreneurial traits, but these are only traits.

For some reason, managers rarely convert from being managers to being entrepreneurs—especially within a single business setting. Although you may create an entrepreneurial team, it won't fill the role of the entrepreneur in your business. Only you can do that.

Furthermore, it is reasonably unlikely that one of the members of your management team will be able to replace you as the company entrepreneur. Certainly such succession does

happen, but less often and less successfully than you would think.

Interestingly, your management team members are more likely to become successful entrepreneurs in another business. There is something about stepping out of the management role in one company and into the entrepreneurial role in another that leads to a greater chance for success. Why is this?

Quite simply, managers (for the purpose of *your* business) have no need or opportunity to develop the somewhat esoteric and instinctual skills of the entrepreneur. This is because someone—i.e., you—is already filling that function.

When the business is starting up, the entrepreneur is usually chief cook and bottle-washer, cashier, greeter, parking attendant and so on. Most of the people I interviewed said that their early success was due in great part to their ability to do almost everything. Survival is a deeply rooted instinct. In Daniel Goleman's bestselling book *Emotional Intelligence*, the author explains the significance of the brain stem, that holdover from the age of reptiles, the root of the brain that triggers survival signals—ones that can't be ignored.

In the early days of running a business, the brain stem works overtime. The new entrepreneur's days and nights are characterized by white knuckles and short puffs of adrenaline-fueled breathing. In this condition, it is very hard to know what to let go of—if anything. As Goleman points out, the individual must employ a level of intelligence—emotional intelligence, as he calls it—to properly react in the face of these mental and physical signs of stress.

And how do you do this? Let's move on to the fourth rule of entrepreneurs and managers:

Entrepreneurs are capable of doing management tasks, but they often do these tasks inefficiently and poorly.

For each joule of energy that a good manager requires to get the job done, an entrepreneur may have to find 10 joules to get close to the same result.

Learning Your Lessons the Hard Way

Some years ago a client awarded my company a very large project with the stipulation that I be part of the project team. I wouldn't run it personally, but rather act as liaison from time to time. This was a big and dicey bit of computer work coupled with complicated administrative processes. I agreed, assigned a team to the job and sent them on their way.

Following my own four rules, I went about my business as an entrepreneur until about four months later when the client called, asking for an emergency meeting regarding her project. I pulled our team leaders together and was treated to a litany of complaints detailing false starts, mistakes, misunderstandings, slipped dates, high costs and discord. I responded poorly and hit the roof (shouting and gesticulating in a legendary blowout). Afterward, I attended the client's emergency meeting, bought some time and decided to roll up my sleeves and *fix this goddamn thing myself.*

Two days later, while wading into a full-fledged witch-hunt, I was confronted by the three senior project team members. Their spokeswoman, who, I am convinced, was a therapist in a past life, told me quietly but firmly that they wanted an emergency meeting of their own—with me, now. She closed the door and the three of them, grim-faced, sat down in my office. "We have been working on this project for three months," she began calmly. "We have booked thousands of hours of work, we have been dancing to every tune this client has played and although there are some problems, you are not helping them. In fact, we, the three of us, have

been designated as the committee to hit you over the goddamn head!"

She went on to describe the difficulties they'd encountered in this project and how they planned to deal with them. She then rather crudely described what my interference was doing to their efforts. I recall her using words like "destroy," "sabotage" and "permanent injury."

I calmed down and withdrew from the project. Our team was, in fact, well on its way to bringing the project home successfully—without me, I might add. Within a month I was back meeting with a happy client.

We worked for three more profitable years completing this installation and providing a lucrative service to everyone's gain. The committee that had been assembled to hit me over the head taught me a lot about my own management skills. What they correctly pointed out is that we succeeded when they managed and I...entrepreneured.

They were right. And being forced to relearn your own rules—when you get over the humiliation—can be an invaluable experience.

Be Willing to Change Your Perspective

At the University of Washington business school, I took a class in microeconomics. The 10-week course was primarily dedicated to the relationships created between supply and demand. Our final exam consisted of eight questions, and we were given three hours to complete them.

I read the first question, which asked something about the meaning of a certain slope of an arching curve. Filled with adrenaline (and caffeine), I ripped open my exam booklet and started speedwriting. There was a lot to say about this curve.

After scribbling through two pages I vaguely recalled that seven more questions remained. Still, I wrote on.

There was so much to say about this one curve, the subject of question number one, I could easily blow at least an hour before reaching question number two. So I froze. I could see myself flunking the course. This made me sweat and I exhaled in exasperation—I was screwed!

Flunk microeconomics, kill a good grade point, and they cut your GI Bill because you aren't performing. I'd ultimately be out of school without a skill. I'd become homeless, live in a Dumpster, then die with the taste of rotgut in my mouth. As I was going under for the third time, it hit me. There was a way of showing all that needed to be said about this curve and its slope. I could use algebra.

I went for it, figuring what the hell; it was better than a Dumpster. In 10 minutes I had written the equation and performed a simple calculation that told the whole story (of the curve, not my demise). I then went to the next question. Lo and behold, I was faced with the same dilemma. I could answer the question using prose, writing out all of the meanings of all of the permutations, or I could make an algebraic statement and manipulate that statement to answer the question.

I finished the test uncomfortably early and headed for the proctor's desk, passing my fellow students, many of whom were frantically filling page after page in their test booklets with descriptive prose. I gulped back a nauseating urge to run back to my desk and try to write all of the answers out, to get as far as I could with words.

Perhaps the test was some sort of morality exercise where the mean grade for the exam was intentionally set to be 25 out of 100, and where those who tried the hardest by writing the most would receive some special reward, I fantasized. Well, the

mean on the test was 25, and I scored a 95, which gave me an A for the exam. There was no special reward for trying hard. Notably, only three in a class of 30 students approached the questions using algebra. And we were not the three best students in the class—by a long shot. When the test was returned with a red 95 circled at the top of page one, I felt like I had gone to Las Vegas with a nickel and won a whole casino.

At the heart of this miracle (which occurred in the middle of an average academic career) was that I was forced to reframe the question, largely because the problem couldn't be solved as I initially apprehended it.

This reframing caused me to shift my point of view, to move to a position outside of the perspective held by most of the students in our class. And from this place the puzzle could be solved in the allotted time.

The rule of entrepreneurs and managers is a continuing reframing, a shifting between the point of view held by an entrepreneur and the points of view held by managers and workers. This shifting is necessary because the entrepreneur is ultimately responsible for the outcome on behalf of the whole enterprise. But she must also ensure that entrepreneurship, management and work are practiced in a dynamic balance, one that adds up to good work and a decent financial return.

That said, I offer you my last two rules of entrepreneurs and managers:

The successful entrepreneur who aspires to become a great manager may be condemning his/her business to death.

And:

The great unifying principle of this paradox is that a good entrepreneur must understand, accommodate and nourish good management, as opposed to becoming a manager.

The Paradox

The most successful working business model is one in which the entrepreneur and working teams operate in a symbiotic relationship. The most successful entrepreneurs are great deal-makers and leaders in their organizations. Managers and others do virtually all of the work in this model.

In other words, the unifying principle of this paradox between entrepreneurship and management is that a good entrepreneur must understand, accommodate and nourish good management without becoming a working manager. Because this is a daunting challenge to any growing organization, I catalogue entrepreneurs as the artists of business. Many of the tools that advance an artistic process are integral to the successful entrepreneurial process, too. An artist may paint a picture using several different palettes, mediums or perspectives to get just the right effect. A musician may arrange a bit of Mozart for a rock and roll band, tempo and all. A writer might discover the end of her story while watching the Three Stooges on TV. Parallel these images with Steve Jobs and the iMac, Lee Iacocca and the Ford Mustang, Bill Gates and Windows or Steve Case and AOL.

Consider the image of a speedboat roaring out into a great lake. Imagine your vantage point is a thousand feet above the boat. The wake created by the boat's progress extends back from the bow, forming a large and growing triangle. Now imagine the triangle is a growing business, you are the boat pushing out into the unknown and the entire space within the triangle is filled with managers and workers who support and drive this developing shape—your company. The shape will not grow if you slow down or turn around. The shape will not grow if you can't figure out a way to keep filling it with managers and workers (preferably work teams).

The simplistic description of this is delegation. The real process is more like reframing over and over, while pushing ahead out into the lake of your marketplace. The trick in building the triangle is to delegate to entrepreneurial teams who will also delegate, so that the base continues to grow and support the rest of the structure.

For although you are the top of the triangle, cutting into uncharted waters, and at the tip of expansion and innovation, you can only go as far as the base can support; your speedboat is refueled by the successes beneath you. This population of managers and workers is absolutely necessary to your continuing journey, just as your journey is absolutely necessary to their continuing employment.

Tools of the Trade

Here are some exercises to assist you in implementing the rules of entrepreneurs and managers.

1. Audit your time

After you've read this book, audit your time for a full working month. Take a daytime planner and carefully account for every minute of your workday. Be sure to note exactly what tasks you performed. At the end of a month, tabulate how much time you spent working as an entrepreneur and how much time you spent as a manager or worker.

Based on your time audit, lay out a plan to delegate all of your management or worker chores. This may take a year or more to implement, as you will no doubt be hiring, promoting and restructuring your staff to accommodate this change. You should be able to do all of the work of a CEO/entrepreneur in about 20 hours a week.

What you do with the rest of your time is up to you. This issue of time and its utilization fills volumes, but the best ap-

proach for you as an entrepreneur is to move from the position of an operative in the business to an investor in the business. The extent to which can do this, of course, depends on you and the business.

2. Build an executive team

As soon as there are more than one of you making decisions about the fundamental operation of the business, resist the urge to structure a command-and-control process. Start right out building your entrepreneurial executive team.

This team might include from two to perhaps 10 people who are running key parts of the business. In the best of settings, the team will take at least a year to mature, and while it does, you will continue making many decisions about the day-to-day operations of the business by yourself.

At the end of a year, however, you should not be making decisions about operating the business; the team should be doing all of this. You are a member of the team and you have one equal vote among the others. The team should meet once a week for an hour or so. It should discuss only matters relating to running the business. All detail or long-range work should be done outside of this weekly meeting. Presenters at the meeting should come prepared, and presentations should be documented and illustrated so the team can deliberate and evaluate issues efficiently.

One caveat about this executive team: as the business grows, some members of the team may not be able to keep up. This seems inevitable, especially in periods of rapid expansion. Members of the executive team must be evaluated—preferably by the team itself—at least once a year.

Members who can't keep up with the company's growth should be encouraged to surrender their seat on the executive team to a stronger candidate, yet be allowed to continue working in the business.

3. Meet with each member of your executive team

While forming an executive team, ritualize a one-on-one monthly meeting with each team member for one hour. This is a private session in which you discuss the business, your relationship and matters of mutual concern. The team member (department head/team leader) should come to the meeting with a prepared agenda and you should do considerably more listening than talking. The aim of the meeting is to keep you in sync with each member as an individual.

You should guarantee the confidentiality of your discussions so as to allow for an honest exchange. This is not a social event; it is not a time for you to take over the conversation with stories of the past or to in any way divert the communication away from the company and the jobs at hand. The phones must be off, and both of you need to devote full attention to your monthly hour together. You should be spending part of your time discussing long-term strategic issues and how you can improve your one-on-ones.

At the end of the meeting, you should both review action items arising from your discussion and commit to their performance. Once you have become comfortable with the one-on-one, your executive-team members should begin holding one-on-ones with their direct reports as well.

Find Your Vision and Build a Culture from It

Because business success combines individual effort, market interaction, and external factors, an exceptional entrepreneur or executive can *consistently* anticipate what consumers want. One hit can be luck. Two hits can be a fluke. But steady success requires (among other things) a particular ability to understand the good or service a company provides and the needs of the consumer.

This particular ability, this *vision*, is the reason that someone like Steve Jobs can come back to Apple Computer after 10 years away from the company and quickly turn out a successful computer model like the iMac. It's the reason that someone like Donald Trump (considered a vulgar man by many people who know him) can turn around his highly leveraged real estate empire while the market is down and other developers are going bankrupt.

People like Jobs and Trump ride in Gulfstream V's and build nine-figure net worths because they see trends and sense value where others don't. This doesn't mean they are nice guys; in fact, visionaries often aren't. But it does mean they can create value.

You may never have your own GV; it's not necessary to corporate success. But to succeed in any business you will need to have enough vision to understand your product or service and what it means to the people who use it. This process is the essence of creating value.

On a more philosophical level, I would argue that vision is the ability to imagine vividly and realistically. This isn't a matter of conventional intelligence or charisma. Being smart does help and being smooth can—but they don't make up vision. At best, they supplement it.

Following the philosophical theme, I argue that vision is the ability to synthesize the things you know and the circumstances around you. Book learning isn't enough and street smarts aren't either. You need both. And you need to be intellectually nimble.

The rest of this chapter deals with how you can attain vision.

Vision is a tricky thing. Its conceptual cousin, *delusion*, is a false belief held in spite of indisputable evidence to the contrary. There is often a fine line between vision and delusion—how fine a line depends on your point of view.

A Clear Vision Is Necessary

When I told my friends that I was building another business on the ashes of the bankrupt one, they must have thought I was delusional. Although the line between vision and delusion is often fuzzy—especially when these terms are applied to entrepreneurs—I promise you, entrepreneurs without vision don't stay entrepreneurs very long.

There are lots of myths about entrepreneurs—usually propounded by people who aren't entrepreneurs. The most common I've heard is that entrepreneurs are born with a special vision—a muscle that others don't have or a third eye that sees things invisible to the normal naked eye. This idea makes for good reading but doesn't stand up in my experience.

My belief is that the tribe of entrepreneurs is composed of people who are equipped with the same set of muscles, eyes

and genes as the rest of humanity. Vision can't be explained so easily.

Howard Gardner, the psychologist and writer, suggests that intelligence comes in at least eight categories, and that our reliance on IQ as a measure of intelligence belies life's complex paths and its many definitions of success. His current list of intelligences includes linguistic, logical, musical, spatial, kinesthetic, interpersonal and naturalist. The kicker here is that I've known one or more entrepreneurs from each of these categories—people who've acquired a special vision about writing, science, music, art, dance, sports, psychology and nature.

Peter Drucker's observation that entrepreneurs come in all shapes and sizes is correct. Furthermore, it is a mischaracterization to suggest that entrepreneurs are the only ones with vision. We all start with some seed of vision or artistic spark; some of us just use it differently than others.

In fact, vision can show itself in indirect ways; this explains, in part, why many good businesses start by mistake. When I sold my consulting business and started a computer services company, I had no idea what the new business would look like. I had a client, a potential application and access to some computer equipment—*vision*, in the classic sense. Yet it grew and developed nicely, and was later transformed into a large and extremely successful enterprise.

In talking with entrepreneurs about starting their businesses, I rarely heard any of them say, "I had a vision." That's too pompous. What I hear is more like, "I had this interesting idea" or "I had a hunch this would work." The interesting idea got them going but was rarely a part of what later became the vision.

Vision, in short, is a combination of innate traits and external stimuli. It's partly what and how you think; it's partly the

circumstances around you that cause you to think. It originates from figuring things out over time. It begins with experience on the river of cash, at surviving. It comes from early flirtations with the secret and projecting those experiences out into the future.

Vision is acquired and exercised. Like a muscle, it needs to be exercised with work and tolerance for the real limits that the world places on any organism.

Imagine again that you have a bird's-eye view of a calm tree-lined lake. Far below a speedboat pulls away from a pier and slowly throttles up, heading straight across the lake. You are so high that you hear just a low rumble of engine noise and see the boat's wake extending from the bow, back to the shore, forming a triangle. The boat moves farther out into the lake, the triangle grows and the boat picks up speed. While you are the boat, the area in the wake is your growing organization and your view over the bow out onto the lake is your vision. It's not as good as the bird's, but it will do for starters. So you have the vision, you drive the boat in that direction and your business develops in the wake created by this movement.

Better vision comes from more experience. Successful entrepreneurs are often characterized by being able to move above their own organization to the bird's-eye view while continuing to drive the boat of their organization onward. Admittedly, this is a sort of advanced state of seeing—but one worth shooting for.

Someone has to provide both the direction and movement for a business to succeed, and this task falls to the entrepreneur alone. Since most discussions of leadership also talk about vision, there is some expectation that a successful entrepreneur be a charismatic leader. Again, Drucker and others say no. Entrepreneurs come in all shapes and sizes. Vision is a quality

expressed by many types of people, only some of whom may be charismatic.

And the vision itself comes in the most amazing forms. For example, there are companies that specialize and sell only metric screws, others that build only natural-gas pumping stations, make replacement parts for airplane seats, keep track of stock certificates, recycle car batteries, make vegetarian sausage, catalogue scientific articles, rent rags, farm catfish, test soil and so on. From time to time, I will give the odd speech to a gathering of entrepreneurs. My favorite reward is discovering what my audience of men and women have conjured for their disparate businesses. There is always at least one surprise; often there are many.

Defining vision is the most upbeat aspect of all the responsibilities that accrue to an entrepreneur. Who doesn't like to be around a person who looks out into the future and moves toward a dream?

Although I am all for good feelings and euphoria, there's an important caveat about vision and its exchange rate here on the ground. Having a vision is not enough to build a good business—not by a long shot. It's an important quality, but it doesn't win the day by itself. There have been many great visions that, though funded and pursued, were not successful in the real world. Consider the promise of nuclear power, a working space station, television as education, antigravity craft, or even the electric car. Having a vision provides a starting point, but it alone won't get you into business. Note that even visionaries like Christopher Columbus have died poor.

Each promise has its shadow—a shadow that evokes the greatest prohibition to an entrepreneur's dream. "That sounds crazy" or "She's nuts" are the sorts of reactions visionary beginnings often encounter. Since most new businesses fail within four years, one can predict doom with a high level of accuracy.

But people keep lining up to try anyway. Today all of Europe, much of what was the Soviet Union, China, most of the Pacific Rim, the Americas and parts of Africa are experiencing an explosion of entrepreneurship in all sorts of permutations. These people—many without a tradition of entrepreneurial business to support them—have no shortage of vision.

I dare say we are all wired to have and follow such dreams.

On the other hand, I can't help notice that *vision* as a concept has been tainted in the last few years—mostly because business writers and soothsayers have needlessly mystified it. The concept has been used to explain many states of being and successes within organizations. Vision has been suggested as a master elixir for business disease. (My own opinion is that most business disease is remedied with more specific medicine and that the presence of a vision is a characteristic of business health, as opposed to the path to business health.)

Having said this, I don't want to understate the power of a compelling vision. Assume you have a good business idea and some capital. Next, assume you understand your job as CEO/ entrepreneur. You understand that you must survive, make the deals, navigate the rivers of cash, borrow carefully, discover and use the secret, choreograph the rule of entrepreneurs and managers, and build a society and define the seasons. Well, vision gives this collection its shape. Much like using a needle and thread to string popcorn, vision ties the bits together—giving it form, meaning and direction.

This phenomenon of *visioning* and *creating* (making dreams come true) is what has lead me to believe that entrepreneurs are the artists of business. There are many parallels between the artistic process as wielded by the writer or painter and the creative design as choreographed by the successful entrepreneur. There is also a social comparison. Generally speaking, artists and entrepreneurs are both viewed as being a little crazy.

The entrepreneur, however, is more likely to eke out social acceptance than the painter or poet because her art creates commerce and sometimes wealth. This economic scheme of ours affords each participant the chance to embrace a vision, make it happen and end up an economic aristocrat. Fame, power and/or money can exist at the end of this rainbow. A pretty compelling vision in its own right, isn't it?

Tools of the Trade

Here are some tools that can help you acquire and exercise vision.

1. Take regular time for solitude

To some, this concept sounds too much like going to the mountaintop. Most entrepreneurs say, "I can't find time to do what's on my to-do list. How the hell can I waste time on solitude?" I agree, it does seem unbelievable that delaying the demands of a crushing schedule can help with your working life, but it can.

There are long-arc considerations in a business that can't be seen in the daily rush (the old forest and trees doggerel). The vision you have for your company is the longest arc you can imagine. It is the projection of the business as far out as you can see. To get at this view you have to have some quiet time; you also have to be able to step back, reframe to a different power or scale and then look and consider the possibilities.

The vision for your business comes from a synthesis of these possibilities. Stories about artists, scientists and business dreamers are replete with great discoveries that snapped into focus while walking on a mountain path, sitting beneath an apple tree or fishing. Nothing could be more conducive to productive thinking than three or four hours of solitude taken, say, once a week.

A consultant friend, Lawrence King Ph.D., calls this "library time," and suggests that it be added to the schedule (by replacing items that could otherwise be delegated).

Hyrum Smith—the founder of what is now known as the Franklin Covey company—suggests that each person (this would theoretically include entrepreneurs) take a couple of hours a day, preferably early in the morning, for both ordering the day and doing the long-range thinking that vision requires.

And here's a pure vision exercise. After you have figured out your secret, think about its components. Then figuratively throw your secret out as far as you can. Extend it into the future, beyond any bounds you can imagine and see what you come up with. Just like a precious stone, throw it as far as you can and see where it lands. Practice this from time to time. You will find you can throw it farther and farther, and the places this takes you can be very interesting.

2. Read history and biography

As I have already suggested, my greatest personal inspirations have come from reading history and biography. When I reflect on an inspirational stick-to-it tale, I immediately think of Winston Churchill leading his country through World War II—after having been shunned and forgotten for almost 20 years. Several hair-raising stories of women who crossed the West on foot along the Oregon Trail also come to mind.

Consider the story of Helen Keller, a woman bereft of sight, hearing and speech who gave the world many books. The most famous, *The Story of My Life*, is a body of speeches and lectures, written on behalf of disabled people, with a searing vision of human potential. Her relationship with Annie Sullivan alone speaks volumes about inner strength and compassion.

Building a Society Out of Your Vision

I remember sitting in a cramped semicircle of desks at the University of Washington business school. My fellow students and I were working a case study in a class titled Administration Organization (Ad Org). The focus of the class was organization theory. Our task that day was to take an organization chart that had been prepared by top management and understand the vertical and horizontal relationships between the boxes, each of which contained both a title and a name. We read a packet of materials that described these people and their interactions with one another on the job and, in some cases, outside of work. Given this supplemental view of the relationships among members of the management team, we drew the "real" organization chart.

Our chart placed the administrative assistant to the president in the second most powerful position in the organization (what a surprise!). I remember wondering why the gods of curriculum didn't just send us all to the psychology department for a quarter, then to the sociology department for a quarter. In my mind, this would provide us with all of the tools we would need to arrive at the right answers. Years of hassling with organizations in my own businesses haven't changed my mind about this.

People act like people whether they are at a picnic, at a basketball game, in a bomb shelter, pumping gas, feeding a baby or working in an office. Psychologists and sociologists have been studying people and their behaviors, habits and relationships for centuries. I'm pretty certain social scientists can do a fine job of instructing us business types about how people behave in a work setting. This bridge across disciplines should be welcomed in both camps. And as a CEO/entrepreneur you can use these social markers to your advantage. If it feels like a lot of power, it is.

Be Careful What You Say and Do

Janet is a very competent business woman. She had a great idea about selling office furniture, executed it cleverly and succeeded well beyond her wildest expectations. As a result, however, Janet found herself working at such a frantic pace that she feared becoming sick and losing it all. Even though the business continued to grow and succeed, she was constantly afraid that she wouldn't be able to hold on to what she was building.

These fears brought us together in what developed into an animated conversation. We were eating at a windowless, underground Seattle restaurant with lots of booths chaotically angled along the walls. Each booth was separately lit so the room itself remained dark, with matching ligneous walls and planking on the floor. I never cease to think how this cheerless setting matches a city that's notorious for grim weather and climbing suicide rates; and yet, this restaurant cheerfully advertises itself as a place to patronize. Go figure.

Although her health gave her considerable concern, what tipped the cart for her was the coincidence of two seemingly unrelated vignettes that had been played out within her organization.

"You won't believe what happened to me," Janet began. "My goddamn accountant misreported our numbers to the bank. He misreported our earnings and for an afternoon the loan officer thought we were out of covenant. They were preparing to call our notes. He was wrong—dead wrong—and after I got the bank squared away, I rounded on him in my office. I closed the door, fully intending to have a quiet conversation about his screw-up and to try to find a positive path forward in dealing with it. Well, I just lost it, and at one point shouted at him, 'You are a humungous idiot. If you had dynamite for brains, you couldn't blow your nose.' "

I started to laugh, then swallowed my mirth. Janet wasn't feeling funny about the story and she wasn't finished with it either.

"So, Walter, flash forward three weeks," she continued. "I was in our Woodenville warehouse [30 or so miles from the main office], wondering how we were going to move some really awful mustard desks, when I hear a crash from the loading bay. I walked over to see what had happened and heard the warehouse superintendent scream at a truck driver who had smacked the loading dock with his semi: 'You humungous idiot! If you had dynamite for brains, you couldn't blow your nose!'"

Janet sat back in her chair, shook her head and half smiled. "I felt like I was looking into the mirror and seeing the face of a monster—a monster with my own voice. It felt like I was looking at an evil twin."

How does this sort of thing happen?

"I know," I commiserated. "It makes no sense but these things happen all the time; you can't stop your culture from adapting. "

By way of an explanation, I offered the following story:

I once had an office manager, Kathy, who was the most enthusiastic, hard working, demanding person I have ever employed. She started as my secretary (this was back in the days when people actually had secretaries) and, as we grew, her role in the company changed from secretary to assistant to office manager to office protector and ruler.

Kathy was the daughter of a preacher and the wife of a preacher; she knew right from wrong and never met a day that hard work wouldn't improve.

She personified a relentless drive for honesty, effort and perfection and thus, she was a great employee, albeit a little rigid. Oh, there was nothing she wouldn't do to help me move the company forward, but let's just say that she had a presence

and control that made others less appreciative of her nature. People didn't like her perceived authority.

At the time, my children were eight, nine and 10 years old. Every Friday I helped coach my daughter's soccer team. I had taken to wearing my sweats to the office on Fridays so I could sneak out after lunch and do my soccer duties. This pattern repeated itself for three months or so, until the soccer season ended. Some two months after the close of the season, I scheduled a client visit at the office on a Friday and appeared dressed as I would on a normal day wearing a coat and tie.

I asked Kathy to spruce the office up for our client. She said yes, and when she left her desk I noticed that she was wearing jeans. My eyes swept the room—my empire—and noted others wearing a jumble of jeans, sweats, chinos, T-shirts and warm-up suits. I immediately asked Kathy what the hell was going on.

She told me, since I had set the trend of wearing sweats on Fridays, she had drawn up a revised dress code: men wear coats and ties, and women wear business dresses Monday through Thursday. Everyone could wear casual dress on Friday. She beamed a smile of accomplishment as she handed me the memo about this routine. Then she set off to tidy up the office. There I stood, in front of Kathy's desk, holding a copy of our official dress code, speechless!

I later told our client about our history, our successes and made a particular point of the high morale we experienced as a progressive office whose culture extended to a casual Friday dress code.

Sharing this story with Janet, I realized we both had triggered reactions from our employees without knowing we were doing so. As we ate lunch, we were both able to acknowledge how many of our own actions or traits played out in our respective organizations.

As CEOs, we both had influence within our organizations that was unplanned and often unintended. We are all human, and as members of this world, we all want to fit in and succeed. Seeing how actions and words have a huge effect on employees is one of the most difficult observations for an entrepreneur to make.

I'm reminded of a series of meetings that were chaired by my all-time most powerful and influential client. He was from the old guard—a cigar-smoking, Scotch-for-lunch capitalist. He was the chairman of a large public company, and I had been retained to help one of his subsidiaries bail out of a multimillion-dollar mess.

Five of us gathered in his boardroom: Chairman Jack, a much younger version of myself and three senior executives, young men from the troubled subsidiary who had never met Jack. If this had been a rock group, it would have been called Jack and the Spear Chuckers.

Our chief sat at the head of the table, cigar fuming, arms pushed out, asking questions like: Why the losses? When will it end? Who is at the bottom of this? He was almost 70 at the time, wore a shiny dark brown suit and had a full head of white hair severely brushed straight back over the top of his head. He pulled a gold pen from his pocket, twisted it and scribbled notes. Most of the time, however, he spewed cigar smoke, cross-examined and listened.

We four youths sat attentively, timidly; well-dressed and painfully responsive. That first meeting lasted almost six hours and ended only when Jack called time. He did so by passing out cigars and great doses of Scotch. Our second meeting was set in the same room about two weeks later. The four of us spear chuckers showed up with our own cigars and three of us brought gold Cross pens with which to make notes. As I look back, Jack was the template for our behavior.

Although Jack's influence over us was relatively benign, there is a darker side to this, too—if you can imagine anything darker than cigars and Scotch! Peter Drucker says in an interview with *Inc.* magazine that there is no one type of character or personality that dominates among entrepreneurs. These people come in as many different shapes, sizes and behavior types as the population at large.

I have spent considerable time with a number of successful business people whose behavior is mean spirited, derisive and condescending. My last boss, a man exuding abusive behavior, convinced me that anything was preferable to extending our relationship.

These sorts of difficult people run businesses, too. What I've seen is that the personality of an enterprise bears a startling resemblance to the personality of its CEO. Hell-raising begets...hell. That's how it works. A business consultant who works with CEOs tells me that most bosses can't objectively view their own behavior. He videotapes them in meetings, does some editing and uses the highlight tape as a private coaching tool. He tells me the big job is to help a boss get over the shock of seeing his raw abusive looks, grunts, twitches, grimaces and wide-eyed stares on the television screen.

Psychologists also know a lot about motivation, and the results have been known for years: people are not motivated to do good work through fear and intimidation. If you are setting an unhealthy tone in your organization—intentionally or otherwise—you are putting your business at risk.

Here, too, is a paradox. It seems that those who lead successful organizations don't have to be overly charismatic or super soft and fuzzy; they only have to foster a positive environment. The best news of all is that this doesn't have to be driven by a mystical skill or special flair. It turned out that my staff really appreciated the clarity and latitude expressed in our

dress code. My staff thought we were radical (this was in the 1970s) and thoughtful to have casual dress days.

Janet, the office furniture entrepreneur, complained to me in exasperated tones that she felt like a mother bird. She described returning to her office after an exhausting day of seeing clients in these terms.

As the mother bird she felt as if her seven baby chicks assailed her at the door, their mouths stretched open, pink as they screamed for food.

Janet flailed her arms as she spoke, jangled bracelets, jutted her fingers and shifted positions in her chair as she erupted with this story. No matter how hard she sold, they needed more and more.

She was discovering that she was the dealmaker, and her chicks needed a hefty diet of deals to stay alive. Her nervousness and fractured attention span made me feel uncomfortable; she conveyed her anxiety effectively. I could only imagine how the chicks were playing off her mood.

I decided to find out what Janet wasn't seeing for herself. "Say you bring in a big order, what happens then?" I asked.

Janet described how the chicks were first ravenous, then lethargic, then started fidgeting and casting about nervously for new work as panic resurfaced. And she admitted to feeling similarly, caught in a vicious cycle. She had reached a point where even landing a large order didn't give her a sense of satisfaction, because she knew the screaming would begin again as soon as the workload lessened.

Define the Seasons

A year later, I had another conversation with Janet. She appeared transformed. Her demeanor was calm and certain. A beguiling sense of humor popped up throughout our conver-

sation. "I've discovered the seasons of my business, the calendar that drives our orders—at least in this sales range."

It seems in her city, leases for the types of offices she furnished fall mainly into clumps, around the months of February, June and October. Janet decided to set up a flexible work schedule for her chicks so that there would be plenty of work to go around. This simple allocation silenced the screaming almost completely. She restructured the work force, creating a team relationship so that her employees could understand the seasons of their business and take advantage of them. Not everyone wants to work full-time all the time, Janet learned.

So Janet not only discovered an important lesson about seasons and their impact on business, but also about culture. In the course of a demanding year she was able to transform a screaming flock of furniture merchants into a flock that understood its seasons, took advantage of them and worked cooperatively.

Janet sorted out the disorder in the nest by creating a single management service team, which included all of the people in her business (her organization was small enough to do that). So not only was Janet transformed, but her business was, too.

John the jeweler was explaining his business over dinner one night when he casually mentioned that he achieved 80 percent of his revenue between Thanksgiving and New Year's Day. Here is a fellow who keeps four stores alive, stocked, decorated, lighted, insured and tended to by competent sales agents so that he can be present during the Thanksgiving through New Year bonanza.

"What do you do from January 2 to Thanksgiving?" I asked in alarm.

"Wait for Thanksgiving," he answered glibly.

John presented a whole different challenge. He must maintain an expensive store for over 10 down months and sell like

crazy for about a month and a half. For over 30 years John's life has revolved around this calendar. He has never spent Thanksgiving with the family, and the whole family sells and restocks their several stores throughout the long weekend. He has never spent Christmas with his family because the whole family is marking stock for the after-Christmas extravaganza that cleans away most of the marginal merchandise before their yearly inventory, which takes place right after New Year's Day.

All of his training is done in the late summer; buying is mostly done in June, with late summer deliveries. He is able to keep employees occupied the rest of the year with Valentine's Day, graduation day and the June wedding business.

A third example that begs to be mentioned is the construction industry, because that's where I cut my teeth. It's a business that can best be characterized as "one project after another." The working calendar is a function of starting and completing projects. Some of these contracts act like independent businesses, in that they take on a separate life lasting from two to 10 years.

Construction is an innately capital-intensive process, so time is gold. An owner pays the considerable cost of building a project, while revenues are deferred until after the project is successfully completed. This creates a high level of energy and urgency about the work and it often means backbreaking schedules and long hours. The people who build often make huge personal sacrifices throughout the critical times in the construction schedule. I clearly remember having to convince an unbelieving electrical foreman that it was indeed Christmas Day as he rushed to complete vital wiring on a new oil refinery we were building in Washington State.

All three of these examples show different natural cycles that occur in businesses and how the seasonal changes affect an enterprise. As the person charged with defining the seasons

and building a society, you should take advantage of figuring out where these cycles come in to play.

Janet may have worked 75 hours a week but she was willing to give in to her salespeople's desire for flex-time. After all, it was a win-win situation. She had happy salespeople and they had enough work and time off for other interests.

These examples of calendar and culture pale in comparison to the volumes of stories about Hewlett Packard, The Body Shop, Nordstrom, Microsoft, Apple, Marriott and 3M. These models of great businesses have built remarkable cultures and rituals that define their organizations. Their building blocks have helped make them successful and revered.

However, to most entrepreneurs, such stories are not motivational. I hear, "Sure, Marriott has a great child-care program; they're a Fortune 500 company; they have all of the money in the world to spend on that type of stuff."

Pay Attention to Employee Satisfaction

From the perspective of a smaller company, the rebuff appears true. But my own experience and the experience of others indicate that defining the seasons and setting the culture doesn't take expensive sweeping programs as much as it takes a positive and respectful attitude toward the team, a little thoughtfulness, a good dose of empathy and some cleverness. As Janet discovered, all she had to do was ask her people what was important about their schedules and their income in order to solve big issues. The front-line people don't have to understand every nuance of a balance sheet in order to have a sense of how things are going.

In fact, celebrating successes with a cheer—popcorn Fridays, the yearly Easter egg hunt on the factory floor, happy

public distribution of bonuses, giving your stump speech, announcing and celebrating large orders and completed projects—creates culture. Acts done to create a positive culture can increase returns on several fronts. If you build a business with a positive corporate culture, you have achieved a considerable advantage in competing for new employees in the workforce.

People not only work harder for a company that treats them well, but they will choose such a company over others. Since people are clearly your route to success, your culture can be a huge advantage. A happy, better motivated workforce rules! If you doubt this, ask anyone who has worked in a culture that is negative, derogatory or inconsiderate.

The keys to culture are consideration and frequency. Birthday cards, recognition, celebration, contests, popcorn, flex-time, vacation and hundreds of other creative cultural incentives can be offered for almost no money.

The way to achieve the biggest bang for your effort is to be sure that your consideration takes full account of your people's needs and wants, as opposed to your *interpretation* of their needs and wants. Watch your team, ask questions, understand what you can about them and then spice things up.

When dealing with recognition, do everything you can to participate yourself; in fact, participate in all of the celebrations and recognition you can. When you can't, be sure other important people participate. Your presence at a picnic can be much more important than the event itself.

Ah, the old ego. "What fools these mortals be," says Puck in *A Midsummer Night's Dream*. If all of this doesn't inflate the old head unbearably, then you haven't been reading carefully. You are indeed powerful within your organization...but it is an organization; there are others involved and those others make the wheels go round and round. Powerful, yes...infallible, hardly!

Without empathy, consideration, active listening and a healthy bit of humility, you can end up running a dictatorship rather than an energetic team. A speaker on team building summarized it best with the assertion that "human dignity is not an oxymoron."

Build a great and productive culture around an active workable calendar and you will have all the support you need to build and run your business.

Tools of the Trade

Here are some tools to help set the seasons and define culture in your business.

1. Create a time line

Take your business and lay it out against a time line. Figure out the natural rhythms of the enterprise. Then set up your calendar for meetings, strategic planning, training and other periodic activities. Ensure that these important activities reinforce the natural cycle of your business.

2. Look at alternate time arrangements

Look at flexible hours, interchanging part-time work, telecommuting and various shift-work alternatives. Allow employees to wrap their working schedules around pressing life commitments.

Some of the best work done in our consulting office occurred from midnight to eight in the morning. We had a programmer who cared for his child during the day but wanted to work full-time. He arrived home just as his wife was leaving for work, would nap at the same time as his young daughter after lunch, then sleep from about seven in the evening until eleven at night, when he would prepare to come to the office. He said he was so productive because it was so quiet.

3. Celebrate!

Celebrate big wins, little wins, extra effort, even mistakes—and celebrate often. Most celebrations cost little or nothing: a cupcake for good client work, an ice-cream sandwich for a mistake that teaches, a birthday card, a get-well card, a birthday lunch, Friday popcorn, two hours off on a Friday afternoon for a special effort. There is a wealth of things you can do to celebrate. The emphasis should be on frequency, not intensity or expense.

Time after time, workers I interviewed did not remember the big bonus check as much as they remembered acts of recognition, constructive involvement and personal support. Since many smaller businesses are much like families, one should simply treat employees like appreciated family members.

4. Share financial information

Share company financial information. There is plenty of information in your income statement that can be shared without giving away trade secrets. Companies that publish their financial information can use it as an important backdrop and measuring device for improving project and management team performance. Furthermore, many workers have misconceptions, such as the owner's salary is equal to the company's sales. Sharing financials helps avoid such misunderstandings.

Lastly, as the company grows, everyone can see the yardstick by which that growth is being measured and feel a greater sense of participation. If you experience a sudden drop in sales or profits, your project teams will know that, too.

5. Figure out your business philosophy

What is your business philosophy? Sound dull? Well, perhaps. But you no doubt have one; and, if you can articulate it to yourself, then consider expressing it to your employees. Many of them care about your beliefs and guidelines, and a

business philosophy can be an important ingredient in the cement that binds you all together.

6. Give your stump speech often

Give your speech about the future of the business to project and management teams often. Your co-workers can never hear it enough. As we will see in the next chapter, everyone wants to be a part of a dream, and we all work extra hard if we think we can help make a dream come true. In short, your dream becomes, in part, their dream.

7. Consider variable compensation for everyone

This is not a simple step and shouldn't be rushed. But most highly successful organizations tie something like 20 percent to 50 percent of real compensation to job-related performance. There are consulting firms that specialize in compensation. I've found using a specialist at least for the first pass is a wise expenditure. Money is an issue that we all take very seriously, and meddling with compensation almost always raises hackles. Additionally, variable compensation also varies behavior. It is important to be sure that the pull of compensation is aligned with the culture and strategic direction of the business. Properly employed and maintained, variable compensation gives everybody a piece of the action, at least from your employees' perspective.

Build a culture of strong professional support by employing outside experts wherever you can. Consider using outside resources for such specialties as accounting advice, legal support, compensation counseling, strategic planning, facilitation, marketing surveys, public relations and so on. The hard part about contracting for such support is the time it takes to find people who can deliver high-quality services. But once found, such relationships are invaluable. By going outside your organization for this work you can also control cost more effectively and maintain a flatter organization, one devoted to succeeding

at your core business processes. Also, the advice and service you receive from proven professionals is often vastly better and more comprehensive than what you might expect from those within your organization.

8. Say thank you!

We all want to be appreciated for our work. Simply saying thank you is a huge boost to those working with you in the business. And it's free!

9. Consider self-managing teams

Give project and management teams the authority and tools to hire new team members. Team hiring is a way of improving the quality of new employees. At first it is a bit ungainly, but as departments or teams go through their own learning curve, the quality of employees improves and relationships are substantially better; people work harder at adapting to someone they hired as opposed to someone you hired. Those individuals on the hiring team should include subordinates, co-workers and supervisors.

10. Stay close to your heart

Build a culture that is close to your heart, and your pocketbook should be well compensated. My friend, the retired Army general, runs a very formal office with strict expectations about dress and orderliness. But the people who work there know what is expected and he is openly appreciative of their work. They are all prospering and happy.

Leap of Strength

13 Get Out and Live!

After nearly 30 years at the helms of several companies and long after entrepreneuring stopped adding meaning to my life, my wife and I were able to break the golden handcuffs and embark on a bicycle tour in the South of France. For nine summer days we crisscrossed farmlands, vineyards, through bauxite hills; we slept in a chateaux and lounged in the ruins of Chateaux Neuf du Pap. By the end of the tour we were speaking pigeon French, eating cheese at every meal and moving at a pace that was outside of our North American sensibilities. No Iowa town or Nova Scotia village could feel so calm, provoke such serenity or move so slowly. We were concerned only about the freshness of strawberries, the smell of basil, the taste of a soft Rhone red and lowering our road-weary muscles into a cavernous steaming hot French bathtub, at the end of the day.

Our last day out, through a coincidence of acquaintances, Deborah and I arrived at the vacation home of an older Parisian couple who had invited us for Sunday brunch. A party of 12 gathered at noon in the old stone building, a warren of rooms in an old fortress wall with windows. The apartment was part of a greater structure, all stone that meandered and wound around the center of the town. Clavier is a fortress town built on a high hill, and is one of a necklace of fortresses that was built to control the routes to and from northern Italy. The

Romans laid the foundations of Clavier. Our brunch was enjoyed in a room that had served as a stable only one hundred years earlier.

Eating in France is a social experience first and a physical activity second. The Sunday meal is in many ways the paragon of social and culinary events. Whereas a civilized dinner on any other day might take three hours, the Sunday meal will take four to five hours. Other main meals may consist of four or five courses; Sunday's could be seven or eight courses. Other meals are eaten at the dining room table; Sunday's meals take place in several rooms to absorb all of the food, wine and discussion.

About halfway through our meal, we all pushed away from the dining-room table and the remains of a giant paella. We adjourned to the living room for some champagne, standing for a while so as to let matters settle a bit before launching into the serious food. I was alone in a corner, a little dazed, when a woman of about 50, with a strong Boston accent introduced herself.

"Hi there, I don't hear a lot of English these days; my name is Madeline, I live just down the road."

She wore no make up, her hair was straight, brownish-gray and cut at her shoulders. She wore khaki pants and shirt, sleeves half rolled up and a drab olive vest unzipped, with lots of pockets. She pulled a card out of her pants pocket and handed it to me. It had a drawing of an olive tree on the left and her name, Madeline Samuels, and address under the outreaching branch of the tree. Under her name read Olive Grower.

"How is the olive business?" I asked.

"Couldn't be better!" she beamed back at me.

"Well, ah, where do you sell your olives and how did you get into this business?" I was getting a little nervous. Madeline

was one of those people who radiate calmness and such people tend to make me want to jabber.

"Oh, I don't sell olives, I just grow them. I live on a small farm down in the valley, and outside of my house is a great big olive tree, just one. So whenever I am introduced socially, people want to know what I do with my life, so I give them this card."

I was struck by the assuredness of her delivery, the well articulated words of a spokeswoman, body language of a person who knew how to deliver a message—almost any sort of message—with meaning and authority. She caught me off guard. Madeline had lived in Clavier for two years; she loved it and had only returned to Cambridge—her prior home—twice in all that time. She was the founder and past owner of a fashion magazine that had been a financial success. She was the single mother of a 25-year-old daughter who lived in New York City.

"What the hell are you doing here?" I asked after another glass of champagne.

"Growing olives, see the card?"

"No, what are you really doing here?"

"My life really began to change when I turned 50. Something about being 50 makes you realize that you aren't young anymore, and you won't ever be young again. I think that's what tripped the whole parade for me." Madeline told me how the magazine had reached circulation numbers and advertising revenues that were beyond her wildest expectations. She had held the thing through a difficult start-up and grew into an earnings sweet spot that felt like winning the lottery. She worked 70 hours a week—which she pointed out is possible if you add Sunday as another workday. She traveled all over the East Coast, was wooed by big publication syndicates and could buy almost anything she wanted. It was a frantic, heady, whirlwind—a giant success that was also incredibly demanding. She worked

this way for 12 years and then turned 50. That same week she received an invitation to a funeral.

"He was my father's brother. I hadn't seen him since I was a little girl. He'd died and was being buried up in Lynn, just a short haul up the road from my home in Cambridge. For some reason, I thought I should go." Madeline was quiet for a moment. She took a sip of her champagne, and seemed to be thinking about her uncle. I didn't say anything, waiting for what must follow. "And that was the first of what would be seven funerals I would attend in two years," she finally said.

"Seven deaths—relatives, one good friend and a niece I had never met, the seventh. I was standing over my nieces open coffin; she was nine years old and had died of cancer. I looked at her pink dress, her thin but polished face, curly brown hair. I realized it was me. I realized that I hated my job, I hated my life and I might as well be in there with her. I had sacrificed everything—including the opportunity to meet this little girl when she was alive—for my career. As a result, I felt terrible. I was emotionally empty and spiritually devoid. I left the funeral, put the magazine on the block, packed four suitcases, got on a plane and ended up here in Clavier. And so I became an olive grower."

Madeline's story is unusual because she actually got on the plane. Too few do. It not only took the opportunity to make the move (i.e. her grown daughter lived on her own), but it required guts. When Madeline jumped to my end of the entrepreneurial lifestyle spectrum, she went from a person who made her career her life to a person who prioritized other things first. She restructured her life, said "To hell with a career that swamps me," and redefined her goals. Now, she reads, writes and grows olives. I looked at her that day in Clavier and couldn't believe that anyone could have the courage to do what she had done. I

know many people who have built successful businesses who feel just like she felt before looking into the seventh coffin. But I had never been able to articulate or define the feeling. Hell, I'd felt the same way myself. Meeting Madeline was a personal watershed!

The Nuts and Bolts of Getting Away

The *Harvard Business Review* contains a useful section called the Executive Summary in which you can blitz through a precis of each featured article and gather a decent understanding of the subject and its high points—in about five minutes. The executive summary of this chapter is: There is a lot of life out there and even if you are an entrepreneur you shouldn't forget to live it. And thus, the ninth—and final—task of the successful and happy entrepreneur is this: Get out and live!

I've made more than my share of mistakes at being an entrepreneur. But this body of error pales in contrast to the mountain of mistakes I have made trying to live a fulfilling personal life. Don't worry, I'm not going unload my garbage truck of sins on you—at least not in *this* book. But if I were to choose one mistake in particular, I'd select one that many entrepreneurs mention: My intensity had me so thoroughly lost in my role of business owner that little focus or energy remained for the other parts of my life.

As with all big mistakes, the realization of the direction my life was taking didn't unfold in a direct or easily-understandable way. I did many things that were wrong. And my first marriage ended in divorce.

I'd be lying if I were to say that I am anything other than an excessive person. I have a predisposition to action, and I acted often without thinking. My children became distant, I was sud-

denly divorced; I gained weight like a baby whale, but the business grew and I became what others considered successful!

In an odd way, most of my mistakes were roundly endorsed by society. Having money and power pumps the endorphins right up. In the good moments this is as much fun as you can imagine and stimulates the body like no drug I've experienced. So even in this flawed but exciting place, I was convinced I was a living success!

Then, let's say the bottom drops out—as it almost always does. You kick into survival mode. Remember: Survival is the first responsibility of an entrepreneur. But, this can have a narcotic effect of its own.

In survival mode, most entrepreneurs report a sense of meaningfulness that isn't found in most workaday lives. The urgency of a real crisis will make you feel more needed or present—alive! The kind of person attracted to the highs and lows of owning a small business is often the kind of person who takes chances elsewhere in life.

I know several business owners who semiconsciously provoke personal or business crises so they can throw themselves into the breach, one more time. And there's a parallel business issue: Living in a market economy means business is either going up or down. There are few times when you can just sit and calmly enjoy the flat spots.

Most of the time, you are holding a tiger by the tail. It's exciting to the extreme—but it usually takes both hands. And it defies the balance that constitutes a well-rounded life.

But let's take a breath here. At this point in the book we have experienced plenty of the excitement, energy and fear related to doing this job. By now it should be clear to you. Being an entrepreneur is a hard job. This is why so few people actually do it. This is also why most who do it, love it. Happily,

there are some entrepreneurs who find living a life *and* doing this job can occur simultaneously and/or serially, in the same lifetime. This is good news!

The most interesting work I do as a consultant is spend time with entrepreneurs who realize that they are holding the tiger by the tail, but who haven't figured out how to let go without being eaten alive. After 20 odd years of feeding, kicking and growing the beast, you should indeed think twice about letting go and taking your chances with what follows. Even if you aren't eaten by the tiger, you have yourself and your family to face with a major change in your life and lifestyle.

But balance is key. And, whatever the cost, it's something that—sooner or later—every entrepreneur seeks out.

Is There Life After Business?

I once gave a talk to a group of entrepreneurs about life outside of business. About halfway through my talk, a 70-plus-year-old fellow named Jacob attacked me with both barrels blazing. He had been a child of the Depression with stinging memories of hardship: recollections of no food, no heat and no home.

He and his family had survived hand-to-mouth, living for two years on the streets of Kansas City, Missouri. It was a terrible experience and then here I came, some smirky smart-ass dancing around the conference table talking about how there is more to life than a job. He pointed out that I had no idea how it felt to live through a depression, how it felt to be without shelter and unable to get a job. He was outraged at my whole premise. And told me so.

Jacob had started and built a successful carpet and floor coverings distributorship spanning three Midwestern states. He was still its president and he intended to die at his desk. He also

expected that his son would gratefully carry on after him. Jacob had given jobs to hundreds of people and although he didn't understand the younger generations, he knew he was doing good by giving them work and teaching them something about the American spirit of enterprise. "As long as I have a job, I am a man with dignity, self-respect and I have something to offer the rest of the world! What other life is there?" he barked at me. What other life? Good question.

My grandfather lived through similar circumstances and emerged with what I consider a more balanced perspective. Granddad was a dentist who lived most of his life in Erie, Pennsylvania—a town of about 100,000 people on the shore of Lake Erie, 80 miles west of Buffalo, New York. He was a prosperous dentist when the Depression hit.

Depending on who is telling the story, he lost either most of his practice or all of it because of the crash. He had a nervous breakdown and spent two years dealing with his creditors and trying to recover his health. He did both, returned to dentistry, made some life adjustments and tended the teeth of four generations of Erieites.

Much as Jacob expects to, Granddad worked right up until he died in 1972 at the age of 82. When he left us he was a relatively wealthy man who was extremely proud of his career. Back when he was recovering economically—and emotionally— he came to a realization about himself. He learned that he was a driven man who loved his work and that if he could have his way he would work six days a week, 10 hours a day. He loved being a dentist. But the pressure of doing good work and providing for his family was too much for him. He needed time away from work. And so, he created a novel scheme.

He decided that he would work six days a week, seeing patients from 8:30 a.m. until 5:00 p.m. (taking only half an

hour for lunch) for nine months out of the year. Come June 1, he and my Grandmother would pack up the family and drive by car and boat two days north to their cottage on an island in Lake Huron (north of Toronto).

There they lived, cut off from the workaday world, until the end of August when he would return to Erie and resume his busy schedule seeing patients.

For the first couple of years, people said he was more nuts than he had been when the practice failed in 1931. His patients wouldn't tolerate a dentist who wasn't in town for the summer; it was financial suicide, they said.

Well, Granddad must have been a very good dentist. And it probably didn't hurt that he was a cheerful one, too. His patients stayed with him and planned their checkups around his unusual schedule.

Though many professionals do this sort of thing today, in my grandfather's day it was a novel arrangement. He figured out how to successfully place a career within a life—his life— fully realized as a provider, father and man.

So what did my grandfather discover? He discovered *balance.*

Achieving Balance in All Things

Balance is the buzzword of the modern hard-working world. But have we really achieved it? We are working longer and harder, shrinking time by robotically performing a rut of tasks and fulfilling endless schedules. The job of entrepreneur is no less difficult than the hardest professional endeavor (whatever that is). So the precept of the new millennium is that on top of our crazy, task-driven lives we are supposed to attain (and maintain) balance? Get real!

Okay, it's more complicated than reading affirmations each morning, exercising regularly, cooking dinner as a family or taking regular vacations. In fact, I think *get real* is pretty close to the answer. Each of us must work to earn a living; that's an immutable rule in a market economy. Many of us have chosen to work alone or as entrepreneurs. And an even smaller subset of us has decided to start or run an enterprise, whether it be a small dental practice or large corporation.

As I have said many times, I think entrepreneuring is an exceptionally hard job when compared to the job of working for someone else. It's vastly more challenging—and vastly more rewarding if you succeed. Whether you follow Jacob, my grandfather or my path, I believe you should embrace this job because of its exceptional payoff—which can only be measured, in part, as a return on capital investment.

The Payoff

A big part of this payoff is the joy of the hunt; another is a great retirement; another is a financial platform to do something else; another is the freedom to live what you consider to be a balanced life. But I know plenty of people who, despite the extra hard work devoted to the job, don't insist on this payoff. In fact, I know almost as many entrepreneurs who feel trapped as those who feel free. It's one of the dirty little secrets about the job: the state of being lonely at the top can rot to fear, unhappiness, sadness, meanness and a bad taste if you are not careful—money notwithstanding.

There is no reason to do this hard work unless it fits into a life—a life you really want to live. Without this payoff, I don't think the job of entrepreneuring is worth it.

Since much of the work I do is with people who are experiencing cuts and gashes from holding the tiger by its tail, you

might think I believe that letting go is the logical answer to living a life. I don't.

Let's consider Jacob. He has discovered balance in his life just as surely as Granddad did. Jacob is fully realized as founder and president of his company. For Jacob, time away from the office defines hell. If you want to see him smiling, go to the office because that's where he's happiest. I think Jacob is as balanced as he wants to be. I would give him high marks for living a life—mostly because he is content. So Jacob is at one end of the life spectrum: he works to live and lives to work.

I am at the other end of the spectrum. I built four businesses, and the fourth was built so that I didn't have to run businesses anymore. I worked hard so that I could follow my dream career—writing, teaching and consulting. I'm off the tiger with most limbs intact. Some place between Jacob and me is Granddad.

He worked exceptionally hard for nine months of the year and spent the entire summer on that island in Lake Huron with his family. Most sunny days he took a boat out and went fishing, he napped every day, was in bed at nine every night and was a happy, well-rested fellow when he returned to Erie in September, ready for another nine-month push.

The majority of entrepreneurs fall between my place on the spectrum and Jacob's. And there are plenty of workable and believable examples of successful entrepreneurs living rich and fulfilling lives at and away from the office. Still, most entrepreneurs find it difficult to build a balanced life.

When I talk to entrepreneurs, this *living a life* thing is often the hardest problem they face. It's hard for an outsider to believe that a successful entrepreneur might be unhappy or unfulfilled, but it can happen to the best of us—regardless of our public reputation or bank accounts. Society likes to assume that happiness and overall satisfaction with life automatically

come with success. Believe me, this is not true! My experience illustrates this point:

In the last four years I have done more than 300 workshops with over 4,000 successful CEOs. The vast majority (over 70 percent) identify strongly with the phrase, "I have a great job, but very little life."

In this workshop, I give them the imaginary opportunity to leave the business with some money in hand, or to continue on in the enterprise. Over 80 percent choose the option of leaving and doing something new or different, something closer to their dreams. The feelings evoked by this drill are typically described by them as "finally getting a life" or "getting what I was looking for all along."

These men and women are not complainers. They are not resentful about choosing to be entrepreneurs (in fact, most are grateful). These are people who are struggling with balance—people w ho w ant m uch m ore *life* than the job itself accords.

In addition to a decent financial return (or better said, *more importantly* than a decent financial return), you must receive a decent emotional payoff for assuming the sole responsibility for running a business.

A good financial return alone doesn't guarantee living a fulfilling life. More to the point, riches can deceptively inhibit rich living. The clincher for me was discovering that people who do this job solely for money never seem satisfied. It's a remarkable paradox.

According to my psychologist friend, psychology is wasted on the mentally ill—that is, we often ascribe the field of psychology to those seeking mental health. His point, of course, is that psychology is not just for the mentally ill; we, too, can learn from their study of the mind and the mechanics of our psyche.

Take the psychologist Abraham Maslow for example. As part of his rich body of work, Maslow studied people he judged to be the happiest in our society. He calls them self-actualized people—those who can live in a complicated world but simultaneously experience a realistic sense of accomplishment and well being. There are many traits he ascribes to these self-actualized folks, each suggested by the empirical results of his experiments.

To paraphrase, self-actualized individuals are somewhat detached from society yet maintain close ties, however, with a few other people. These people also seem to intensely appreciate simple or natural events like sunrise, while they are deeply committed to solving problems they deem important. They also often experience profound changes that Maslow calls *peak experiences*.

What strikes me about this model of happiness is that it presents a paradox of accomplishment on one hand and an internalized sense of well being on the other. To accomplish is to push, to be relatively self-sufficient, to be energetic and forceful. These are not warm-fuzzy, socially nesting types of traits. Yet, a sense of well being has the elements of being settled, accepted and connected. Tough trick to incorporate all of these elements! I believe it is the nature of this paradox that makes living a life so challenging for many entrepreneurs.

Even the cheeriest advice books don't mince words about the need to face challenges. That's a basic point. But entrepreneurs who have begun to taste some success face all kinds of temptations and distractions. The challenges become more complex.

Doing well in a growing enterprise requires a constant input of effort and skill; so, you can be driven frantically and praised richly at the same time. Furthermore, the actual *doing*

of the job can be a lot of fun—at least in the near term. The result of a whirlwind of impulses; there is a lot of pressure and a lot of acceptance and a lot of adulation as you get cranked up in your enterprise.

Another social incentive is derived from our transformation to a functional society. The greater amount of near-term functionality, the greater the value. Taken to an extreme, this can lead to an inability to delay gratification.

At least in American culture, we are committed to the immediate—socially and institutionally. "I want it all," "Just do it" and "There is no need to wait" are all motivational slogans of today's popular culture. I don't like this culture particularly; in fact, I think it hurts us. But it is what it is and you—as an entrepreneur—work in and get your feedback from this culture. This all adds up to powerful forces which grant you, the single-minded entrepreneur, a wide indulgence to commit everything you have to running a business, to a life that would make Jacob appear a slouch.

But, again, this can lead to unbalanced decisions.

The Standard Profile

I most often meet entrepreneurs who are some place between 40 and 70 years of age, who have been exercising this indulgence for 10 or more years and who feel that there is something missing in their lives. Because they are successful members of our economic aristocracy, because others see them as hugely fortunate and powerful, these men and women are almost prohibited from questioning their lives. And here is the cautionary tale: many of these people never break out of this straight jacket! Many of them cannot risk exerting control over their fuller lives. They can't bear the thought of risking every-

thing by being themselves, people, human beings, souls in the universe, children of some God (if that's appropriate), who just happen to be successful entrepreneurs.

As part of my work I tell stories about entrepreneurs who have hit the wall. The audiences often contain students and working people who want to break out of their current stage in life and go out on their own. Their almost universal response to the notion that success in business does not necessarily translate to a well-balanced life is something like: "Boy, that's a problem I'd like to have. Give me a chance to be a single dimensional successful entrepreneur and I'll deal with it along with the money and the freedom and the Cadillac."

I like that spirit, but I've included this chapter for a reason. Even though *Live a Fulfilling Life* is the last on my list of entrepreneurial tasks, in fact it's the most important. Living a fulfilling life is really the only important task anyone faces. To be a successful entrepreneur, you have to make more sacrifices than a person with a workaday job. Your career will only be fulfilling if you have some overriding reason for making such sacrifices. Those reasons must, in some way, be attached to your heart, your soul and your spirit. An attachment to your pocketbook alone won't do it, at least not in the long run, believe me!

The Grand Canyon

One of the things that happens when you have succeeded, or are succeeding (paying the bills, giving yourself a salary and surviving as a business) is that you begin to feel that if you divert the slightest bit of your attention from the enterprise it will crash and burn. And as your business develops, you imagine you are losing control over your time, and ultimately, over your life.

Deborah and I were trying to break out of this trap, so we took a raft trip down the Colorado River through the Grand Canyon. I divorced in 1979—after a 12 year marriage. Deborah is my wife and partner of 19 years now.

For nine days, you are completely cut off from anything except your guides, fellow travelers and natural beauty. Time seems suspended. Each morning you divide into fours and board your raft for the day. There are 24 in a party so there are seven guides, one for each passenger raft, and a "swamper" who rows a raft with food and equipment aboard. This voyage was a life-changing trip for me, but the part that relates particularly to this chapter regards the guides.

These men and women, ranging in age between 25 and 60, run the river in the spring and summer and most have some other sort of job that carries them from October until May. These other jobs include being a biologist, a ski instructor (lots of those), a teacher, a writer (God, they are everywhere), an airplane mechanic, a restaurant chef, a hunting guide and so on. I came to like all of our guides, as they revealed themselves to be interesting, lively, entertaining, and most of all, content! Most of them were college educated and many had guided on this river for 10 or more years.

Now, I don't know about you, but I didn't think anyone was allowed to go get a college education and then have that much fun in life! These people taught me something about fitting a job into a life and having the whole thing be an appetizing salad of work, discovery, adventure and abundance.

On the last part of the last day of the raft trip you slowly drift into the upper reaches of Lake Meade. The canyon has melted away and there is barely a river channel, a low bank and desert as far as you can see. There is a palpable sense of pending loss; it is a sad time.

While I was contemplating this, Rick, our guide, said, apropos of nothing, "You know what I hate most about this day?"

He dipped his oars in the cool river and took a slow long stroke then let us drift some more.

"Some idiot will pipe up with 'Well, back to the real world...' It never ceases to amaze me: there is always some dummy who can spend nine days and nights in this place and still not get it. What is it with people anyway?"

Balancing the Compass

We all need to pay attention to the mind, spirit, heart and body—our human compass. Healthful living requires a successful working relationship between these four points on the compass. In my view, this sets up a multilevel paradox. The medical community, including everyone from low-caliber alternative medicine warlocks on up to the Surgeon General, suggests that we should take care of our bodies. Our careers, it implies, are mostly a function of the mind.

This talk has an air of profundity—but can veer quickly into mushy gibberish. Who can achieve this body/mind balance each and every day? No one I've ever met. Furthermore, the notion of "balance" seems to suggest that being away from the center is dangerous, which places almost everyone I know at risk. Now, I must admit, many of my friends are way out of balance. This is what makes them so interesting.

Recently, I was giving a workshop to a group of chief executives. We were discussing life and what it might be like without the daily tug from this job. One young fellow stood out in the group because of his deadening moroseness. He was 29, and had just inherited a family business from his father who died suddenly of a heart attack. For three years prior to his

father's death neither father nor son exchanged a kind word, even though they worked together in the same office. The dispute was over the son's choice of a bride.

The old man, Alexander, just didn't like her and refused to attend the wedding or acknowledge that any marriage had taken place. He also refused any contact with his only grandchild, a daughter whose name—Alexandra—was given in an effort to reconnect the family. So when Alexander died his son was devastated. Feud or not, he loved and respected his father and was completely unreconciled with his passing.

This young man was in deep mourning and my guess was he would stay there for some time to come. Furthermore, it seems to me that he would reside there. He must somehow work through his loss or be consumed by it. I believe there are many key moments in life when we hover in one place because we have exhausted our ability to live and thrive.

Say you start a business from scratch. It takes a ton of energy and attention, so you are at the mind of the compass and there you will stay until you can safely reduce your effort in that area. While you are in this phase your relationships, your body and your spirit aren't getting much attention—there's only so much juice in the system. So is there any hope for balance?

Balance is first making sure that your heart and spirit and body are well cared for before you go off and dive into a start up. Often, this involves making some sort of pact with these parts of your life. For instance, letting your partner know that you are both off on this adventure and that your fixation with the start up will be mutually beneficial is a good idea. Also, making it clear that work will take most of your energy for a year or two is a smart move for both the start up and your relationship. And as soon as you can, return to paying more attention to your relationship, put your body back in shape

and tend to your spirit. This is the best balance an entrepreneur can cultivate.

Having spent great chunks of my CEO career out of balance—mostly working obsessively—I was, one day, proudly showing my most recent idea for regaining balance to my friend Larry. The solution as I saw it was to designate the hours between five in the morning and 10 in the morning each day as "my time." Larry looked at the open page of the day-timer where I had marked off the morning hours, targeted me squarely with his gray-blue eyes, put his finger on the page below my mark and asked "who does the rest of this time belong to, Walter?"

With one remark Larry broke a 20-year-old mental logjam. It's all our time and it's all the time we have. By the way, it is also plenty of time to do what we really need to do, only each of us has to figure that out for ourselves. So, *Live a Fulfilling Life* is a central mandate for *all* people, not just entrepreneurs.

When I first read this chapter to a couple of my friends they asked, "Don't you mean a life *within* a career?" Spoken like true, intense builders of value. I most certainly don't mean a life within a career; I mean a career within a life. We, each of us, control the time we are allotted on this earth. Every minute of every day is spent choosing what we do and choosing what we don't do.

I chose to write this sentence. I also chose not to bungy-jump, face paint, sleep, run a marathon and so on.

Larry made this embarrassingly clear to me: It is my time, my choice and my consequences. This truth debunks the main excuse for unbalanced lives: the "I can't help but work obsessively" argument. The balance issue facing every entrepreneur I have ever met is one of working too hard, not of playing, praying, relaxing or exercising too much. Taking responsibil-

ity for the way you spend your day goes a long way toward creating a balanced life.

A balanced life is one that adds up to a centered existence, one where health, relationships and the spirit are proportionate with a career and ego. This doesn't mean that they all get equal time each day, it means that they are all attended to so that you are able to say; "yes, on the whole I am content." Of course, contentment varies wildly from individual to individual, and can vary wildly within a single life.

There are plenty of people who work from waking to sleep and love every minute of it just as there are those who would cringe and whine incessantly at such a plight. There are people who never eat too much, always remain thin and seem to stay fit effortlessly. There are people who spend fifteen minutes on their relationships a month and seem to have abundant ones—go figure! Balance is feeling okay about your own life.

The reason I'm taking pages of your time discussing all of this, though, is that many entrepreneurs don't. They most often just work and work and work until reaching a point of serious and perhaps destructive imbalance (read divorce, heart attack, depression, obesity, addiction, loneliness or just plain unhappiness). Assuming you live through this experience, take heart! You are still able to choose how you spend the next hour of your life!

Tools of the Trade

Here are some tools to help you live a fulfilling life and succeed as an entrepreneur.

1. Allot Time for Solitude and Introspection

This is the time when you immerse yourself in an environment that allows you to read the gauges accurately. The only way you can know if you are getting out of balance is to read

the gauges. Waiting for the seventh coffin seems dangerous to me. I know people who read the gauges while fly-fishing, going to a monastery, hiking, mountaineering, meditating or rafting down the Colorado River. I also know people who get up at five in the morning to pray, read or write in a journal and think about the coming day.

2. Tend to the Opposites

If you find you are spending most of your time in one arena, say work, then consciously add some tasks from the other three points on the compass. Weekends, vacations, parent teacher conferences, youth soccer, 10K runs, golf and pleasure reading are all ways to regain some balance in your life. A little creative rummaging in our lives should produce a satisfactory diet of contrasting (balancing) activities.

3. Understand Normalcy

All lives have coffins. Just because we are particularly successful in business doesn't excuse us from the rest of life. Our hearts, bodies and spirits will, in the end, deliver a regular life. The idea that prosperity somehow insulates us from mortality is one of the great misunderstandings of our time.

Leap of Strength

Part Three:
Valuable Tools

14 Management Tools

I discovered a gem as I poured over my interview notes: "In theory, theory and practice are the same. In practice, however, they are never the same."

The gap between what theory tells us about successful businesses and the practice of building a successful business is large enough to be a wonder of the world.

This chapter presents a collection of tools that successful entrepreneurs have used to build successful businesses and happy lives. I sometimes refer to them as *big tools* because they are heavy, take a lot of space, require considerable time to employ and in return, they give the business big leverage. And they are tools; they will assist you if you use them correctly and regularly. None of the ideas presented here and in the subsequent chapters will make a bad business work. These are merely devices to help a business work better.

So, the trick is to know how and when to use these tools. Patience and persistence must coexist in their implementation. Otherwise, you won't get the desired results and you won't proceed down the path to your vision's fulfillment.

Julia Cameron, author of *The Artist's Way*, describes this effect: She tells of a person who prays for apples day after day, then one morning trips over a basket of oranges. According to Cameron, the trick is to know what to do with the oranges.

The tools in this chapter will enable you to know how to handle and deal with the oranges. That said, let's get to them.

Perform a Yearly Personal Assessment

Consider your direction, progress, aspirations, dreams and goals on a yearly basis. The purpose of such an assessment is to make sure you are proceeding along the right track. Leadership training guru, Stephen Covey, gets at this idea when he cautions against tirelessly climbing a ladder of success only to discover that the ladder is against the wrong building. The desired outcome is to "know thyself," which at the best of times is tough.

This tool is first because it is by far the most powerful of them all. At its heart is an important observation from the CEO workshops. There are two groups of CEOs, generally. There are CEOs who are successful, and there are CEOs who are successful *and* happy. Those who are successful and happy routinely do some form of deep personal introspection, asking difficult questions about life and using the answers as the basis for future actions. A yearly personal assessment is one of the most popular ways of doing this introspection.

Earlier, I mentioned the rafting trip my wife and I took down the Colorado River, which snakes through the Grand Canyon. One of our guides was a chap named Scott. He worked as a full-time guide on the river from May through October, then took a month of vacation prior to reporting to Snowmass ski resort near Aspen, Colorado, during the winter. As a young man, Scott earned a degree in Geology, graduated cum laude and started this life I've just described. When I met Scott, he was 45 years old and one of the happiest people I've ever encountered. I would have never guessed a person could create such a life.

In fact, I told Scott about my long-held belief system: That each member of our society was obligated to finish college, get a real paying job, don a suit and work at that job—anything less, and you were a reprobate and deserved to go before the firing squad. At the time, it was inconceivable to me that I might graduate from college then choose to run rivers in the summer and ski in the winter for life.

Scott had done his own personal assessment as a young man and had made choices about life that drew from a much bigger palette than mine. So this exercise of doing your own yearly assessment is one of creating a big palette, of assessing your life's canvas and of conjuring what's left to create. Above all, the palette must be big enough to extend well beyond the bounds of business.

An Assessment Exercise

Here is one exercise that should help you assess yourself as I described. Think of this process as a kind of one-person retreat. This should take two full days (it does for me).

Go some place where you can be alone, away from any interruptions, and can work for as long as the task takes—until you reach a natural ending to these exercises.

I have taken this retreat in a rented cabin on the south rim of the Grand Canyon, once in the Laguna Nigel (California) Ritz Carlton and at several beautiful resorts. The idea is to be comfortable, alone in a place conducive to uninterrupted reflection.

Session One: Answer the basic question, "What do I want to do before I die?"

Write down everything you can think of—no matter how far fetched. Don't edit, free associate: just write, write, write!

Get out of the box, stretch the envelope, be as wild as you can imagine. When you get tired, get up, walk around and come back in five minutes or so and write some more.

A good list could easily cover three or four pages of lined paper or several computer screens. The medium is not important; use whatever is comfortable. When you feel like you've exhausted what I refer to as your *life list*, look at the list item by item and see if there is any way to categorize the words and phrases. If so, do so. The act of placing items into categories often conjures up new ideas and categories.

Work this back and fourth until you are done. Put the list away for a couple of hours and get some rest.

Session Two: Pare down your life list with the question, "What do I want to do in the next *five years*?"

Using your life list as a source, create a five-year list. Though this list will most likely be shorter than your life list, you may find that it is more difficult to compile. Categorize this list in a way appropriate to you. You may find you need to add more items to your original list as a result of doing this work. This ends day one; get some rest.

Session Three: Make a third list that narrows the focus even more. "If I knew I was going to die in the next six months, what would I do in that time?"

This is, of course, a mental trick, but sometimes it's useful to pretend. If you know you are going to die in 180 days, how will you spend those days? This may be a list, a series of paragraphs, bullets . . . whatever.

When you are done, take a stretch, walk around, then look at your five-year list and your life list in light of your six-month list. Make whatever adjustments you think appropriate. For

example, many people who follow this outline discover in making a "six month to live list" that the first item they write is "write a will." Most people—even wealthy ones—do not have current, actionable wills; make sure this critical step appears on all of your lists.

Most of us do our jobs in part for money and financial well-being. So each year you should measure, on paper, where you stand financially today versus last year at this time.

Session Four: Make a financial review. Consider your three lists and make some projections of what kind of money you'll need to accomplish each. Will you be there?

In this review, you should calculate not only your assets but also your real liabilities—whether they are derived from your business or personal life. Based on this work, you may want to reconsider your life list and your five-year list. Also, assess your estate planning as of the end of the year and make whatever changes you think are appropriate. Be sure you include a legal and tax review in your personal financial plan.

Doing this work should give you a good handle on what you really want in life, what you want in the nearer term (five years) and what you need to attend to immediately (six months). You have a good view of your financial condition and expectations. Finally, there are two reinforcing steps left.

Session Five: Reinforce your conclusions.

Put your lists away in a neat package marked *Yearly Personal Assessment.*

Read your lists: For that's all you have to do. Take four hours a quarter in a quiet place and reacquaint yourself with what you discovered and committed to during your yearly personal retreat. Mark appointments on your calendar and

keep these appointments with yourself.

There are many other ways to approach a personal assessment. For example Franklin Quest Time Management seminars proscribe techniques that are very useful and powerful. Any of the Stephen Covey processes will also guide you toward a considered future. The key here is that you think energetically, optimistically, critically and seriously about what you want from life. Then take your thoughts—however you organize them—and compile commitments to make your dreams come true.

A personal assessment such as the one I have described here is the first step toward integrating your career into your life. I found from my interviews of successful entrepreneurs that those who are the happiest—in both work and life—possess a clear sense of self and direction. Most of these people understand the differences between a career and a life, and the most successful were sculpting *lives*, not careers.

Conduct Yearly Strategic Planning

I discovered the wonders of strategic planning during a talk given by a friend, Rick Flatow, to a group of CEOs. The first thing I wondered was why Rick hadn't told me about his notions on strategic planning sooner. But after I got over his treachery, I sat mesmerized during his three-hour presentation.

The idea that you can project three to five years into the future shocked me. It had never dawned on me that you could actually plan things in a small business.

My experience with a growing business was that it was a free-for-all. We seemed to be operating from one micro second to the next, putting out fires and hoping to make the next micro second better than the last. My grandmother would have called this "close work." Assessing and planning weren't any-

where on the radar screen, or so I thought. Then along came Rick, who presented the dream of a quantum shift in our thinking and what ultimately became a whole new culture for our company.

Since you are carefully following the instructions presented in this book, you already know a lot about what you want from your life and business.

This means you are ready to check out some of the literature on strategic planning. I suggest *Creating Strategic Change*, by William A. Pasmore; *Choosing the Future: the Power of Strategic Thinking*, by Stuart Wells; and *Creating & Implementing Your Strategic Plan* by John Bryson and Farnum K. Alston. I also suggest you talk with your CEO peers. Learn something about the many processes that are available because your first step in implementing a yearly strategic plan will be to find an outside facilitator.

Remember: you are looking for someone to create a process, not to write your plan for you! You and your management team are the only ones who can write a strategic plan that is worth a hoot. But you will need an outside facilitator to drive the process.

I could easily fill three separate books describing different approaches to strategic planning. But this is more than my publisher is willing to tolerate and it is also a lot more than you need to know about selecting a facilitator and setting appropriate planning expectations. Thus, the following is a brief synopsis of the minimum elements of a good strategic plan and planning process.

The Planning Team

Your strategic planning team should include at least enough people from your organization to provide expertise in each

important business and function. So, even though you can't stand all of that human resources stuff, you must include at least one senior person who understands the people issues of your business. The same is true for finance, accounting, production, sales, marketing, R&D, administration, information services, compliance and so on.

The people you choose for the first planning cycle should be the most senior or most competent people in each of your business functions. In my first consulting company there were three executives who covered all of these bases. In my largest company our planning team grew to 10 people. I'm not bragging, but rather trying to show you that coverage is important and, of course, teamwork.

If this is your first strategic plan, your team will be recruited from within your company. Your chosen facilitator will be responsible for preparing team members for the planning session, which typically takes place at a facility other than the office and may last several days. I know one company that schedules its strategic planning sessions on four consecutive Saturdays during a slow time of the year.

In my company planning sessions, we usually met three times to prepare for all-day meetings, then went away for three intensive days of work to hammer out the written document. It isn't unusual for the complete process to take four to five days or more. The second element of the plan after assembling the team is finding the time to implement it!

Typical Planning Elements

At a minimum, your planning work must place your business believably in the universe of other companies, your customers and suppliers. This means that it should include a thor-

ough analysis of the world your company lives in—preferably from an outside point of view. Additionally, you should compile a list of all the threats and opportunities indigenous to this universe. These are the events over which you have no control, including flood and fire.

Remember the story of the shingle distributor? He made most of his money from real cedar shakes distributed to the Southern California market. Then came the firestorm and untreated cedar shakes were banned for use in new construction. This was both a threat and an opportunity, as he went on to take a significant share of the market in fire-resistant cedar shingles.

Your team should also identify the areas of your business where you want to obtain results. What are the functional processes that are important to your business—accounting, finance, administration, sales, marketing? Businesses grow and change, and so do their key result areas. It is a good exercise to examine and name these areas during the planning process.

You should do a careful review of the business strengths and weaknesses. This can be a difficult exercise, especially for the owner. Talking about weaknesses is tough, but is often illuminating. The key to this exercise is to identify and articulate weaknesses, not find a solution. That will come later.

Some businesses like to use strategic planning to articulate company values and personal values, and attempt to hammer out a core purpose. Certainly these are worthwhile goals. It's really an issue of time and energy—do you have enough of both to get all of the work done? I suggest that you consider doing strategic planning before the start of the year and focus on company values and a core purpose later. This gives you a chance to balance your off-site meeting schedule and keep the processes separate.

Once the strengths and weaknesses are identified, investigate your organization's core competencies. When finished, your team should have a clear picture of what differentiates your business from others. You should have discovered and understand those attributes that are unique to your organization. You also will have identified the most effective skills and resources that you and your teammates use to promote growth, change and development. These core competencies are closely related to the secret behind your business's future success. They are driven in part by vision and culture.

By this point, the team should have assembled a plan that spells out your company's long-range goals and attendant objectives. These are usually of the one-to-five-year variety and should express direction and energy for the company's key result areas. Goals and objectives should be articulated clearly and simply, using common verbs and nouns. They should mean something to most readers and not resemble corporate jargon.

For example, "We're committed to actualize the concept to conformity" is not only incomprehensible but it also turns people off. The idea of a strategic plan is to turn people on. "The payroll system will be improved so as to handle at least 5,000 workers paid weekly" makes a lot more sense to most people.

The Key to Strategic Planning Success: Action

Under each goal (or objective), make a comprehensive list of related action items. These items should describe the specific steps team members will take to advance or accomplish the stated goal. This is the tactical part of the strategic plan. Action items are the difference between a document that simply expresses ambition and one that expresses action and intention. My personal take on strategic planning is that it is a

waste of time unless each goal is supported by a detailed work plan—action items. If you are unwilling to chart a path toward the future, you will almost certainly not get there. In short, if you stop after setting long-range goals, my experience is that the plan is doomed to fail so why bother? Conversely, by working out the action items, you create a powerful blueprint for moving the company forward.

Action items should be fleshed out to include specific steps, with implementation dates and a list of the individuals responsible for carrying out these steps.

The implementation of the action items should be spread throughout the year so as to balance the strategic planning in conjunction with the operation of the business and other strategic activities. Include a calendar of action items and responsible parties as an addendum to the plan so that it may be referred to later.

As part of the planning effort you should include financial projections based on plan assumptions. Your numbers should be projected for the period of the plan (again—three to five years out). A full treatment would include pro forma income statements for each year and a list of the underlying assumptions.

Lastly, the plan should include a schedule of dates for quarterly updates and reviews. These are all-day meetings held once a quarter, in which the planning team assesses its progress, makes mid-course corrections and resets action items. Thus, the plan articulates long-range goals, the steps for attaining these goals and the process for checking and implementing these goals.

My preference is to have the team self publish the plan and distribute it widely, although some prefer to have the facilitator do this work. In my experience, however, the act of drafting and publishing steps is useful reinforcement for the planners and provides a tangible step between theory and action.

Strategic planning is a yearly activity, in my opinion. It should take place over a period of about two months, during which last year's plan is wrapped up and the groundwork for the next plan is established. As a company becomes more skilled at planning, I suggest including customers, suppliers and other related parties in focus groups to obtain their input.

This is the minimum. There are plenty of additional exercises that can be added to your strategic planning work, but get this much finished, at least.

Those who commit and execute this type of program have a considerable edge over those who don't. Next to developing your own personal assessment, strategic planning is the greatest tool of them all. At the end of the first year you will be surprised at the progress your company has made—it takes about that long. At the end of the second year you will fully understand why strategic planning is such an important tool. Good luck!

Work Through a Disaster Plan

I spent my career thinking that my companies were the only ones in the world whose sales fluctuated wildly. We always faced the prospect of losing sizable amounts of our revenue simply because of the nature of our contracts. As I ventured out among other entrepreneurs, I discovered that many of them faced the same sort of dangers.

This is why I suggest to companies that they consider adding one additional exercise—a disaster plan—to their strategic plan. This will add only about a half a day to the entire process. Once all of the future prognostications are complete and the financials are projected out, say, five years, challenge your core team with the following scenario:

The company has just lost a number of its best clients or a certain part of market share (whatever it takes to make this realistic) such that revenues in the coming year are half what they were the previous year. In other words, you immediately face 50 percent loss in revenue. The task is to save the company. Cut back and reorganize so that the company is not only saved but also profitable (if possible).

I call this disaster planning. Although people often think of a disaster as a natural catastrophe—an earthquake, flood, tornado or the like—this exercise relates to a much more likely type of disaster—for example, the loss of a key customer, termination of a major contract or a blistering price war. Many small to midsize businesses experience this type of speed bump at least once in a business lifetime. This is a great exercise in preplanning, training and broadening the team's experience without actually going through such a downturn.

Survey Your Market and Plan

The truth is start-up companies are rarely market driven. By that I mean that a start-up is rarely managed and guided skillfully in the market place. The main reason for this is that entrepreneurs don't really know a lot about how the market works—all we know is it works.

"I'm doing fine, I'm earning a good living, don't screw me up with a lot of talk about the market," is a common attitude.

Well, assuming that you *are* doing fine, and that you continue to do so for a number of years, I still maintain that there will come a time when you will need to test your market—at least once. To do this effectively you must engage a marketing service or consultant.

A competent marketing service consultant will provide you with the answers to the following types of questions:

- What is your market?

- How big is your market in numbers and dollars and what is its geography?

- What players are succeeding in your market?

- What are the characteristics of your competitors?

- What do your market's customers look like, what are they looking for and how do they get it?

- What do your customers think of you, specifically?

- What do your suppliers think of you, specifically?

These consultants will then make suggestions about how to better position yourself in your market, how to relate more positively to your customers and suppliers and how you might make alterations in your operation to take advantage of your strengths.

The reason why some companies don't take advantage of outside consultants is that they can be expensive and the data isn't always accurate. Market surveys are both science and art. And there is a lot to be learned from experiencing this science/art at least once. However, the information gathered by the consultants must be evaluated carefully before any of the suggestions are actually implemented. Some businesses do marketing surveys each year—it's that important to their success. Some do this work once every five years or so and some never.

I encourage you to do it at least once when you have some money to spend on the future. Engaging your customers and suppliers in a survey process will pay big dividends in your relationships and get you closer to the people who matter most to your business.

The survey process can be humbling. This is where you hear, in your customers' own words, what's right and wrong in your relationship.

I once discovered that my most important clients called me in the afternoon because our morning phone person was disagreeable and dropped as many calls as he put through. In the office he was the picture of charm, but to callers he was inept and surly. I wish I had known this sooner!

There are true market driven companies, and those businesses start their strategic planning cycle with a market survey, using the information as grist for the strategic planning mill. It's a good scheme as long as the customer and supplier surveys are well-conceived and the market data is attainable and useful.

Big Tools, Closing Thoughts

When I was 10 years old my father assigned me the task of digging a trench—100 feet long, two feet deep and a foot wide. We were installing some sort of sprinkler and electrical pipes to the farthest point in our yard. The soil was more like rock—shale, in fact— held together by a little dirt. So with a pick and shovel I began my task, committed to work at least four hours each day until I finished the job over my summer vacation.

After a week I had completed almost 15 feet. My father wasn't satisfied and as I tried to explain about the shale, he took it upon himself to teach me an object lesson. He grabbed the pick from my weary hands and began to pick; he picked laboriously until he'd removed a small shovel full of material. He then picked and picked and picked and removed another small shovel full of the tailings. As he was doing this for the fifth time, he threw the pick down saying, "What a bunch of bullshit," and disappeared.

He returned two hours later with a rented compressor and a jackhammer. In four hours of ear-ringing noise and brain—jarring concussions I'd chopped up the ground along the full length of the trench.

I was furious! I was a kid, and had no concept of air compressors or jackhammers. Yet, my father let me pick and pick and scrape my way along for a whole week of blisters and futility. He knew about the *big tools*, ones that made the job a snap. I swore then, that when I grew up, I would never be without big tools again. In the spirit of this experience, from one entrepreneur to another, I offer you: personal assessment, strategic planning and market planning as the biggest tools of all.

15 People Rules

You will be focusing on the mechanics of the business and—perhaps—their effects on you in the early stages of a business start-up. But there are other factors that can impact your business; and many of these factors show up at your office, plant or store every day. Your employees will be your first and clearest link to the outside world. You need to tend to them carefully.

A critical thing that you need to realize is that the people working for you have their own particular way of thinking about the business. Compared to yours, their views are often frustratingly narrow and short-sighted. But how they experience working in your business hour by hour, their feelings, hopes, aspirations and expectations are critical to morale, productivity and, in many cases, the overall success of your venture. The phrase, "You are as good as your people" is an understatement!

I vividly remember the first day in my own office at the center of my very own business. I was scared, I was uncertain, I was anxious. And I was exploding with energy. This is the typical mix of feelings that running your own business brings (especially in the early days).

I also had a set of core expectations. The one that, in retrospect, seems particularly humorous was my assumption that getting the revenue would be the hardest part and running the organization would be easiest.

Isn't youth wonderful? Nature makes us ignorant to protect us, I guess. Those who have already ventured out to start an enterprise know how far off base I was. Those of you who haven't started yet: pay attention. Dreams are wonderful but execution is what counts. Your people—the people you hire—are the only ones who can convert your dream into a successful adventure. Working with people is complicated, stimulating and wonderfully enriching.

Note that the word *easy* didn't appear anywhere in the last sentence.

My initial organizational training came from the football field and the United States Coast Guard. Now I know many consider these to be great proving grounds for leadership, as I too believed—inaccurately, as it turned out. Frankly, most of the leadership qualities I learned on the field and in the military either came up short or added to the confusion. I know this opinion runs against the tide of conventional management wisdom, but I've come to believe that team sports and the military are over-hyped guides for business management.

Running a business—at least a start-up—has more to do with multilateral negotiating than setting rigid, linear structures. And the people who will be attracted to working for a start-up aren't usually the kind whose second choice would be some management-trainee slot with Procter & Gamble or IBM. They're more likely to be young, nontraditional and (consciously or not) antiestablishment.

This is as it should be. But managing these people by some formulaic career-track model will be a waste of your time and their efforts. One of the most challenging parts of starting a business is finding your own, original way to deal with your people.

This chapter extends my discussion of the tools that smarter—and more successful—people shared with me during

and after my career as an entrepreneur and consultant. Here, I offer up *people tools*: those attitudes, processes and relationship exercises that help build a competitive, strong and reasonably harmonious business society.

These steps are outside of the stereotypical hierarchical model—the one that is most prevalent on the football field, in the military and in thousands of North American business organizations.

The Core Team

My mentor and guide in this—my most influential of people tools—is Lawrence King, industrial psychologist, MBA, filmmaker, athlete, world-renowned speaker and consultant. I recently heard him called the "apostle of teams" and as such he certainly converted me. Our relationship, however, began long before he became famous.

During regular discussions over the course of a year or so, he convinced me that the great American model (you bear the brunt of managing and running your organization alone) was a waste of talent. This model, he said, effectively blunted the creative and productive inclinations of the rest of my management team. He said that people, if given the opportunity, will take up the cudgel and move forward on behalf of themselves and the organization, creating a stronger and more creative management force in the process. However, the company head must instill trust, empowerment and accountability in his people in order to create an efficient team.

The first step is to choose your core team. The core team should include each person who has the most senior decision-making potential or authority for each of your key business functions. Another way of assessing inclusion in the core team

is to choose people who would remain in the company if you suffered a significant business setback. Who are the people you would want with you in the lifeboat if and when you start to rebuild?

The members of this team should be willing to have part of their compensation tied directly to the bottom line, as they are the people empowered to make the decisions for your business—as a team. With this in mind, you should be aware that you will be sharing all of the company's financial information with this group. Since numbers are the rules of a business, your core team can't be expected to make decisions without knowing the rules.

Once the team is formed, set up a structure in which you meet regularly and make the decisions necessary to run the business. The key to succeeding at this is to turn all business issues over to the group and resiliently work each issue to a consensus. It takes about six months to a year before the team really starts digging in and being energetic and creative.

This will happen sooner, if you set up your team early in your business life.

Most of us started our companies by personally controling and often doing everything ourselves. And, early on, people (including employees) will *expect* this kind of approach. But, eventually, this becomes a hindrance to peak performance. We gather people around us and treat them like worker bees; we think and they work. The worker bees—who are otherwise creative and energetic people—begin to assume they don't *have* to think.

This system won't work very long. At some point, usually sooner than you expect, you will need to school your people in developing team skills, as you will yourself. My way of doing this was to lay down the following core team manifesto:

- The core team has full authority and responsibility to make all operating decisions in the business.

- Each member of the core team has exactly one vote, if it comes to that. Strive to make all decisions by consensus.

- Core team members are automatically part of the strategic planning team and have access to all accounting records and other business information.

- Core team members receive as much as 50 percent of his compensation based on the company's financial performance. This works both ways (up or down, as the company does).

- Core team meetings occur weekly and last one hour. There is an open agenda. Each member brings necessary agenda items to the meeting. The first step in the meeting is to collect and prioritize the items. They must be concisely presented with supporting materials so as to allow for the most efficient use of meeting time.

- Core team members attend all of the meetings. We cannot do business with absent team members (except for vacation or serious illness).

In addition to developing the manifesto and resulting structure, I took some lessons in meeting facilitation. Nothing draconian, just the basics of running a participatory meeting as opposed to holding court. (Although Lawrence King was my primary teacher here, I can also recommend *How to Make Meetings Work* by Michael Doyle and David Straus as a good resource.)

So what does the core team do? Everything! This team replaces you as the single manager (boss/despot/king) in the

company. The team sets policy, discusses and plans for the future and manages all aspects of the business. A team of committed people will inventively make much better (creative, more efficient, better reasoned) decisions than one person acting alone. From the owner's standpoint this can be tough on the ego but good for the business.

For most entrepreneurs, this is a considerable culture shift, but I must say it was the most successful step I took in my entire business career. Core team management is the ultimate in exercising The Rule of Entrepreneurs and Managers. You work within the construct of your nine core tasks, and your team manages the business.

What types of issues are outside the core team's authority? In our model I owned all the company shares, so I always had the right to "vote the shares." The core team was not empowered to manipulate my equity. Of particular interest from that experience (and it's been confirmed many times over by others) is that during five years of doing business this way, I never had to vote the shares. Much like a public company, there was a clear division between shareholders and management. Both can function effectively within the constraints of their mandate. So, for example, when it came time to sell shares or sell assets or the business, the core team provided management advice but I was left to make the call.

Monthly One-to-One Meetings

I believe strongly in monthly, one-hour meetings with each of my key people.

Meet separately with each member of the core team. Encourage each to bring a list of items he or she wants to discuss. Here are some guidelines that often work for these meetings:

- Everything said in the meeting is completely confidential. This must be a place where both of you can air any issue with a mutual sense of privacy, comfort and confidentiality. This takes some practice, but if you both guard the integrity of these meetings, the relationship and future meetings will be greatly enriched.

- No phone calls, beepers, interruptions or any other distraction during the meeting. You are there to discuss your work, your relationship—anything your teammate wants to discuss for one hour a month.

- In addition to your teammate's agenda, you may have agenda items of your own. Place them after the issues your teammate brings to the meeting.

- As the boss, everything you say has a huge amount of weight with your teammates. You have no control over this. You can, however, use this condition to good effect. Be conscious of your position; listen very carefully to what your teammates say. Ask questions to clarify and, as a rare last resort, offer advice or suggestions.

Lawrence King says you should speak no more than 20 percent of the time, and your teammate will feel as if you've spoken just a little over half the time. Your utterances are that powerful and provocative. As the boss, *less is best* is always the rule. You will quickly discover how the term "bite your tongue" originated.

- Don't miss a meeting—guard your time and have a one-to-one every month.

- If you run out of agenda items before the hour is up, keep meeting. Learn more about each other. You can

ask questions about your teammate's life, children, partner, whatever. Share something about yourself. Take the hour you have together and use every bit of it. If you are uncomfortable with off-agenda discussions, make a list of open-ended questions that can help you through this inevitability. I can't tell you how often the most important point in a meeting has happened near the end, after what seemed like lots of casual or personal conversation. You've allocated an hour with this person and you owe it to your employee to spend the time.

- In closing your one-to-one, create a list of follow-up or action items that both of you attend to during the coming month. Be sure to account for these in the next one-to-one. As always, action items should be assigned to responsible people, have dates due and a specific description of the desired outcome.

At the end of one year, you will likely share a very different relationship with each of your teammates. After three months of one-to-ones, insist that your members start one-to-ones amongst themselves. This way, each core team member will be involved in a round of 360-degree one-to-ones each month. This is a huge culture changer. A year of 360-degree one-to-ones can completely change an organization—for the good. You might consider bringing in a person to help develop one-to-one skills if the process is too difficult.

What this process does is set—and reset—the deals between all of the core team members. It is an opportunity to discuss and evaluate the one-to-one relationship and have a candid discussion about the team, other teams and the company. This is like the earth's crust slowly and non-destructively adjusting in

small increments as opposed to the adjustment that takes place during an earthquake. And, just as with family, each person doesn't have to be enamored with all of her teammates. This is a matter of people working together and paying attention to their relationships as a way of doing a better job.

Annual Core Team Assessment

In addition to the 360-degree one-to-ones, this exercise replaces the traditional employee evaluation. Once committed to a team process for working, I believe you should also commit to a team process for evaluating each other and the team as a whole. This should take place away from the office, and depending on the number of people on your core team, could take one to two days.

You should also have an outside facilitator run the sessions. Your role in this process is that of a team member, not as the person in charge of the exercise.

Each team member should prepare a written summary of the strengths and weaknesses of each team member prior to the meeting. This is a document that contains both lists of notable strengths and noted weaknesses, objectively and fairly written. Additionally, each member should prepare such a list for the team as a whole. The process is then to draw lots to see who is the first to be evaluated. Once that person is chosen, each team member reads and, if necessary, explains her list of strengths and weaknesses for the chosen teammate. When all of the team members have completed the presentation, questions for clarification can be asked by anyone attending, but only questions—there is no additional evaluation.

When this is complete, the chosen teammate is then asked to tell that group what she heard from her teammates.

Then, another member is selected by lot and the process begins again until all of the team members have been through the exercise. As a last segment, go around the table and collect the impressions of each team member for what went right about the process and what could be improved upon.

Next, each member is asked to present the strengths and weaknesses of the team as a whole. The process is to go around the table and collect these strengths and weaknesses on a chart or some common document. Once all team members have spoken, there is a question session—again, only questions of clarification. Finally, the list of strengths and weaknesses can be boiled down to a single consensus list whose elements are clearly understood by all of the team members. The rest of the session is spent discussing action items, processes, education or training that can improve team performance and specifically increase team capabilities and skills.

I've attended and facilitated quite a number of these core team evaluations. I'm sure it will come as no surprise to you that most team members approach these meetings with dread, trepidation and sometimes just plain fear. This is because employees—especially those at small companies—have usually been trained to expect benevolent dictatorial management.

After the sessions, however, the mood is usually buoyant, energetic and purposeful.

This is true even for teams that have dysfunctional relationships. Facing and naming the difficult issues on a dysfunctional team makes everyone feel much better than pretending that these issues will go away. And in many cases, a dysfunctional team can take great strides toward repair and health. Doing this work hugely enriches functional core teams. But emotions are close to the surface and this works best with a skilled facilitator directing traffic and watching for potholes.

Maintain a Dynamic Team

One last point about the team evaluation: many people ask me about teams whose makeup includes one or more notably weak or dysfunctional members. How do you keep the team together while exposing weaker members to this sort of event? In most cases, my answer is that there is always some risk that a weak team member won't like what they hear and opt out of the team.

Alternatively, the process might cause weaker members to step up and take hold. It is my belief that either outcome is good for the team and that you should go forward, eyes open, and travel through the experience together. Those who can't ultimately make it shouldn't be part of the team. Losing such a person gives you and the team an opportunity to find a more competent individual who can be a better contributor.

Team Rules, Company-Wide

Once you've succeeded in developing a functioning core team, organize the rest of your business groups in the same way. The goal is to have a business consisting of a core team at the center, surrounded by a number of self-managed teams. These are the units that actually do all of the work. These teams need the training and leadership that after a year or so transform a loose group of individuals into a self-managed team. The team will hire, fire, budget, plan, assess technology, set production runs, priorities, improve quality and so on.

In my experience, organizing the first group beyond the original core is hard. But once started, the model can be replicated around all of your business functions. *Team Rules* and the core team model produce an organization that has at its core your chosen company leaders operating as a team. Attached to that core

are self-managed teams, outside specialists (lawyers, accountants, tax specialists, consultants) and subcontractors. This is the team rules model for the whole company.

As the self-managed teams are assembled and as they mature, you might augment this culture by bringing in a consultant to design and install performance-based compensation for all of the team members. This is a tricky business, which is why I suggest you hire a specialist who has had success in designing compensation systems. A carefully considered and implemented performance-based compensation scheme is a powerful boost to team members' sense of belonging and well-being. If you succeed, make your numbers and get a financial reward for your efforts, the whole system takes on a different type of energy.

In the end, you will have formed what economist and management writer Charles Handy calls a *federal organization*, a small core with self-managed units driving the enterprise.

Throughout this organization, team rules apply; there is a close relationship to the bottom line as well as the unique culture developed within each self-managed unit. The financial information for this enterprise is public and used as the basis for compensation. Wherever possible, outside experts or organizations are brought in as subcontractors to provide technical or business expertise. This way, the organization can take advantage of top-drawer technology without incurring the ongoing expense of employing experts on the payroll.

From time to time I use team rules experiences and outcomes in talks about entrepreneurship. When I reach the point about self-managed teams and a federal organization, many of the CEOs in the room take on the look of inmates looking for a jailbreak. At the heart of many of the questions that follow the presentation is, "How do you control this monster?"

Many of us who have used the football or military model are accustomed to having employees follow specific instructions—promptly—and in the order the instructions are given. To the extent that you (as quarterback or general) can think of everything, this model works okay.

Team rules is a model where—after time—you let others conceive of the ideas and implement them while you bask in their genius. And rest assured you will find real genius on your self-managed teams. When I work with entrepreneurs it often becomes apparent that this last part—the genius of others and the creativity of a motivated team—is a difficult idea to accept.

Once you experience this model, however, your company is in a very different place and its potential, with you acting as its entrepreneur, has increased exponentially.

Leap of Strength

16 Personal Tools

In the course of researching this book, I've interviewed more than 4,000 entrepreneurs and small business owners. The main conclusion I draw from these interviews is that the kind of people who start their own businesses share some extreme traits—intensity, intelligence, restlessness and the drive for self-actualization.

As you would expect, rummaging around in the lives of these intense people produces some surprising moments. One of my subjects—John, a perfectly affable and successful business owner—insisted on telling me over and over how he detested running management meetings and how he wished someone else would step in and do the work for him. Of course, this was impossible. He owned the business outright, he was the quintessential CEO/entrepreneur and thus, he was the person who *had* to run these meetings.

The topic of management meetings came up so often, however, that it gave me pause. Listening to him, I wondered if he was really saying that he wanted out of the business—you know, some subtle protest announcing deep discontentment with his current lot in life.

Thus, I accepted his invitation to attend a management committee meeting scheduled for the following morning at 8:00 a.m.

Learn Public Speaking

It was a rainy day in Los Angeles. I mention this because the entire city is emotionally distraught whenever it rains. People drive long distances to work and water on the roadways of a city that doesn't understand rain presents a genuine condition of danger and potential mayhem or injury to millions.

Having just survived this adventure, all eight members of the management team arrived. The room was a mix of tension and giddy animation.

I was prepared for a difficult hour as John, the confident-looking and calming CEO, brought the group together. He cast an easy smile and broadcast it as a greeting to each of the men and women seated around the table. He then set the meeting in motion by acknowledging the weather and asking if there were any harrowing stories or immediate concerns that should be aired.

He listened attentively as one manager bemoaned the crush of drivers outside of his daughter's day care center and how his child had been splashed by a driver speeding through a puddle. Another manager had witnessed a bad accident on the freeway and it upset him. The last comment came from a woman reporting that her windshield wipers were worn. She imitated the sound the wipers made—a funny mix between a scrape and a slurp—and said she listened to this for the entire 45 minutes of her commute. She suggested that everyone replace his wipers once a year or face the ordeal of scraping sounds that she again mimicked. Everyone laughed.

John then guided the meeting through its complicated agenda. They worked for an hour. He couldn't have done a better job if he had been an amalgam of Regis Philbin and Bill Moyers. A shared sense of energy and accomplishment permeated the room while John's easy manner added to this positive

ambience. Oddly, the scene beguiled me. And when the meeting ended, they all moved from the conference room in a completely different state than when they had entered. It was magic, and I was confused.

"Ah, John," I hesitated. "John, I don't get it."

"Get what?"

"I don't get what you were telling me about your hating to run meetings."

"What's not to get?"

"John, that was a masterpiece. You are great at it; you obviously enjoy it. I could see it in your face, in the energy you brought to the group. You're a natural."

So John proceeded to let some of the air out of my balloon. He told me that the whole meeting was made up—learned. According to John, he knows how to smile and relate to people but his insides don't like him to run meetings. It seems he spent time with a public speaking coach, a chap named Ron Arden in San Diego. Ron taught John a whole bag of tricks—which mostly emanate from the acting profession. He gave John access to the physical queues that allow John to appear at ease and give him time to think on his feet. John, who is a good student and works hard at everything he does, learned the queues and developed this remarkable speaking and managing style.

It turns out he hates meetings because he is hypercritical of himself. The perfectionist in him feels that he ought to be able to do this work without coaching and without thinking about it—like a natural. Nonetheless, John learned an indispensable skill: public speaking. He not only uses this ability to run meetings, but also to give his stump speech—of which he has about 20 versions—to make sales presentations and industry speeches. He has become a competent negotiator and is quick to deliver an appropriate impromptu piece about his company's excel-

lent attributes. And John credits Ron Arden and the process of learning public speaking. He's right!

As if by magic, out of the great void, John gives us the first of this chapter's eclectic collection of tools: learn public speaking. Many other successful entrepreneurs have told me the same thing, but no one has presented the argument as convincingly as John has.

Establish a Board of Advisors

Having a group of advisors is one of the great tonics to "it's lonely at the top." It is also a wonderful way to get real, as my children say. By *real* they mean having your feet squarely planted on the ground—the real ground.

During my last five years as CEO, I was blessed by the guidance of a strong advisory board, and I now sit on several as a sort of quid pro quo. Most entrepreneurs I've met who use an advisory board are relatively happy about the process. Most often the response is, "I don't know what I did before they came along." This certainly mirrors my experience.

First, of course, you must be a company of sufficient size to be able to attract advisors. I suppose the larger you are, the more advisors you might have on your advisory board. Typically, this is a group of people who bring business and professional expertise to your meeting table. You should choose people you admire, people who have professional skills that add to your experience. This may include other business leaders, CEOs and entrepreneurs. It might also include a lawyer, high level accountant, financial planner or a management consultant.

Typically, these people meet once a quarter for three to six hours. Expect to schedule these meetings around your advi-

sors' busy calendars. Many of the boards I know of meet either late in the afternoon or early evening.

Most advisors I've associated with tend to get paid between $1,500 to $2,000 per meeting. As the CEO, you present everything that you consider important about your business to your board. You present your plans, ideas, tough issues and dreams. Then follow their discussion and review. You should prepare each issue with briefing materials and ancillary material that will help them through the learning curve as quickly and efficiently as possible.

A good method is to prepare a briefing book for each member at each meeting. Then you can work through a published agenda keyed to the briefing materials. If you are dealing with a particularly difficult or complex issue, you might circulate the briefing materials to the advisors before the meeting. In any case, they will question and work to understand your issue...then work on the problem. Typically, at the end of each discussion it's good to poll every member in order to get his or her final opinion or summary advice on the issue.

These advisors do not vote as a board of directors might. This is, after all, an advisory board and so your final step is to gather their advice.

Part of the meeting will also be devoted to reviewing the results of issues discussed in the past. Your advisors will not want to participate unless they feel that their opinions are being considered and that you are sharing outcomes with them. Naturally, this meeting is a good place to review your financial results and learn from their observations and comments.

As you settle in with your advisory board, it's good to bring the members closer to the company by having management team members present selected issues. This gives both your advisors and your management team useful information about

each other, which in turn makes everyone's work easier. Your management team member can be excused from the meeting once the issue is processed.

As an advisory board member, I particularly appreciate a monthly update from the CEO. Typically, such a document might consist of current financial information and a paragraph or two on the top issues facing the company at the moment. Admittedly, preparing and distributing this type of information takes time and effort. It does, however, make the meetings more efficient because all of the advisors arrive well-briefed on the company's progress between meetings.

An interesting result of this advisory board process is the benefit you'll receive by preparing working materials for the board. Many entrepreneurs find great personal returns from sorting out the data surrounding an issue and presenting it to their advisors in a logical way. The nitty-gritty of plowing through the material and pre-thinking possible options often brings to light many more problems and, in a perfect world, some solutions.

Further still, CEO/entrepreneurs aren't used to reporting to anyone! That's one of the reasons we work for ourselves. Agreeing to engage advisors around key issues forces you, as entrepreneur, to be clear, thorough and realistic.

Many of the people who have included an advisory board in their lives have told me that the preparation is as valuable as the meetings themselves. Given our clan's natural propensity to dislike accountability, this is high praise indeed! Higher praise comes from the several CEOs I've met who manage public companies and separately retain a board of advisors—*in addition* to their boards of directors. (The board of directors is a fiduciary body bound by law and governance to represent the shareholders. This is not the same thing as a group of advisors

who are bound to the CEO by loyalty or admiration.) So, as one CEO told me, he takes all of his tough issues to his advisory board first in order to get a preliminary read, reaction or early counsel. Ultimately, of course, he takes all relevant board-level issues to his directors, but he does so with, and these are his words, "greater polish, clarity and confidence."

Find a Personal Financial Advisor

Ever wonder why some insurance entrepreneurs are both successful and wealthy? Well, I did. Of course, we'd all like to think that their wealth comes from gouging the poor business person. My reasoned guess, however, is that in the competitive insurance environment the gouger would be undercut...to death. So I've had to investigate past the obvious.

Much to my surprise, the successful insurance entrepreneurs I've known were wealthy because they not only knew how to make money but they knew how to keep and invest it. The second part is the prize in this pudding, a prize that many other entrepreneurs don't achieve.

As often as I've seen insurance entrepreneurs accumulate wealth and keep it, I've also seen entrepreneurs in other fields earn great sums and keep only a small part of their earnings. It's quite amazing, but many of the successful people I've interviewed have world-class skills at earning money...but less than adequate skills at keeping it.

Part of the problem here is, of course, life style—the need to look bigger, better, glitzier and more abundant than the next person. But I think the greater issue is that people who know how to earn money spend so much effort and energy learning and earning, there is little or no time to learn to invest. There are rules and guidelines for turning an earned nest egg into a big

pile of security. At the center of this system is a population of professionals who give investment advice for a living.

Hence, this is where insurance comes in to play. Managing money and risk drives the insurance industry. People who make their money in this field also learn about keeping and growing their money. So, insurance entrepreneurs have a distinct advantage. Acquiring the skills to evaluate risk, diversify and invest is very advantageous in making more money from money.

I believe that the "sweat equity" experience is, for most of us, the second inhibitor to learning about investing. Throughout my career, when someone talked about a nest egg, I had this innate tendency to think, "Don't sweat it, you made lots of money last year, you know how to make money whenever you want. Saving and investing is for wimps."

Apologies if that gives offense, but that's what the voice said to me.

If I were the only entrepreneur who heard such a voice it wouldn't warrant inclusion in this chapter—I could save it for the memoir. But I know many successful entrepreneurs who have lived their lives from dollar to dollar even though they earn in the top one half of one percent of incomes year after year. So my advice is this: the tool for a better, longer financial life is to find a personal financial advisor.

Find a person who will help you manage your money. So as to avoid your incredulity at the thought of someone else touching your money, let me say that this finding and engaging is a careful and gradual process. Investment managers—reputable ones—say that you may have to try out a number of people before you find the right person. Not only are you looking for someone who will invest according to your wishes and temperament, but you must also connect with someone with whom you have implicit trust.

Money managers suggest you do a survey of your friends, your banker, your lawyer, your accounting firm—whomever. Get references from people. Interview the prospective candidates from this list. Then choose a person for a test—give them a small part of your savings and let them show you what can be done.

There is only one thing better than making a lot of money: investing the returns so that you reap the appropriate gains. It is absolutely extraordinary how many entrepreneurs accomplish the first...and how few accomplish the second. Teaming up with a good financial manager is key.

One last point: good financial mangers have good track records, good references and don't sell you instruments that can't be explained in the context of your financial ambitions. Clearly you must choose this person with great care. If, after sifting through people who do this work, you are still uncomfortable giving control of your nest egg to one person, consider learning how to invest yourself, because getting and keeping are two distinctly different activities.

A Probing Valuation Technique

Once a year, I do a personal assessment—the lists of things I want to do before I die. As part of the exercise I also do a personal financial review.

Any idiot can add up what is in the savings accounts, the mutual funds, stocks and bonds, etc. That is the simple part of the process. But when you are an entrepreneur this whole thing is greatly complicated by owning a business (or part of one). For not only are there the issues of calculating all of the collateral sorts of indebtedness—lines of credit, promissory notes, personal guarantees, lease obligations—there is the juicy issue

of valuing your business assets as well. I say juicy because this feels like the fun part.

If you've been reading this book carefully, you know that I think you should figure out your total personal and business indebtedness at least once a year. Executed properly, this can be thirsty and depressing work. The point of the compensatory exercise is to try to value your business. How much is your business worth?

If you've spent any time with entrepreneurs, you know this question isn't answered by merely fumbling around and finding a price tag. Options for calculating the worth of a business seem limitless. Some people use earnings and find some industry multiple for which businesses are sold. This could be earnings before interest and taxes, earnings after interest and before taxes or net after tax earnings, multiplied by this magic industry multiple, which theoretically equals the value of the business.

I hope you are beginning to see the problem, as the multiple of earnings is by far the simplest of methods. Industry multiples seem to be spread over a wide range of credibility.

On one of those occasions when I've been known to take my own advice, I set out to find someone who could help me value my business. After having calculated the monstrous hole of debt I'd dug, there was need for some big-time cheering up. And what better way to cheer myself up than to have a whopping big price tag figuratively attached to my company? It turns out I knew three other entrepreneurs who knew a lot about business valuation, and year after year I would ask them to look at my numbers and, given their experience, help me arrive at a reasonable valuation (read: *whopping big valuation*).

I performed this ritual for four years. After talking to each of them separately, I self-righteously selected the highest number and went on my merry way, happy in the knowledge that

I could fill that hole of debt in a heartbeat. All I needed was a hungry buyer with industry multiples on the brain.

As I prepared for my fifth yearly personal assessment, I again set about my rounds. I spent the requisite amount of time with my helpful friends number one and two, and received valuations that looked very pleasing. Knowing I already had a wonderful number in the bag (self-deception is a wonderful tonic) I attended my third meeting—a session with my friend Barry Rodgers.

Barry has the intelligence and training of an engineer, the experience of a corporate career, an MBA and several partnership and LBO successes under his belt. He is also an Englishman by birth and I like just listening to him. As we were settling into the discussion of my company and its value, he looked up from the wad of spreadsheets and statements I'd handed him and asked, "Why are you doing this?"

"What do you mean?"

"I mean what is the purpose of this valuation?"

"I want to know what my business is worth."

"To whom?" he asked looking out over the top of his black-rimmed reading glasses. "You know it's not about what the value is as much as who is valuing it. Supply and demand are the setting principles, I'm sure you know that, Walter. So if you are asking me to value your business, I need to know who for?"

"Who for? For me, Barry, for me for godsakes what's with all the philosophy all of a sudden?"

"Yes, of course. But wait a minute. What are you trying to do here?" he insisted.

And I explained. I told him that this calculation was part of my personal financial review and how accounting didn't seem to hold the answer to any question I cared about. I explained my method of valuing my business and using that as part of

my work each year. I was beginning to feel stupider and stupider as an impish grin filled in the whole space beneath his reading glasses.

"You're kidding, right?"

"No, I'm not kidding, why do you ask?" I was feeling a growing sense of foreboding about the whole meeting.

"Walter, you're making up a whole pile of BS, then buying into it. What's wrong with you? You can't make up a buyer and then call that the value of your business, that's nuts."

"Oh. Well, thanks, Barry. I guess that covers what I needed."

Once he saw my uneasiness the grin softened and he gave me the most useful lesson in valuing a business I've ever had. He told me first of all, that very few companies are really ever sold for real cash. My subsequent journey in the world of entrepreneurship has confirmed this in spades. So a theoretical buyer is really an oxymoron. One can either conjure a buyer or one can't. Value is dependent, really, on what I can get in money for my business.

Barry gave me a uniquely ingenious and thoughtful answer. Here is the gist of it:

> Since I am valuing the business for myself—in the absence of a real buyer—why not take a conservative baseline approach? Shut the business down (on paper of course), sell the assets for what they will fetch on the open market and collect all of the receivables and payoff all of the company debts. Whatever is left over is the value of the business today.

This is what I call the Barry Rodgers Valuation Model. Any money you get for your business over and above this amount, were you ever to really sell, is a bonus. I can say from experience, a real bonus earned is hugely more satisfying than a theoretical bonus calculated.

The number I calculated that afternoon was a small fraction of the numbers I'd received from my other friends. Begrudgingly I accepted Barry's logic; it has served me well ever since.

Simple, Accurate and Timely Reports

Business success begets accounting; it is an immutable certainty. As your fledgling enterprise rises beyond a one-person enterprise and begins to grow, so do the needs of the bookkeeping and accounting department. At some point, fairly early on in the exercise, you find that your monthly financials, which in the early stages consisted of five or six numbers derived mainly from the balance in your check book, are beginning to look like real income statements and balance sheets. As you grow and become an enterprise that sprouts the trappings of a real company, these documents arrive at your desk later and later in the reporting cycle.

It is a recurring marvel to me as I visit one successful entrepreneurial business after another to discover, in the middle of the computer revolution, that financials are often completed 30 to 45 days after the close of a month. Insanity!

Numbers are the rules of business and you need them as quickly as possible. I suggest that all businesses find a system that produces at least a preliminary income statement, and sources and uses of funds and a balance sheet no more than two days after closing (or sooner). And if there's a lot of accounting rigmarole, then let it happen out of time and earshot of important day-to-day operations.

I once ran a nice little $8 million-a-year business using Quicken—the cheap version! It cost $49.95! We ran the necessary (simplified Quicken reports) as the sun was going down

on the last day of the month. We then bundled the information for the month on a disk and gave it to an accounting service that produced much of the same results in four days along with all of our tax forms and tax reports. Okay, we had the right kind of business and circumstance to take advantage of Quicken's simple structure. I admit it. But if you don't get current numbers you could be dead and not know it. Any decent computerized accounting system will give you those current numbers.

Part of the problem with growing administrative and accounting red tape is that we, as owners, revel in the fact that we are big enough (finally) to have such problems. Oh, you know my accounting department; well things are so damn complicated because we are so damn successful.

That was my voice speaking in the last sentence, one voice in a chorus of entrepreneurs in full growth and flushed with success. My strong advice is to insist on accurate and timely accounting reports as emphatically as you insist on water to drink and lease a big car if you want to flash success.

Your Own Daily News

In England, they say if you want to hear someone's life story just take a long train ride and someone will likely sit next to or across from you and share. It's true, too; I've taken several long train rides between Edinburgh and London and been gifted with a good life story each time. Life stories were also often exchanged in the first-class cabins of North American transcontinental jets as well, but alas that day has passed. Now it's a CD Walkman and earphones.

In the old days, I was seated next to a chap who was CEO of a company whose sales had just exceeded $2 billion. I was

(and am) impressed. We were talking about business in general and tricks of the trade in particular when he hauled out a notebook he was carrying and pounded his index finger on the first page.

"This is it," he said. "This is the daily news." He smiled as if he were showing me his first grandchild.

"I get this document," he went on, "updated to the moment, wherever I am in the world—every day. With this document I can look at all of the numbers, indicators, precursors and values that tell me exactly what I need to know about the whole company, everything!"

His finger pounded out the words as his voice rose to overcome the roar of the engines. He then settled into himself, became visibly secretive and whispered, "I can be anywhere and catch the slightest glitch coming down the pipe. No one has his finger on the pulse of this company like I do. No sir!"

No sir, indeed! As I looked at the sheet it appeared to be a very densely populated spreadsheet, printed in a font just large enough to allow for clear transmission on a fax machine. And each number reported one of the 40 or so items he used to make for a clear "electrocardiogram"—that is what he called his daily spreadsheet on his company's health.

I've never even imagined running a business that large, but I know plenty of smaller businesses where such a daily news sheet provides management with very current and eclectic indicators of the business's health.

The trick is to design your own and if you so choose, have the information delivered via e-mail to every manager's computer mailbox each workday. I've seen the daily news concept carried right through the organization, down to the shop floor. Each production team publishes its own version of the daily news and distributes it at the start of each shift.

Know Your *No Thanks* Money

If you take the whole population of CEO/entrepreneurs and put them into a room, there would be a minority group, over in a corner, laughing and generally behaving more happily than the rest. These are the people with *no thanks* money.

This is a state of business development where the entrepreneur can afford to be selective about the customers or suppliers she works with.

Imagine that you receive a call from a large company with whom you haven't done business for five years. The president of the company proposes that you get together and do business; the amount of business she proposes is huge—a substantial percentage of your present revenue level.

The conversation continues and in her tone of voice and the sharp way she clips off her consonants, something interrupts your mind. You are reminded of the last time that you did business with this woman's company. You remember that they gave you a huge order then, too, that they ambushed you with crushing and ever-escalating delivery schedules, and then threatening not to pay you. They paid late, made daily changes to the terms of the deal and never paid in full. Instead, they withheld 5 percent of the total contract as a "warranty", which they unilaterally converted to a "quantity discount" after final delivery.

Now for a confession: In financial circles, this is usually called FYM—or *f*** you money*. It's called this because of the swagger that financial types always envision themselves having.

The FYM scenario is this: You listen politely to the business offer. In your head, you consider the deal, consider what else is going on in your company and you realize that this order is more danger than opportunity. So, in your head you

say, "F*** you, I have enough money that I don't need your offer."

With your mouth you say, "We sure appreciate the opportunity to work with you again, but our production runs are full up until summer. Why don't you give us a call then? By the way, how's your golf game faring?"

Having FYM means you can choose who you work with as opposed to taking every stroke of work that comes down the pike. In fact, it isn't just a matter of having enough money as much as it is having a diverse and stable enough revenue source(s) to allow you to steer away from those tremendously difficult clients or customers whose actions make running a business hell (or at least much riskier).

When you start out, you have to work with what you are given. As you grow and succeed, you have a much greater choice. Having that choice is having FYM. It is a much happier place to be; and it's the logical conclusion of self-actualization.

The Equity Point of View

I ran into Richard at a meeting of entrepreneurs and he stunned me with an uncharacteristic answer to my, "Hi, Richard. How are you?"

He said, "I'm fine, Walt. Business is pretty good. My life seems on track and, no matter, if my life weren't on track I could sell the company and get my life on track."

I never could resist a good straight man.

"What do you mean, Richard? You love your company. Your family works there; you've been at it for something like 20 years. You'd never sell it, would you?"

"My business is always for sale. What's the point of having a business if it isn't also a good investment as well as an interesting thing to do?"

And that was it. Richard gave me the gift of an equity point of view. It is the point of view that professional managers (a group I don't spend a lot of time with) understand well. A business is indeed a society, but it is also an economic entity as well as an investment. Why would you have an investment and not assess it as such? Richard taught me to do just that.

Each year, while doing your personal assessment, I suggest that you assess your company purely as an investment. Look at it as if you were a detached shareholder. If, for some reason, your company does not measure up to a good investment, figure out why and introduce the needed changes into your strategic planning process.

As I later learned, Richard used the equity point of view to keep his company sharp and running efficiently. He had found in his experience that closely-held businesses often suffer from slack and complacency to the point of danger. To prevent this, he views his business as an owner and shareholder as well as a founder and CEO.

Read Anything...and Everything You Can

Now here's a tool anybody can master. Hell, if you've gotten this far in my book you are ahead of the game. But there is a little more to it than that, so read on.

I once had a friend/client whose business needed strategic planning more than almost anything in the world—according to my friendly yet professional opinion. He successfully resisted for myriad reasons, the most interesting of which was that he didn't believe in planning because it might cause his organization to miss important opportunities.

We were members of the same athletic club, so there was ample opportunity to see each other. I would listen to his

bitching about this and that in his organization while we were both going nowhere on exercise bikes and he would bristle in a friendly way as I said for the millionth unconvincing time that a strategic planning process might help him. After a while, I got tired of talking about the whole thing and acted as if I were listening. I'd nod off inside—at least to the extent that one can do such things on an exercise bike.

A year had passed when he took me aside at the juice bar and asked if we could talk. Moving to a private table by the squash courts, he asked in a conspiratorial tone whether I knew any good strategic planning facilitators. I gave him three names, smiled a bit too cheerfully and asked him what had happened—had his entire office quit? Had he been to Lourdes? Was he dating a psychologist?

"No. See, I read this book."

"Which book?" I asked, thinking this must be some business book.

"*D-Day* by Stephen Ambrose. It's an oral history of the whole thing, preparation and the first five days of the landing."

"Okay, and so how does that connect with strategic planning?"

He told me a story that runs through the pages of this book. As he summarized the tale, the allied generals went away to some castle and wrote out this huge plan for the great D-Day invasion. They wrote unit orders from their work and took troops away to do some practicing at selected beaches. Many men were killed during the practice landings and, worse, the troops were in chaos just trying to get to the beaches.

Eisenhower called the generals together and reversed the planning process. He and the generals articulated several main goals for each landing. They took those goals to field level troops and had each division plan their own part of the mission. Ex-

ecuted this way, the training of 500,000 men proceeded smoothly. The part that really hit my friend though, was what we all know about D-Day.

It was stormy on the day of the real landing and many of the assumptions about shore defenses and German troop locations were incorrect. So, when the troops were committed under these conditions, tens of thousands of men set out under hellish fire only to discover that their circumstance bore little resemblance to the mission plan. The thing that this oral history made clear to my friend was this: it was the fact that the troops had learned to plan that helped them past the obstacles and onto French soil that day.

Instances of unrelated cues triggering inspiration are everywhere. For readers, these cues come most often from books. Interestingly, fiction as a source is equal to nonfiction. I've seen more than one solution to a murder mystery transformed into a significant business principle or concept.

I've also watched as a reader poached personal qualities from a fictional character and used them to real advantage. An example of *this* comes from an entrepreneur who sold his business for a sum of money that would not sustain him and his family for life. Having to work again—at least at some time in the future—he explained to me that he was going to live the Travis McGee life. As he described it, the Travis McGee life was patterned after the fictional hero of the John D. MacDonald's series of mystery novels.

In those books, Travis McGee lived on a houseboat in the Florida Keys. He kept his net worth in $1000 bills hidden in a cigar box. When the number of bills diminished to a certain point, he would go back to work. He was a private investigator and salvage specialist. He would recover lost items for people who, for some reason, couldn't ask for help from more tradi-

tional social channels. His terms were a 50/50 split of the re-covered goods, plus his expenses. Each recovery was then con-verted to bills, placed in the cigar box and McGee would then go back into retirement. He described this lifestyle as taking his retirement bit by bit all through his life, as opposed to tak-ing it at the end of this life.

My friend literally carved out a Travis McGee life. He took on intense business consulting assignments, ones that paid par-ticularly well. He punctuated these assignments with periods of rest during which he read, sailed, visited friends, traveled for adventure and so on.

All of this supports my conclusion. Those who enjoy read-ing have greater sources of creative material than those who don't. And by default, creative people who are exposed to more creative material have more possibilities in life than others. The most exciting lives I've heard about are, in some way, defined by the abundance of options.

Travel

This tool has, at its heart, the same intellectual principle as the tool of reading, but some consider travel more fulfilling. I have an equally voracious appetite for both activities.

Travel is a physical way of moving completely out of your box. Domestic travel works fine and foreign travel works even better. Foreign travel has the added aspect of pulling the cul-tural rug completely out from under you. Aside from the won-derful experiences of getting to know people who live in for-eign places, there's a lot of self-learning in an out-of-culture experience.

For example, if you want to know something about power, stand in the center of St. Peter's Basilica in Rome and look all

around. The people who built this structure knew something about power. Then, navigate yourself to a good restaurant and struggle through ordering a full mid-day meal from a menu written only in Italian. This is a complete out-of-the-box experience, and one that I heartily recommend—no matter what shows up on your plate. Just remember that *vino* is a reliable accompaniment to almost anything!

Foreign means different things to different people. My wife and I agree that our nine-day trip through the Grand Canyon on a raft was so foreign and otherworldly that it etched life-changing memories for both of us. I promise there is nothing domestic or pedestrian about drifting through billions of years of geology, and millions of years of history in an ever-changing kaleidoscope of color, breezes, water, sun, sand and the ghosts of our ancestors. Accounts receivable doesn't have a lot of impact in this setting.

Involve Yourself in Nonbusiness Activities

This presents yet another paradox. Many of the entrepreneurs I've met who are both happy and successful spend a considerable amount of time attending to family and/or other nonbusiness matters. They somehow find the time to be active in Temple, as deacons at Church, coaches of children's sports teams, scout leaders and big brothers or big sisters—all on top of running a business.

I know this flies in the face of reality and I've struggled with the issues of a broader life outside of business for my entire career—but it's true. Successful people do both. I think the secret is that the nonbusiness activities are as important to them as eating is to me.

When I ask these folks how they manage, I get answers like, "Oh, it's just part of the drill," as if to say there isn't really

a choice. But what I find remarkable is the correlation between people who have other lives and people who appear to be running a successful business while exuding strong signals of inner contentment.

These people possess their own secrets about the greater process of life. But intuitive people can sense the gist of the secrets. Intensity, high energy and enthusiasm carry people a long way.

Leap of Strength

Let the Games Begin!

Lawrence King set out as a psychologist to learn about entrepreneurs. He likes to tell the story in the form of a metaphoric adventure in which he is the searching hero. After earning his Ph.D. and practicing psychology for a few years, he entered the land of entrepreneurs. He likens the trip to visiting a distant planet where humanlike beings live strange lives. He observed these beings from a safe distance, taking careful notes before returning to his ship to decipher his observations.

Eventually, he became convinced that he was in no personal danger. So, Lawrence wandered out among the beings, mingling with them and observing their behavior at close hand. The inhabitants of this planet came in all shapes and sizes, mostly male—but some female—often loud and always moving. Many, but not all, talked as they moved. And the level of activity and noise among these beings was striking.

It took him awhile to notice that, beneath the noise and frenetic activity, these strange beings also exhibited the early signs of the softer emotions—such as caring, longing and even love. However, they would usually disguise these feelings cleverly as enlightened self-interest.

Lawrence wandered and researched the species for so long that he would, from time to time, accelerate his own level of activity and speak more loudly. On one occasion, he found him-

self making a stump speech about the positive attributes of this foreign land. Years of self-discipline in acquiring a Ph.D. then an MBA and even an MFA were barely adequate for Lawrence to decipher what was happening. Lawrence was becoming one of *them*.

He was on a speaking tour when we met in Phoenix, Arizona for dinner. He talked about the change he was experiencing. He described his years of wandering among entrepreneurs and discovering, much like Dr. Jekyll, who he really was. But in his case the discovery was a pleasant one. We both laughed at his metamorphosis.

His speaking tour was a one-man show by an entrepreneur for entrepreneurs and their helpers. He was teaching, telling, motivating, cajoling and performing for one gathering after another, improving as he went along...and giving a great deal indeed. He was walking a high wire woven from strands of performance art and entrepreneurship—and I couldn't stop laughing at the sheer joy and spectacle of his act.

Like many before him, Lawrence had survived an extended autodidactic episode—an unrehearsed, seemingly random passage through apparently unrelated lessons of commerce, attitude, self-reliance and creativity. He'd arrived at a place where he could combine academic interests and commerce.

Listening to him, I remembered what it was like for me to discover the same feelings, what it was like to face the white cliffs of Dover. I remembered how the converging currents of fear and excitement buffeted me when, in April 1972, I set off on my own entrepreneurial career. I also laughed at the irony of it all. Lawrence, in his role as observer and counselor, was one of the people who helped convince me that I had run businesses long enough and should move on to whatever was next. And this book is part of what was next for me.

After dinner and a good douse of nostalgia we left the restaurant and headed in different directions. He left to practice among my old haunts and I left for the realm of writers. It's a very odd place indeed...and I am just beginning to get my bearings. But even here, in this new place, I am still an entrepreneur. I just can't help it.

The scale of things is vastly different. Gone are the armies of employees, the pump of importance and conference tables full of advisors. But I can still feel the rush of expansiveness that pushes the blood harder, makes me breathe a little faster and paints a *let's just do it* smile on my face.

I am alone, now. I guide my own destiny and if I fail it will have been worth the risk. Being an entrepreneur is truly the best job in the world, whether you work alone or lead teams of thousands! So if you are an entrepreneur, I hope you can use this book to make your trip smoother and hugely successful.

If, on the other hand, you are still considering the plunge into entrepreneurship—let the games begin! How could you not do this job? And when you have finished your career as an entrepreneur, don't forget to tell others about how it was and what you learned along the way, so that they, too, can build successful careers and happy lives and share your legacy.

This is my gift to you. I hope that it will be part of *your* gift to those who follow.

Leap of Strength

Index